HOW TO
SHOOT
VIDEO
THAT
DOESN'T
SUCK

By Steve Stockman

WORKMAN PUBLISHING • NEW YORK

For Debbie, who by now probably deserves something more like a statue

Library of Congress Cataloging-in-Publication Data
Stockman, Steve 1958-
How to shoot video that doesn't suck / by Steve Stockman.
 p. cm.
ISBN 978-0-7611-6323-7 (alk. paper)
1. Video recording—Amateurs' manuals. 2. Video recordings—Production and direction—Amateurs' manuals. 3. Digital cinematography—Amateurs' manuals. I. Title.
 TR851.S75 2011
 777' .6—dc23 2011014579

Design by Janet Vicario and Yin Ling Wong
Storyboards by Renee Reeser Zelnick

Workman books are available at special discounts when purchased in bulk for premiums and sales promotions as well as for fund-raising or educational use. Special editions or book excerpts also can be created to specification. For details, contact the Special Sales Director at the address below, or send an email to specialmarkets@workman.com.

WORKMAN PUBLISHING COMPANY, INC.
225 Varick Street
New York, NY 10014-4381
workman.com

WORKMAN is a registered trademark of Workman Publishing Co., Inc.

Printed in the United States of America

First printing April 2011

10 9 8 7 6 5 4 3 2

Contents

PART 1
Think Like a Director

PART 2
Preparation—The Secret of the Pros

PART 3
Setting the Stage

PART 4
How to Shoot Video That Doesn't Suck

PART 5
Special Projects and How to Shoot Them

PART 6
After the Shoot

PART 7
Wrapping It Up

Appendix

A Couple of Notes . . .

About Video Equipment

This book isn't about equipment.

Video is like cooking: A good barbecue chicken recipe works on a $12 charcoal grill; a bad one tastes like crap even if you rotisserie it on a Viking. In video, you can shoot something great on your cell phone or something awful on a $100,000-a-day film set with a top-of-the-line Panavision package.

This book doesn't care what kind of camera you use, or how it connects to your computer, or how many "p's" there are in your HD. It's about your ingredients and how you put them together.

About Language

Since the dawn of home video, people have used "film" and "video" interchangeably, as in "I'm filming my mother's birthday party," when they're actually using an HD video camera that records on chips rather than celluloid. Or "Let's rent a video," when what they really rent is a DVD digital file of a two-hour theatrical feature shot on film.

Now, in the twenty-teens, it's even more confusing. Many of the movies you see in the theater are shot on video then transferred to film to be projected. Your favorite TV show may be shot on film, digitized for postproduction, then output as files for digital broadcast. TV and movies are shot digitally and shown digitally. And many of the commercials you see were created entirely on a computer—no film or video at all.

Given the practical pointlessness of the distinction, I'm going to use "film" and "video" wherever they seem to fit and not worry too much about the technicalities. Neither should you.

The Opposite of "Good" Is "Off"

G reat video is a communication tool of unparalleled impact. It can change history, inspire movements, share and amplify emotions, and build community.

Bad video gets turned off.

Nobody watches bad video. Not your employees, even if you tell them to. Not your parents, even if you send them "the cutest" videos of your kids.

Faced with the choice of watching your terrible video or something good they can get with the touch of a button or mouse, no reasonable person will watch yours—unless you're standing over them going, "Watch this. You'll love it!" Then they'll grit their teeth and mumble, "Oh. Yeah, this is great." But trust me, if you'd sent them a link, they'd have been gone in under 20 seconds. Admit it—you would too.

Nobody watches bad video unless you're standing over them going, "watch this!"

Even mediocre video doesn't stand a chance, because we live in a world of *great* video. From Hollywood to Bollywood, pros crank out video that's technically perfect and reasonably entertaining. When you scan YouTube, the most-viewed videos are the best of more than one billion served by

the site every day. The ones that float to the top of that enormous pile have to be pretty damn good.

That's why the opposite of "Good" is "Off."

If your video's not Good, it's gone. And so is all your effort (and time and money). Like an unheard falling tree, it makes no sound—except the sound of you whining that nobody watched your video. Which is why I suggest that the first and highest principle of creating video is to make one that doesn't suck. Like any Hollywood director worth her paycheck, your most important job is to entertain your audience.

"But . . . but . . . but . . ." Yes, I can hear you gasping from here. "But," you want to say, "what about the ideas? What about training my employees? What about promoting my business? What about my daughter's birthday party? I'm making this video for a *reason,* not just to *entertain!*"

If your video's not Good, it's gone. And so is all your effort (and time and money). Like an unheard falling tree, it makes no sound—except the sound of you whining.

Of course you are. Films are made out of passion for the story or the subject matter. We shoot our daughter's birthday party because we love her and want a record of when she was young; we record a speech because we're moved by the speaker; we create a Web video about stamps because it's our passion; we put together a funny video about work to help build a stronger team; we shoot our friend who did the marathon in a wheelchair because we want to inspire; we interview our 100-year-old grandmother because we want to remember.

Those are the reasons we start a video project. But at some point, once begun, we have to consider our audience. They need to be intrigued, led, and taken care of. A poorly done video, one that bores people to the point of ejection, is worse than no video at all.

If your video doesn't get watched, you have no chance to inspire. No chance to inform, or build your team, or share your passion. In fact, you may *un*inspire people. Want proof? Check out a YouTube video that's been up for a while but has less than 100 views. They are, universally, horrible. They may have been born out of passion, but they were executed ineptly. Nobody will watch them except guilt-ridden family and friends—and maybe not even them. You don't want that to happen to you.

Luckily, stories about inspiration, success, nostalgia, humor, and passion *are* entertaining—as long as you don't push your audience away by giving them video that sucks! You're inspired. That's a great start. To serve that inspiration, you have to tell your story well. You have to entertain.

Video as a Second Language

Video is the new language, and most of us are illiterate. It's not that we don't understand video. We've spent years watching movies, television, and YouTube. We know how the camera angles should look and, at least unconsciously, what they mean. We know how the stories go, whether the guy and girl belong together, or when the monster will jump out.

We *understand* video better than any humans that have ever lived. Most of us just don't *speak* it very well.

Learning how to make really effective video is like learning to speak a second language: You have to learn not just what to say but how what you say will be received by others. When visiting France, you don't want to say something you think means "Can you tell me what tonight's dessert is?" and find out you just asked the waiter why his clothes are so ugly.

In the language of video, camera angles and movement have meaning. You don't want to play back an interview with your 100-year-old great-aunt and discover that by hand-holding the camera and positioning her by the window so she was looking up at you past the lens, you made her look like a creepy, silhouetted serial killer.

Some people think that having great equipment will save them. And it's true that today's cameras do more, better, than any video cameras in history. But like your computer, your video camera is a tool, not a storyteller. It only speaks video as well as you do.

Knowing how to work a video camera doesn't make you a film-maker any more than knowing how to cut with a scalpel makes you a brain surgeon. As in the PowerPoint Revolution before it—and the Desktop Publishing Revolution before that—good equipment is helpful but not sufficient to create good output. Some people focus on the equipment, not what they do with it. They're so busy worrying about wires and pixels and computer software that they never think about how to make something an audience will want to watch.

Here's the good news: You already understand video language. Learning to speak it just takes awareness, a little thought, and some practice. And here's the really good news: The people we're trying to communicate with are a lot like us. If we can create video *we* really like, odds are they'll like it too. And vice versa.

As a bona fide Hollywood director (don't be too impressed; you can't swing a cat without hitting one where I live in L.A.), I see a lot of bad video. Friends send me their stuff, looking for ways to improve. I've even been hired by companies to watch somebody else shoot a video and consult on how they can make it better. I've taught hundreds of people how to shoot better video. Now I'm going to teach you.

How to Use This Book

How to Shoot Video That Doesn't Suck shows you how to think about your video communication in terms of how the audience will respond. You'll learn how to plan, shoot, and edit with the story in mind, and how each small decision you make impacts your finished video.

Making great video is an art, but it's also a craft. Remember that everyone's videos suck when they first start out. Mine did. I bet Steven Spielberg's did too.

All the chapters are short, and each focuses on a single, self-contained concept. You can open the book anywhere and find one idea that will make a big difference in the quality of your video. The more you try, the better you get. It's okay to skip around, but you may want to

|||

KICKING CASUAL VIDEO UP A NOTCH

You and three friends have Super Bowl tickets. It's the morning of. You point the camera and say something cool like, "Yo, Jerry! You're going to the Super Bowl!" To which Jerry, already on his third beer, smiles and says, "Dude!" And fist-bumps the camera.

Congratulations. You've just created today's equivalent of the squinty wave in 1950s home movies. You know, the shot where Aunt Betty would walk right up to the 8mm windup film camera, squint into the incredibly bright lights mounted on it, show her teeth, and wave like she hadn't seen another human being in a decade.

Back then, being able to make your own film—to see yourself on the silver screen—was astonishing. The kind of astonishing thing you'd see at the "GE Future Living" Pavilion at the 1954 State Fair. Merely being captured on film was enough to entertain.

That quaint time when just being on video was thrill enough is now long past. As a culture, we have officially grown out of lingering by electronics store display windows because there THERE!—was us, on TV via closed-circuit camera! Now we give monitors the same quick glance we'd give a mirror as we go by.

We expect to be captured on video. We know that there are cameras in the elevator. We're unsurprised when a friend whips out a smart phone and starts shooting. While you can still hold people's attention with videos of themselves, even that fascination won't last as long as it used to if your video is dull.

If you're the one who finds herself behind the camera at most events, it's time to grow out of "look at the camera and wave" videography. Ask yourself—how interesting is this, really?

If what you're pointing at doesn't rise above "look and wave," keep it short. Practice hitting that "stop" button as soon as you realize that all Jerry's going to say is "Dude!"

read straight through. If you do, you'll get a complete course on how to make better video.

Reading is one thing, doing is another. You'll find a "Try This" section in most chapters with tips or exercises you can use to make your next video better. You can also go to the book's website, www.VideoThatDoesntSuck.com, for more information and links to videos. You can ask questions, which I'll answer on the site's blog, and look for tips from fellow videographers.

Making great video is an art, but it's also a craft. The more you practice, the better you get. Remember that everyone's videos suck when they first start out. Mine did. I bet Steven Spielberg's did too. A little reading, a little practice, and you may never suck again.

What's *Not* in This Book

This book is not about equipment. It includes nothing about how cameras and computers work. No lines of resolution, 1080i or 1080p, disk drive or tape, Sony or Panasonic, Final Cut or Avid. No technical knowledge is required, nor is it provided. Nothing we'll talk about requires jargon, special equipment, or mastery of computer minutiae.

Today, almost any video camera on the market does the work of an entire film crew: lighting, sound, focus, steady movement—even editing. This book assumes that you have a camera—whether it's a pocket video camera, a cell phone, or a high-end HD video cam—and you know how to get it to record pictures and possibly sound. It also assumes that if you want to, you'll find a way to edit—or at least cut out the bad parts.

Great video comes from thinking humans, not equipment. This book will show you how to shift your focus to how the video *works*. What story do you have to tell? How do you make it speak to your audience? How do you suck them in and give them an experience they'll remember?

You don't need to learn how to make your camera shoot in "poster-vision." You need to learn how to make your video entertain.

12 Easy Ways to Make Your Video Better Now

If you're pulling out your video camera now and don't have time to read the whole book before you shoot, here are 12 tips that will instantly improve your video. For more detail, flip to the complete chapter for each topic. More quick tips for special kinds of videos (like vacation and business videos) start on page 157.

1. Think in shots.

There was a man sitting near me at my kids' cello recital last month. He had his camera on a tripod in front of him. At the start of the recital, he pressed record. For the next 45 minutes, he swung his camera back and forth, back and forth across the assembled cellists. Back and forth as they played their various solo and ensemble pieces, as they changed chairs, as the audience applauded. There are problems with this approach to video, not least of which is motion sickness for viewers.

When you're physically present at a concert, you can look anywhere you want. You can look at audience members. You can look up at the carvings on the ceiling. You can read the program or the *Sports Illustrated* you snuck in or, if it's

not too dark and your wife won't notice, your iPhone. In short, there's an entire world of visual excitement to be sought out.

Watching a video, you can look only where the camera looks. If the camera looks at the same thing for too long or doesn't look where *you'd* want to, you're bored. That's why they cover the Super Bowl with 27 different cameras—every few seconds, BANG, a different shot. And each shot focuses on a new piece of information: Here's the snap, here's who has the ball now, here's a defender coming in from the right, here's the quarterback pulling back to throw, and CUT to a wide receiver catching it on the first-down line. Each shot has a point, and cutting between them gives you a lot of information without boring you.

From now on, think in shots. Shoot deliberately. Every time you point the camera, who are you pointing it at? What are they doing? Is it interesting? When it's not, cut and find something else to shoot. Don't run the camera nonstop. Even if you're going to edit later, it's a bad habit that will only cost you time when you have to watch tons of thoughtless, unusable footage.

For more on this, see "Think in Shots," page 41

2. Don't shoot until you see the whites of their eyes.

In the movies, on the big screen, we're impressed by giant vistas. The stunning Old West, where cacti and cowboys roam, or a panorama of stars and planets as we float through the vacuum of space. These amazing landscapes look great in IMAX, okay on our 52-inch plasma screens, and like tiny, blurry garbage on a Droid.

Best you skip more than a second or two of big, wide shots. Which is okay, because here on planet video, we're more likely to be shooting people anyway. People who communicate half of everything they're saying with their mouths and the other half with their eyes. Miss the eyes, and you miss half the message.

A Soccer Game in Short Shots

Parents on the sidelines watching the game, and CUT to:

Your daughter as the ref drops the ball and CUT to:

A shot of her making the big play.

Think about the shifty lawyer on the news whose mouth proclaims his client's innocence but whose demeanor somehow makes you feel he isn't. It's in his eyes. Or in a drama, when she says, "Yes, of course I love you," but you and the hero know she doesn't—it's the eyes again. That's why TV (and Web video even more so) is a medium of close-ups.

The subtle facial patterns that make up more than half of the communication between humans vanish if you're too far away. Your video will improve 200 percent instantly if you always stay close enough to your subjects to clearly see the whites of their eyes.

For more on this, read the aptly titled "Don't Shoot Until You See the Whites of Their Eyes," page 109.

3. Keep your shots under 10 seconds long.

If you watch great videos, movies, or television, you'll notice that, with some deliberate exceptions, nobody uses shots that are more than 10 seconds long. Most are much shorter. These short shots are part of modern film language.

Shooting shorter shots gives your video more impact. At your daughter's next soccer

game, instead of turning on the camera and leaving it running, try this: A shot of the crowd of parents watching the game, and CUT. The team taking the field, and CUT. Your daughter as the ref drops the ball, and CUT. A quick shot of her making a play, and CUT. Continue for 20 more shots.

In 20 years, when you play the footage at her wedding, the three minutes of short shots you've compiled will richly recall a time and a place with more information and feeling than if you had let the shot drag on.

For more on keeping your shots short as you shoot them, see "Keep Your Shots Short," page 105. For more on editing, see "Editing 101," page 196.

4. Zoom with your feet.

Networks cover baseball with cameras all over the ballpark. The cameras have huge lenses that can zoom in on the pitcher's nostrils from high above home plate. It looks great. And all of these long-zooming cameras are attached to huge platforms by the smoothest system of ball bearings and gears modern engineering can design. That's because a little jostle or bump on a camera with a huge zoom lens looks like an earthquake on TV. If the cameras weren't bolted down, shaking would make the game unwatchable. I could draw you a complicated diagram showing that the width of an angle increases over distance, but all you really need to know is 10× zoom = 10× shakier.

To keep your camera from shaking, you could put it on a tripod instead of holding it. But for better video, don't use the zoom on your camera at all.

To get a great close-up, set your lens all the way wide (i.e., no zoom), walk yourself physically closer to your subject, then shoot. When you stay on the wide end of the zoom lens, minor shaking becomes virtually invisible.

Note regarding the "digital zoom": Don't. Ever. Use. It. So-called digital zooms don't see more than the camera's lens normally does. Instead, a computer chip in your camera blows up the picture, reducing its quality. The more you blow it up, the worse it looks.

For more on this, see "Zoom with Your Feet," page 107.

5. Stand still! Stop fidgeting! And no zooming during shots!

Pros get to move the camera. You will too after you become a pro—or even after you've practiced enough to reach "skilled amateur" status.

Until then, treat your video camera like a still camera. Point the lens, take your finger off the zoom button, look at the LCD screen to make sure your picture is good, and press "start." Stop when you've got the shot, and repeat. The rhythm you're going for is Move, Point, Shoot, Stop—Move, Point, Shoot, Stop.

The result will be a series of well-framed shots in which the motion of the subject catches and holds our attention, without the distraction of the frame careening all over the place.

For more about moving the camera (or not), see "Set the Shot and Hold It," page 111.

6. Keep the light behind you.

Modern video cameras, from cell phones to HD, adjust automatically for light. If the light's too bright, they close down the lens to let less in. Normally, no problem for you or the video camera. Your outdoor shots in bright light look great, and so do your indoor shots by candlelight.

The camera gets confused when it has to deal with multiple light levels in the same shot, though. It has only one lens—if it closes that lens to keep out light that's too bright, something else in the frame that was darker to begin with gets really dark. Most video cameras expose for the biggest, brightest thing in the frame. If you put your grandmother in front of a window at 2 P.M., the camera will show you the beautiful scene outside the window and only a black cutout silhouette of grandma.

To prevent her from looking like a refugee from the witness protection program,

Light the subject's face, not yours.

keep the light at your back, or as I like to say, KTLAYB. (Just kidding. No acronyms will be used in this book [or "NAWBUITB"].) If the light is in front of the lens, it's always brighter than the person you're shooting, and they'll be dark. If you keep the light behind you, it will fall on your subject, and they'll be the brightest thing in the frame. And we'll be able to see them.

If you're outside in the daytime and your subjects are squinting, try moving so that the sun hits them at an angle instead of straight on. That will help.

For more on this, proceed to "See the Light," page 118.

7. Turn off the camera's digital effects.

There is no digital video effect that your camera can do that you should allow it to do. Ever. If you shoot nice clean video, you can always add a dorky effect like posterization later with one of many computer editing programs designed to do it. But if you shoot posterized video, you can never take it off. You're stuck with it forever. Did I mention it was dorky?

Despite what the box at the store would have you believe, digital effects don't give your camera special powers. Instead they take the high-quality picture your camera is capable of at its best and degrade it with digital zoom or "night-vision" or some other ghastly thing they thought up in marketing to make their list of features look longer.

Shoot all your footage normally, always. If you feel the need to "night-vision," "night-vision" it in your computer's editing program. That way, you'll still have the original, nice-looking footage just in case.

For more on this, see "Turn Off Your Camera's Digital Effects," page 104.

8. Focus on what interests you.
Really interests you.

I recently watched a video blog post that featured an orchestra whose only instruments were iPhones. The players—it looked like there were about 20 of

them—had special gloves with speakers on their wrists. Pretty cool idea, no? And very visual—a big circle of musicians playing iPhones.

The problem was the video. It started with a very wide shot of the group and then wavered, as if unsure where to look. Occasionally it veered off to one part of thegroup, then another, with no apparent motivating goal. I felt adrift. There were things I wanted to see—like a close-up of the glove speakers, or what the players were doing on their iPhone screens. But that never happened. I felt like the author of the video had no real interest in the subject, so he didn't know what to film. I wanted to be taken on a tour, shown what was so interesting about the orchestra. Instead, my curiosity went unrequited as the shots moved from moment to moment without any real intent.

Every video gets better when you apply an organizing principle, and it almost doesn't matter what that principle is. Suppose the shooter of this video had become very interested in one player and showed us everything about her: the concentration on her face, how she moved her arms, what she was doing on her screen. Or suppose the video had focused on the audience's reaction, showing their faces as they listened, what amazed them, and interviewed them after the show. Or the video could have focused on the music and how it's made— what do the scores look like for an iPhone symphony? Who is the conductor, and what is he doing while they play? How does the music get played?

Find something to focus on—a person or an angle of interest—and your video will improve instantly.

For more on this, see "Show Us Your Passion, and We Will Be Fascinated," page 26.

9. Don't use amateurish titles.

Unless you have a real design sense (you'll know because everyone in middle school wanted to work with you on group projects involving posters), stay away from titles unless they're really necessary.

When you *do* use titles, keep them both short and simple in wording. Use an attractive, plain font—perhaps a nice Helvetica. Keep the title as small as can be easily read. Put it on the top or bottom third of the screen. Use white over dark backgrounds or black over light—no shadows, no outline, no underline, no motion, no glows. No postervision. If your background is too mid-bright for the type to read in either black or white, try putting a simple gray bar behind it.

Keep titles on screen just a beat longer than it takes you to read them out loud. As in all things video, strive for simple but elegant.

For more on graphics for your video, go to "Easy on the Graphics," page 223.

Yosemite, 2011

10. Keep your video short.

When it comes to video, the old show-business expression "Always leave them wanting more" applies. Anything worth saying in video is worth saying shorter. TV commercials tell a complete story, entertain us, and sell us—all in 30 seconds. Benjamin Button lives his entire life on screen, backward, in 2 hours and 46 minutes (not a long time for an entire life, but still some might suggest it could have been done in 2:20).

The record of your mother's second birthday party probably exists as either a grainy two-minute silent home movie or six photographs stuck in an album. Yet if you look at those photos now, you get a real feeling for the time and place. The home movie is short because 8mm film came in two-minute rolls back in those days, but just because you *can* shoot for an hour and a half on your video camera doesn't mean you *should*. You don't need 10 minutes to

show us a birthday party. A sales video longer than three minutes? Unless it's for Victoria's Secret and directed by Martin Scorsese, don't even think about it. And even then, it had better be good.

The best way to make your video shorter is to aim for short when you start. The second best way is to internalize another old showbiz adage: When in doubt, cut it out.

See "Keep It Short: The Rubbermaid Rule" (page 49) and "When in Doubt, Cut It Out" (page 212) for more on this.

11. Use an external microphone.

Most video cameras adjust their own sound levels. That means they take whatever they hear and boost it to a constant, listenable level. Unfortunately, if they hear crowd noise around you, they boost that. Traffic noise, sirens—it all gets boosted.

In fact, if the camera mic hears nothing, it boosts that too. In an interview where the subject is too far from the mic, the camera will crank up every hint of sound between you and them, creating a big, echoey overlay of room noise.

If you're as close to your subject as you should be, this is less of a problem. To make it no problem at all, head to Best Buy and plunk down $25 for a terrific clip-on mic. Plug the wire end into your camera, clip the mic end to your subject's shirt, and your sound problems are over.

You can also buy a boom mic, which requires an assistant's help. The assistant holds the mic very close to the subject, just outside of your camera's shot. Noise problem solved.

Further ruminations on sound quality are featured in "Make Sound Decisions" (page 152).

12. Take the quality pledge.

Please rise, raise your right hand, and read aloud in front of witnesses:

"I, [state your name], promise not to inflict lame video on my friends, relatives, customers, or complete strangers who might find it on YouTube because I put something about sex in the title.

I hereby promise that I will always keep the microphone very close to the people talking or use an external mic if I'm too far away. If the picture is too dark to see, I won't use it. If I left my thumb in front of the lens, I won't use that shot.

If the person I'm shooting is so far away you can't even see them, I promise not to make anyone watch—not even my mother—for more than 10 seconds.

Unless it's footage I accidentally took of a once-in-a-lifetime thing, like my son catching Alex Rodriguez's record-breaking 610th home run or a thief breaking into my car, I promise to keep jerky, hard-to-follow video entirely to myself, erasing it where possible.

I pledge to conform to a higher technical standard, realizing that making someone watch bad video is disrespectful, that in most cases they would chew off their leg to get away from it, and that technical problems will keep them from appreciating the funny/cute/beneficial/talented/shocking thing I'm trying to share with them in the first place.

In short, I pledge to think about how to make quality video for my audience at the same time as I'm thinking about getting my point across. I won't make anyone watch anything so crappy-looking that I wouldn't watch it voluntarily if they handed it to me."

You may be seated.

Think Like a Director

A director's job is to shoot video that people will want to watch.

That means thinking about communicating with your audience, about how they'll view your video, and what might make it a better experience for them.

This fundamental shift in the way you think will guide you to different—and better—decisions as you shoot, even if you don't do anything else.

Since most people who shoot video don't think about it *at all*, just giving it your attention creates change.

Entertain or Die

Your own experience is the same as everyone else's: It's painful to watch bad, boring video. Bad video takes your time and gives you nothing in return. And like anytime anyone steals from you, you quickly come to resent it. Whether that resentment causes you to click away (if you're alone) or start to hate your relative/employer/friend (if they're making you watch), the resentment is real and powerful. Watching video is a transactional experience, and if the video doesn't do its part, you feel cheated.

Audiences pay (with time and/or money) for that which entertains them. Period. No entertainment, no audience. The minute you hand someone a DVD or send them the link to your video, you enter this transactional marketplace, whether you want to or not.

Here's the implicit deal: I (the viewer) will give you my time, and you (the video) will give me an experience that I'll enjoy. If you give me a good enough time, I'll even pay you—by buying a ticket or watching your commercials. But if you give me a bad time, I want out. Immediately. I have other things to do.

This trade is called "entertainment." Audiences pay (with time and/or money) for that which entertains them. Period. No entertainment, no audience. The minute you hand someone a DVD or send them

the link to your video, you enter this transactional marketplace, whether you want to or not.

Now, it may be that your audience already owes you. Maybe they work for you. Or maybe you watched *their* lousy video, so they're obligated to watch yours. This doesn't get you off the transactional hook. You still have to entertain them. Somewhere in the middle of your lousy video, they'll forget they owe you and start to hate you for making them watch.

Or it may be that your video is the most informative in the known universe, one that will teach the viewer more in five minutes than four years at Harvard. Or that it's about an issue so urgent that life as we know it will end unless it is watched. Nonetheless, if it's boring and badly made, nobody's life will be changed, because nobody will ever sit through the whole thing.

Even if you strap people to their chairs, their attention will wander. They'll text. They'll sleep. They'll daydream. You can't will people to watch. You can't pay them to watch. You can't make them watch. You can only offer them the age-old deal: Watch me, and I'll give you a good time. Then you have to deliver.

The first step to preventing bad video is accepting this truth: Entertain or die. Leave the audience wanting more. If you don't, they'll leave you. You don't need explosions or nudity or Will Smith to entertain. You just need competent, compelling video that intrigues your target audience.

Insist that any video you release to the world seem competent, compelling, and intriguing to *you*. Let go of your preconceptions and think like a first-time viewer—someone who has no idea what

What Entertains Us?

Pick 10 YouTube videos more or less at random from the "videos" front page. Try to have a good mix of amateur and professional, some with many views and some with just a few.

Hit "play" for the first video. Stop the second you find yourself wanting to change the channel. How many seconds have you watched (there's a timer on the lower right of the video box)? At what moment are you bored? Why? What made you tune out, and what made you stick around?

If you watched the entire video, why? What kept you interested?

See if you notice any trends in your viewing patterns. By thinking about how these videos are (or aren't) paying you back for your time investment, you'll start to think consciously about what makes a video entertaining.

you meant to do, but fully understands what great video looks like. Someone who doesn't automatically think your friends are cute, who doesn't get your in-jokes, who won't understand you if you mumble. Honestly now—what would this person think of your video? What would make it better?

Professional directors spend all their time thinking about how to entertain the audience. And so should you.

The Road to Bad Video Is Paved with No Intent

B efore a professional director takes on any project, she knows why she's doing it—her intent. "I want to expose the dangers of global warming to a large audience" is a great intent. But so is "I want to scare the hell out of people." Either way, it's clear what the director is setting out to do. But think of the poor director who begins without a clear intent. How do you know if a scene is working or if an actor is right for a part if you aren't clear about what you're trying to do? As Yogi Berra famously said, "You've got to be very careful if you don't know where you're going, because you might not get there."

Every video needs a clear intent. The intent can be as simple as "I want to share my trip to Namibia with friends" or as complicated as "I want to change the 20-to-40-year-old, non-college-educated audience's perception of recycling." Whatever it is, it's the reason you're doing the video in the first place.

Want to really make your video suck? Confuse "intent" with "result." An intent is what you're trying to accomplish when you

make the video. A result happens after the video is done—and you don't have much control over it. "I want to point out absurd behavior in a hair salon" is an intent, whereas "I want to be discovered by a Hollywood agent" is a result. One guides you through the process. The other won't, because it's all about things that won't happen until the video is complete.

If your intent is to "show absurd behavior," you can guess that when you shoot something that strikes you as absurd or funny, you're on the right track. But how would "being discovered by a Hollywood agent" help you decide how to shoot your video? You can't evaluate the discovery-making potential of a cut. Nobody knows what kind of soundtrack agents like. Basing a project on results doesn't help you get it done. Worse, getting caught in the trap of trying to guess results will drive you crazy.

Is it okay to want to be famous on YouTube or make a lot of money? Sure. But don't look to those hoped-for results as a guide to your video-making decisions.

I once asked a CEO of an environmental equipment company what his goals were. I was expecting to hear some intent, like "Give people inexpensive tools to reduce carbon emissions" or "Help coal companies be better neighbors in their communities." Instead, he replied that he wanted his company to make the Fortune 500. That might be a result of his success, but *success doing what*? Only intent points to clear action.

Another friend of mine is the founder and CEO of a craft brewery. When I asked him his goals, he said he wanted to make beers he loved, beers that challenge the senses, and to share them with people. That's an intent. The environmental CEO's company was bankrupt two years later. My beer buddy's company is the fastest-growing brewery in America.

TRY THIS

What's Your Intent?

Before you shoot your next video, brainstorm a long list of why you're doing it and how you want to treat the audience. Select the most useful intents from your list and keep them in mind. Let the intent live in your mind, and your video will instantly take on a life it may not have had before.

Here's my brainstormed list from a video I codirected for Summer Stars Camp for the Performing Arts. Summer Stars teaches disadvantaged kids ages 11 to 14 how to succeed through the performing arts, and we needed (need! www.summerstars.org) money. To brainstorm, I tried to let my mind go, and wrote down *everything* that occurred to me, without judging:

My intent might be:

- To raise a lot of money

- To show people what happens when kids come to Summer Stars

- To show how kids grow through the choices they make after attending camp

- To make the camp look like fun

- To invite the audience in to play with us

- To get the *Today* show to cover the camp

- To impress viewers with the level of performance the kids achieve

- To make the audience tear up thinking about these kids

- To make the audience feel the pain of the lives these kids come from (and are going back to)

- To show how good gets done, one kid at a time

- To make the audience feel they're participating

- To show a before and after view of the kids who've been to camp

- To show how hard work and challenges pay off for the kids

I went through the list, rejecting the obvious "results" like "raise a lot of money." I looked for what excited me and gave me a lot of ideas on how to shoot.

Ultimately, I went with the intent "to show a before and after view of the kids who've been to camp." This led me to interview kids on day one of camp, when they were defensive and shy, and again on the last day, after their triumphant performance in the camp-ending show. I also interviewed counselors now in college who'd been on the verge of gang membership when they first arrived as tough and terrified 12-year-olds. The result was a solid little video that makes you feel what happens when you give to Summer Stars.

You can see it at www.VideoThatDoesntSuck.com/examples.

SHOW US YOUR PASSION, AND WE WILL BE FASCINATED

My favorite street performer has been playing for the last 15 years on Santa Monica's Third Street Promenade, a mile-long open-air pedestrian mall not far from where I live. But his appearances are rare and his performance odd, and he comes out only at night.

He's a little guy, and he dresses in black, with a big utility belt around his waist. A giant flashlight dangles from the belt, along with various wire hoops, some tubes, and a folding fan. He carries a flat pan of liquid and smokes a cigarette. When he feels inspired, he takes one of the wire hoops, dips it in the liquid, and waves it, creating a giant bubble. Then, using one of the tubes, he blows cigarette smoke into the bubble, and shines a flashlight on it.

The flashlight shows off the swirling smoke in the dark, which is stunning—but that's only the beginning. Somehow, using another tube, he blows more bubbles inside or around the first,

adds more smoke (or not), and creates astounding, reflective bubble sculptures that float above him, kept aloft by the warmth of his breath and the wafting of his fan. Bubbles in bubbles, complexes of spheres, pyramids of bubbles, shapes you never imagined a bubble being. Eventually the sculptures hit the ground or the wall and explode in a beautiful puff of smoke. The light goes out, and we're off to the next bubble.

What fascinates me about his performance is that not only is it visually stunning, it's unquestionably bizarre. Why would someone practice (and he's a master, so you know he practices) blowing bubbles with cigarette smoke? What first inspired him to shine a light on them? He frequently draws as big a crowd as the jugglers, the guitarists, and the guy who paints himself silver.

To port this idea to video, take a look at the YouTube performances of Brandon Hardesty (www .VideoThatDoesntSuck.com/examples). Brandon

Is it okay to want to be famous on YouTube or make a lot of money? Sure. But don't look to those hoped-for results as a guide to your video-making decisions.

Once you commit to an intent, your work will instantly be more focused. If you have no intent, you might shoot randomly through your daughter's first birthday party. The intent to "share with my parents how cute my daughter is on her birthday" will lead you to focus on your daughter's behavior instead of on the adults in the room. You might shoot more close-ups of her, or move the camera down to shoot at her level. You might look for more candid shots of your daughter, taken when she doesn't know you're watching.

reenacts scenes from movies, playing all the parts, in his basement. It's every bit as odd a performance as a guy blowing smoke into bubbles. But Brandon is also every bit as committed to his art. He performs with passion, giving it everything he's got—and he's not a bad actor. As odd an idea as it is, it works.

I think the lesson for videographers is this: Your passion, your commitment, are entertaining in and of themselves. Show us that passion, and the reason for it, and you open our eyes. It doesn't matter what it is—we are as happy to visit a museum with a giant ball of string as we are to watch Morgan Spurlock eat McDonald's every day for a month (*Super Size Me*). The sheer passion of humanity captivates us. Shoot what you love.

The mysteries of human passion fascinate us.

The corollaries to this rule are just as important, even for the less passionate: 1) To make interesting video, you *must* find what's interesting in everything you shoot. Even the most boring topic has some fascinating aspect you haven't discovered yet. And 2) Your best video will always come from shooting what you love.

The intent to "showcase the lead guitarist's incredible playing" will totally change and focus the decisions you make when you shoot the video of your friend's band. "Show the customer how our in-store experience is quicker than ordering online" will lead to different choices than "Show the customer how nice our employees are." Either of those choices leads to a better video than "Help increase sales" or any other vague, results-oriented wish.

What's your intent?

Should It Be a Video?

V ideo shines at communicating motion and emotion. Facts and figures? Not so much. If what you have to say is best said with charts and lists, it may not be good video material. It's not video's fault—it's the way we're wired.

Early humans evolved to survive on the plains of Africa. We had to respond quickly to threats, and for the most part those threats moved. Our eyes became sensitive to motion and, since rocks and trees aren't that threatening, ignored things that didn't move. That's why wild animals freeze when you surprise them in the woods. They know your eyes won't be drawn to them, because you're looking for motion. The same with video—our eyes go to the motion in the frame. Anything that doesn't move becomes invisible.

This explains why it's so difficult to sit through the college graduation video where your friend set the camera on the tripod, pointed it at the stage, and let it run. The speakers stand in one place and speak. The guests sit in their chairs. Everything's static. Try as we might to pay attention, our eyes wander, seeking wildebeests, or lions, or please God, anything that moves.

Emotion also comes through loud and clear on video. Babies and pets are all over YouTube for a reason (crowd: "Awwwww!

Babies and pets!"). Humor, fear, patriotism, anger, inspiration, awe, and lust are the stars of the video universe for a reason. You can try, but you won't find a successful video or TV show or movie that isn't an emotional ride for the audience.

This too is not video's fault. Human beings are not a dry species. We remember stories with emotional value ("Don't chase tiger without spear! Og dead!"). We're inspired to war, to marry, to work, to have children—all by emotion.

Despite this, people persist in trying to sell to, convince, or motivate others by creating videos focused entirely on facts. The next time you're considering showing a long list, timeline, or chart, think again. Dry, emotionless lectures try people's patience, and they try it even more if you make them watch the lectures on video.

This isn't to say that you can't communicate facts with video—you just can't communicate very many very well. There are facts in any story you tell. The ones you want to avoid are the ones *not* in a story.

> ### TRY THIS
> ## Why Should We Care?
>
> Next time you're tempted to list facts, brainstorm a list of "why should we care" for each one. For example, "Polar ice caps have decreased by 20 percent in the last decade" is a fact. Why do we care? "The world will be at war 50 years from now as millions are driven inland by rising tides—including your children and grandchildren." Now you have something that could easily be the basis of a video (or feature film!) and appeals through story, emotion, and motion.
>
> Also note that answering "Why should we care" leads you to a strong intent.

For example, you could do a video for your musical instrument store that lists all the vintage guitars you sell: shot after shot of Stratocasters, Flying Vs, and Les Pauls, each captioned with the year the guitar was made and who played it. Or your video could document the emotions of a 16-year-old customer on the day he plunks down a hard-earned $3,800 to buy the vintage twin-neck Gibson that Jimmy Page played on "Stairway to Heaven." Both versions convey the fact that you sell vintage guitars. Only one will be memorable.

Instant Creativity

Brainstorming is my go-to mode when I need ideas for a shoot. It's also a huge help in getting me to take more risks on the set. It's a useful skill that's well worth taking some time to practice.

Brainstorming is a business buzzword that people often use to mean "we'll just come up with some ideas," but it was actually created by an adman named Alex Osborn in the 1950s, with a set of simple rules that still work today.

When we try to think creatively, we often say things like, "I know! What if we . . . Nah, we did that last year." Or "Wouldn't it be great if . . . Forget it, we probably couldn't afford it." Ideas come up, but they get slammed in pretty much the same breath.

Brainstorming separates that hot "I've got it!" moment from the cold "I don't think that will work" moment. Separating the two phases inspires you to more and wilder ideas, which gives you more to choose from—and makes you more likely to take a creative risk.

Break your brainstorming session into two phases. The "hot" side involves making a long list of ideas without judgment. Then, separately, the "cold" side kicks in as you make choices from that list.

1. Making a List: During this phase, you list as many ideas as you can on a sheet of paper or computer screen, no matter how stupid, wild, or awful they are. In fact, stupid can be good if it makes you laugh, or triggers another idea! In this phase, you don't judge ideas at all, good or bad. Your goal is a long list.

Wild ideas, like shooting a kids' soccer game from a blimp, can lead to useful ideas—like shooting a big shot from the top of the stadium.

2. Making Choices: Review the list. Start by marking all the interesting ideas, even if they seem a little far-fetched. Then narrow down the ideas to the ones you really like. I try to look for ideas that make me nervous—those usually turn out to be the most interesting when I give them a shot. But you can choose the ones that excite you, that seem different, that seem easy—the selection criteria are up to you.

Here's how it works in real life:

Planning to Shoot

I've promised my relatives I'll post some video of my son Matthew's soccer games. It sounds kind of boring, so I'm looking for a new way to shoot it. I'll brainstorm by separating my thinking into two parts: "Making a List" (brainstorming) and "Making Choices" (picking ideas to use).

I want a long list, so I won't judge these ideas as I go. I'm going to write down even the stupidest ideas. In fact, to loosen up, I might be intentionally stupid:

- Tape a camera to the ball
- Ask the ref to carry a camera
- Rent a blimp and shoot overhead
- Dress like an AYSO ref and run the field with the team

- Give Matthew a pocket camera he can drop on the ground during action
- Dangle a camera from a 50-foot pole over the field
- Have his sister narrate the action live
- Shoot at a practice instead of a game to get into the action

Really **getting close to the action brings the emotion of a sports video to life.**

- Interview the team about their approach to the game
- Use a *huge* zoom lens and a tripod
- Put a camera on the coach's hat—helmet-cam
- Shoot from the team bench
- Focus on the coach and his approach to Matthew
- Do a "behind-the-scenes" video with Matthew practicing and getting ready

Now I'm ready to make choices. There are a few things I like:

- Dress like an AYSO ref and run the field with the team
- Give Matthew a pocket camera he can drop on the ground during action
- Rent a blimp and shoot overhead
- Shoot at a practice instead of a game to get into the action
- Interview the team about their approach to the game
- Use a *huge* zoom lens and a tripod
- Shoot from the team bench
- Do a "behind-the-scenes" video with Matthew practicing and getting ready

Obviously some of these ideas just aren't going to fly. But if I talk to the coach, I bet I can get the okay to run with the team during practice and get a lot of cool shots. And I'll try to interview them

during downtimes. Combined with some game footage, that should make a pretty interesting soccer video.

During a Shoot

When you're in the middle of shooting, say, a company retreat, you won't have time to whip out a pad or laptop and start making a list. But the idea of brainstorming is still useful. You have a camera in your hand and something you want to shoot. Then, brainstorming looks like this:

Making a List. Get in the habit of questioning, just for a moment, your actions:

Instead of standing where I am and holding the camera the way I always do, in what other ways might I shoot? What if I sat in the front row? What if I got right next to the speaker?

Who can I talk to on camera? Can I interview the CEO after each session? Who's the newest staff member in the company—what would be interesting about her point of view?

Making Choices. Go with anything that strikes you as interesting. Video memory is more or less free, so try whatever catches your imagination.

TRY THIS

Storming Your Brain

What's your next video opportunity?

If you have something planned, try brainstorming a list of new ways to shoot it. Get wild—then try an approach you wouldn't have thought of otherwise.

For a looser brainstorming experience, whip out your camera right now. Shoot what's around you. Now ask yourself a few "what ifs". Try the one that seems strangest to you, and see what you get.

Know Your Audience

A great home video of your Fourth of July barbecue has a different audience than a Web video for your blog on gardening. The first audience will be friends and family—the people who came to the barbecue. They're interested in how they looked, remembering the events they forgot after the margaritas were served, and maybe sharing that good time with their friends.

Even if you think your video will be great for everyone, there has to be a subset of "everyone" who will especially like it.

The second audience comes to your blog to get advice on plants and how to lay them out in the yard. They might like to see a few shots of your party if it happened in the garden, but they're less likely to want to hear your two college buddies reminiscing about the time you ran naked through the quad.

Consider the likely target audience for your video. It's more likely to be a hit if you've thought about the audience and what will make it great *for them*. Even if you think your video will be great for everyone, there has to be a subset of "everyone" who will especially like it. Who are they?

Think before you shoot:

WHO is your audience, literally? Male? Female? What do they like to do? If you're doing a video on stamp collecting, the audience is philatelists. Why will they be interested in what you have to show them? Where do these people live? How old are they? Why do I still snicker at the word "philatelist"? The more you know about the people who will be watching your work, the better.

WHO is the competition? This is not that important for the kid's birthday video, but if you run a business (or you want eyeballs for your band's music video), you need to know what the other guys are doing. Knowing before you shoot will help you do better than the competition.

WHAT does the audience want? Presumably you know what *you* want: to sell them stamps, or your sports videos, or your ideas. Or to show them an event they missed or to keep a record of a speech. But what interests your target audience? Information? Inspiration? What entertains them? In short: What's in it for them?

WHEN will they be watching? During work? At home in their spare time? And . . .

WHERE are most people going to see your video? What works on the Web may not work on CBS. A wide shot that looks great in a theater looks like a tiny, featureless nothing on a smart phone.

WHY use video? What will it show the audience that you can't show them any other way?

TRY THIS

Am I Their Audience?

Here's an easy way to see the power of audience targeting: Go to http://trailers.apple.com/. Check out the graphics the movies use and the little descriptions they provide. Look first at a few trailers that seem interesting to you. Then click on a few you know nothing about. Finally, check out a couple that you know, just from looking at the posters, you are completely and unalterably *not* interested in.

How'd the movie studios do at getting your interest? Can you see which movies are clearly *not* aimed at you? What's the difference?

|||

KNOW YOURSELF

You need to know your audience, but you also need to know yourself. After all, you're the first audience for your video. You'd better love it.

A screenwriter friend of mine told me that he chooses a project by deciding whether or not he'd pay to see it in a theater. If he can't see himself getting excited about buying a ticket and a bucket of popcorn and waiting for the lights to go down, he won't try to write it. The few times in his very successful career he's violated that rule have been disasters. Every moment of writing, every meeting with the director, every ad that eventually ran to advertise the movie made him feel like a fraud.

If rule one of making great video is that it has to entertain an audience, our first corollary is that it has to entertain *you.*

An audience of one is fine, as long as you meet the needs of that audience. My company has created videos that cost tens of thousands of dollars targeted at exactly eight people—all the decision-makers at major cable networks. To create them, we had to think long and hard about the needs of the networks and how to convince them that the TV show we were proposing met those needs.

For your video: Who is your target audience, and what will entertain them?

Know Your Story

When someone wants to tell you about their favorite movie, they start with the words "It's about a..." We pay attention because we instinctively recognize a story about to start. "It's about a girl who learns she's really a princess and has to grow into the responsibilities of royalty." "It's about a guy who dances with strangers all over the world." "It's about a girl in love with a vampire."

If you ask about a movie and your friend starts her description with "It has good special effects," she's given you the equivalent of dating's "He has a great personality." You already know you're not going to love it. "Once upon a time" is what draws us in and makes us want to put our butts in a seat for 90 minutes or more.

> **We love story. We crave story. We remember story. Every video, no matter how long or short, will be better if it tells a story.**

We love story. We crave story. We remember story. Every video, no matter how long or short, will be better if it tells a story.

Stripped to its essentials, a story has four elements: A hero, a beginning, a middle, and an end. The beginning of any story introduces us to the hero and what situation he's in. The middle tells what happens to the hero next. The end is how it all turns out.

The Four Elements of Story

Beginning: The hero climbs the diving board.

Middle: The hero dives.

End: The hero enjoys victory.

The Hero: For our purposes, this is the "who" that the video is about. It can be your son the day he gets his first haircut, your best employee, or the singer in your band. But make your video about someone. ("Someone" could be "something," of course—a dog, an oil-soaked pelican, or even a cardboard box that ends up in a landfill. But it has to be the main character.)

The Beginning doesn't have to be complicated. In the beginning of any story, we introduce the hero, tell where we are right now, and give some sense of where we're headed and why we are watching.

The haircut story might begin with shots of your husband trying to convince a two-year-old how much fun a haircut can be. The video about the employee might open on a customer-service phone call she's making. And when the drummer bangs his sticks together on the opening beats, we know we're in a music video. All simple, all beginnings.

The Middle: Something happens. Baby meets barber. Service rep calms an irate customer. The band sings the chorus of the song that you shot out on the street. It doesn't have to be complicated, it just has to progress. If you can challenge your hero, so much the better. Show the scary scissors coming toward us or the wheel falling off a customer's new car.

TRY THIS

Story Strips

Before you shoot your next video, no matter what it is, write out some notes on the four story building blocks. Who is your hero? What happens at the beginning, middle, and end of your story?

The daily comics are masters of three-panel storytelling. Take a look at your daily paper (or a site like http://comics.com) and break any three-panel strip into story components. No need to write—just notice: Each one features a hero and a setup (beginning), complication (middle), and joke (end). Simple and elegant storytelling.

Practicing looking at story this way will help you internalize story structure. And all by itself, that will change for the better the way you shoot video.

The End: What do you want to leave your audience with? Endings should have some kind of resolution or closure. Maybe your son finally stops crying when the barber gives him a lollipop. The employee takes another call while explaining in voice-over that customers —even crazy ones—are why she loves her job. The song ends, and the band members smash their instruments.

Story structure makes video easier to understand. You don't have to work it all out in detail, and the result doesn't have to be a feature-film script. Without any extra work, practicing with the rhythm of story will help you shoot better video.

Think about something as simple as your son's first dive off the high board. In story terms, he's the hero. Beginning: He approaches the board. Middle: He climbs up nervously. End: He dives—and comes up smiling. Just thinking about this sequence before you shoot gives you ideas about where to stand and when to press "record." You're more likely to be in the right place at the right time, shooting the right video.

THE HERO'S JOURNEY

In most well-constructed stories, the hero wants something. How he tries to get it is the story we tell about him. So it is with many videos:

Beginning: The hero expresses a desire or need. Middle: He struggles to fulfill it. End: He overcomes the trouble and gets it.

Not all heroes are Luke Skywalker. Sometimes the hero is your son, learning to ride a bike. He wants to ride without training wheels. He falls a lot. And finally he makes it down the street without crashing. A complete hero's journey in a two-minute video.

There is also a *tragic* hero's journey—in the end, the hero doesn't get what he wants. Think *Hamlet,* where everyone dies at the end. That's also the structure of the *comic* hero's journey. *America's Funniest Home Videos* has been on the air damn near 20 years with its version: Boy wants candy. Boy is blindfolded and swings at piñata. Boy hits father in the groin. A tragedy, to be sure, but one that apparently is *never* not funny.

Here's a real example of what *isn't* a Hero's Journey (anonymously adapted from the website of a nonprofit organization that should know better): Beginning: A scientist heading a major environmental group more or less reads her résumé on camera, ostensibly as a way for us to get to know her. Middle: One unrelated and unfocused anecdote after another about how much she cares about the environment. End: She finishes the résumé. Fade out.

Had there been a story about how she went into environmental science after her neighbors came down with a mysterious cancer, we would have seen some struggle. Had she come from a poor background and worked nights at a landfill to get her doctorate, we would have cheered her. But no. Just one job after another until—BANG—she's heading this organization. Yawn.

We all struggle through life. We tend not to be interested in people who don't.

Think in Shots

L ift your head from this book and look at your surroundings. Don't worry about looking at anything in particular. The goal here is to see how you visually examine where you are.

Notice that your eyes don't stay in one place very long. Your head turns. Your eyes shift. Something catches your attention, or you just get bored, and BANG—you're on to the next thing.

This is normal human behavior. Like our ancestors, we're scanning the Serengeti Plain for food or danger. It's built in.

Imagine you're being forced to watch a video of a speech. The video starts on the podium, capturing the speaker from the waist up as she enters frame. It stays locked in that position throughout the entire speech. At first the speaker, if she's very dynamic, will hold your attention. But as the speech goes on, it will get tougher and tougher to watch. By the 20-minute mark, keeping your eyes open becomes a struggle. Even if you do, you won't remember much of what the woman says.

Watching a static video without cuts makes us claustrophobic. Nothing's going on in the frame—and we can't see outside it. Our animal brains wonder—what are we missing? Our eyes want to move. Our brain screams DANGER! There might be a *lion* lurking just outside of frame.

Four shots that are unrelated . . .

. . . .until they're edited together.

The uncut video violates the laws of nature. That's why God (or some anonymous moviemaker in 1897) invented the *shot*.

Hollywood directors don't make a two-hour movie by rolling the camera for two hours nonstop. Instead, the film has lots of *cuts*—zipping from one picture to another every few seconds. That segment of video between the cuts is the smallest unit of film: a *shot*. Before our eyes can get bored, our attention is pulled in a new direction, with a totally different shot. BANG. We're interested again. To make video that holds our attention, you have to cut.

All TV and movies compress stories and time by cutting (yes, even *24* cheated). If they didn't, we'd find ourselves watching characters opening their mail or picking their noses when we'd really prefer to see them in a car chase.

Furthermore, cutting shots together creates meaning and creates a richer story. Here are four shots, each lasting just a second or two, and each with the camera stock still:

1. A dog in close-up, lying on a rug, shifts his eyes right.
2. A shot out a window to a suburban street. Rain pours down from the sky.

Then our minds fill in a story . . .

. . . of a dog that wants to go out.

3. The same dog shifts his eyes left.

4. A man in an overstuffed chair by a crackling fire turns a page of his book, completely absorbed.

Notice what we didn't see. We didn't move the camera from the man to the dog to the window in one shot. In fact, we never see the man and dog and window together at all. These four shots are totally unrelated—they could have been shot on different days, in different places (and in a movie, they probably were!). Nonetheless, *we*

From Slow to Pro

Take any five-minute documentary video you've shot recently (by "documentary" I mean stuff you shot at a real-live event, not something staged. Could be the kids taking a bath or an event you attended, like a baseball game). Using your computer editing program, cut each shot in your video as follows:

• Every time the camera focuses our attention on a new hero and action, consider that a new shot—even if the camera never cuts. If you're on two people talking for 45 seconds, that's one shot. If you're on one person while they talk for 25 seconds then move

to the other one while they talk, that's two shots.

• Find in each shot some definite action on the part of the subject (e.g., "A baby smiles").

• Cut each shot to be less than 10 seconds long. Cut so that the action is clear, then get out. If the action is "Jim takes a sip," make sure Jim doesn't also put the cup down and scratch his ear.

Once you've cut all your shots, trim the whole video to two minutes or less by reviewing and then deleting your least-favorite shots.

connect them in our minds. Viewers, watching the shots cut together, make meaning.

The individual shots mean very little, but taken together, they tell a story of a dog who wants to go outside. If this were a YouTube video, we'd be eager to see what the poor dog does next.

Not only does uncut video bore us, it's impractical: If you record video in real time, you need an equal amount of real time to play it back. An event we really enjoy in life can be torture to watch on TV in real time—that two-hour ballet recital will make you suicidal.

GROUP EXERCISE: THE RANDOM MOVIE

I use this exercise to train people at workshops and in companies to think in shots. It's also a great party trick at weddings, sporting events, rehearsals, or family reunions—anywhere you have an event and a group.

You'll need a video camera, a way to show what's on it to the group later (like a monitor or laptop computer), and equipment to simultaneously play a song loud enough so that everyone can hear it.

1. Select a song you like and think the group will like too. Make sure it's got a good beat. If the song's theme relates (however peripherally) to the event, that's fine, but it's also fine if it doesn't. Note how long the song is. Three to four minutes is about right—a standard pop song length. Keep the title you choose a secret.

2. Make sure your camera has a full battery and plenty of space to record. Set the counter to zero by rewinding, starting a new card, or whatever your camera requires.

3. Here's how to explain the exercise to the group:

"We're going to chronicle today's event on the video camera I have here. We're going to pass the camera around. Everyone should make sure they have it at least once. When you do have it, shoot one or two or three shots that you find interesting. Then pass it on or put it where others can find it. Make sure your shots are short—three to five seconds max. We won't be using the sound from the video camera, so nothing you say will be heard—obviously interviews or jokes won't work.

The video is over when the counter gets to [the time of your song goes here, say: 3 minutes and 20 seconds]. Don't let it go over! When it's done, I'm going to play our video together with a song I've chosen, and we'll see what happens."

4. Answer questions. Here are a few answers you might want to have up your sleeve:

Wouldn't three minutes of short, sequential shots be enough to remind you how it went?

We only get one life, and at the risk of waxing philosophical, we're probably better off living it than watching it in real-time reruns.

Tell your video in shots. Either shoot it that way, or edit it when you're done. Less is most definitely more.

No, it doesn't matter what you shoot as long as it's short—three to five seconds—and you find it interesting.

There's no rush. We won't look at the video until [time or event here].

No, I won't tell you the song.

No, we won't use any of the audio you shoot. This exercise is picture only.

5. At the appointed time, hook up the camera and the sound playback of your song. Rewind the camera to zero, get the song ready, and hit "play" on both at the same time. You and your group will see a movie that looks surprisingly like it was shot with the song in mind and edited by pros.

Lessons: Keep your shots short and interesting, and you're 90 percent of the way to shooting a good video. This exercise is also a great lesson in the beauty of chance. Art happens by accident, if you let it.

Notes: If you have a big group, you can use multiple songs and cameras. When it comes time for

playback, turn the whole thing into a "Random Movie Film Festival." Groups will love seeing others' points of view and rooting for their own video.

This is great practice to do on your own with home movies too. Pick a song that works thematically for whatever you're about to shoot—say a party, family gathering, or sporting event. Keep your shots short, and stop shooting at the end of your song's running time. When you're done, play them together as above.

If you have iTunes, you can be even more random. Shoot for about five minutes *without* choosing a song. Once you see how long you've shot, sort your iTunes library by time. Then pick a song whose length exactly matches your video's and sync them.

If you want to share the finished video, you can also permanently marry the picture and song in your computer editing program.

Make Every Picture Tell the Story

Every part of a well-made video, no matter how small, tells a complete story. Even the smallest part of a film has a hero, a beginning, a middle, and an end. The small parts add up to larger parts, which also tell a complete story. Those larger parts combine to make the whole video, which also tells a complete story. Let's take a film example:

The film is about *a boy* (the hero) whose family is tragically killed, forcing him to join forces with a strange guru/warrior and flee his home planet to avenge them. After being captured by a corrupt and powerful enemy, he escapes, returning with a band of rebels to destroy the enemy's army.

A sequence is a section of a film that covers a big part of the story. In this film, one sequence tells the story of *the boy* and the guru entering a lawless town to find transport on a mercenary spaceship. They meet a corrupt ship's captain and barely manage to leave the planet one step ahead of enemy forces.

A scene is a smaller part of the sequence that happens in a single place and time. One scene

Subject + Action = Shot

Start thinking of your shots in a complete sentence—noun, verb—just like your English teacher taught you in fourth grade. The noun is the hero of the shot, the action verb is story.

Ask yourself: What's this shot about? If you can answer in a complete sentence, you've got a good shot. If you can't, you don't. "A dog walks past the house" is a complete story in one shot. "A dog" all by itself is not.

in this sequence shows *the boy* meeting the rogue ship's captain in a bar and taking an instant dislike to him.

A shot is a single piece of film or video without cuts. One shot in our bar scene shows us the action of *a mercenary bounty hunter* (the hero of this shot) catching sight of the ship's captain, who has a price on his head. Note that the boy isn't in this shot, but the action affects him. He's still the hero of the movie, but since he's not in it, he can't be the hero of this shot.

Star Wars is much bigger and more complex than your video, but the principles remain the same. If any part of your video is missing its story, the video feels stagnant. Story-less shots add up to a bad scene. Bad scenes make bad sequences. One bad sequence can kill a film. Every single piece of your video needs a hero, beginning, middle, and end.

In a birthday video, a shot might be "Daughter's hand reaches cake." It starts with a piece of cake (the hero!) on a pretty dish on a high-chair tray (beginning). A chubby one-year-old hand reaches out (middle action) and lands—*plop*—in the middle of the cake. Cut. End of shot.

For most home videos, if you worry about the shots, the story will take care of itself.

Three Frames from One Shot

Beginning: The hero of the shot (a piece of cake) sits on highchair tray.

Middle: A hand threatens our hero.

End: Our hero is destroyed by the marauder.

THE CASE FOR MULTIPLE HEROES

What happens if you're doing a music video and the band members won't be happy with a video that's just about the lead singer? Or a wedding, where you have a bride and groom? Can you have more than one hero in a video?

Yes and no. You can tell more than one person's story in a well-made video, but you'll still have to pick a hero. Peter Drucker, the top business consultant of the 20th century, is famous for saying that "Concentration is the key to success" in business. Concentration on your hero is the key to success in video too.

There may be more than one starring role in a film, but there is only one hero. The director's job is to tell the hero's story well and tell the other characters' stories as they relate to the hero.

Figuring out who the hero is is your job. You don't always need to share your decision with your subjects or get their approval. You may be able to get away with "the couple" as the hero in a wedding video, since they'll be joined at the hip anyway, but probably one or the other should dominate. (Hint: There's a reason the smart money in the wedding industry targets the bride.)

If your video involves a group like a band, remember that every group has a leader. Somebody has to be Bono. You don't need to exclude other group members, but you do need to acknowledge at least to yourself that if you lean on the leader as the hero, your video will be better.

Once you've selected a hero, you can get to the secondary characters. Think of them as heroes in their own stories, each with a beginning, middle, and end. Of course we want to see what the groom is up to before the wedding. We want to see him walk to the front of the hall and stand waiting for the bride. And we want to see him after the wedding, and how much in love he is.

For the band, the more of a story you can create for the DJ, the drummer, and the bass player, the better the video will be—even though the main story (the "A story" in TV and movie lingo) is about the lead singer.

Under no circumstances is having multiple heroes an excuse to have NO heroes. If you're featuring more than one character, each one needs a story with a beginning, middle, and end. Figure out their stories and make sure you're getting the coverage you need.

Keep It Short: The Rubbermaid Rule

W oody Allen's *Annie Hall*, winner of the Best Picture Oscar in 1978, tells the story of a complex relationship that takes place over five years. It's 87 minutes long. That movie trailer you saw last week in the theater—the one where you said, "I hate when they show me the whole movie!"—lasts a maximum of 2 minutes and 30 seconds. Your favorite, very funny Super Bowl TV spot: 30 seconds. Average time spent looking at a Web page? Just 15 seconds.

Why would you think that a video about your company needs to be 10 minutes long?

It doesn't. "Brevity is the soul of wit." "Always leave them wanting more." "Pad your chapter with lots of old sayings, and you bore the reader." All of these aphorisms lead us to the same point: Take the amount of time you think you need to say what you want to say and cut it by two thirds. If you think you need a 10-minute Web video, plan for 3 minutes. If your video feels long when you're done— if it doesn't fascinate *you*—cut it even shorter.

The advantages of planning a shorter video:

1. You won't expand to fill time. "Padding" is just another word for boring. With a tight time goal, each shot you include will have to

compete with every other shot for its part of the limited time you have. Only the strong will survive.

2. You're competing with the universe for people's attention. No matter how brilliant your video is, more people will watch the whole thing if it's shorter.

3. The faster pace will keep it moving. Even if it's less entertaining, fewer people will notice.

4. Planning is easier. Fewer different shots = less work!

5. It's cheaper (if you're spending money at all, that is). You can spend triple the money per minute—maybe allowing you to hire a better cast or pay for other frills.

The only possible disadvantage to a shorter video is that it's a lot harder to make. It takes more planning and more editing. But I don't think of that as a real disadvantage. More like a "challenge."

What does Rubbermaid have to do with all this? We have a kitchen cabinet full of Rubbermaid containers that we use to store leftovers. After a few years of transferring food from the serving dish or pot to plastic container, I've noticed that I always pull out a bigger Rubbermaid container than I actually need. Sometimes twice or three times as big! Something in my brain estimates the food volume of the leftovers as being much larger than it is. Through careful observation of houseguests doing the exact same thing, I've concluded that most brains have this odd software glitch.

For some reason, the video-estimating cells in your brain think exactly the same way. No matter how long you initially think your video should be, it's probably too long to hold your audience.

TRY THIS

Choose the Small Container

Until you've had a lot of practice, you'll probably always overestimate how long your video needs to be. Next time, apply the Rubbermaid Rule. Cut your first guess by two thirds. Your video will be tighter and more entertaining. And if you get really lucky and shoot a lot of great stuff? You can always move the video to a bigger container.

GROUP EXERCISE: THE FREEZE-FRAME STORY

If you are part of a group that uses video regularly (say, a video class, business, or band), this exercise will get your group used to thinking about stories in terms of the hero, beginning, middle, and end.

Divide your group into teams of two to six people. You'll want to end up with no more than four or five groups, since the exercise takes a little time.

You're going to give the teams a series of setups—everyone gets the same setup at once (for example, "First-Date Disaster"). Each team will make up their own story using that setup and then present it to the entire group.

The goal is to tell a complete story—with a hero, beginning, middle, and end—in three sequential tableaus, or "freeze-frames," like a comic strip.

There's no movement in each frame and no talking. They're just making "pictures." Each group starts in "Frame 1" frozen position, then moves to "Frame 2" and then to "Frame 3." When each group has presented its story, you give the entire group a new setup.

HERE ARE THE RULES:

1. Give all the groups the same setup, at the same time. Setups should be simple and open-ended, but imply a place and some sort of action. Here are a few to get you started:

- The world's worst doctor
- Trouble at a birthday party
- A chance meeting
- The not-so-great outdoors
- First-date disaster
- Kids at play

2. Everyone must play. Not all players need to be in every frame, but in each presentation, everyone in the group must be in at least one frame.

3. Give the groups about 15 minutes to plan and rehearse their first story. It gets easier the more they do this, so you can reduce the time as the groups get the hang of it.

4. At the end of planning, all the groups come together. You designate a "stage" area, and have each group present their comic strip.

5. After all groups have presented, you may want to invite feedback. If one or two were especially good, why did we like them so much? Have any of the groups done a particularly good job establishing the hero? What groups made the beginning, middle, or end work best? Why?

6. Repeat.

By the end of an hour, your entire group will be masters of the basic story form. This will dramatically improve their ability to think about video as a medium for communication.

Always Leave Them Wanting . . .

Improvisational acting means acting without a script. You go on stage armed with nothing but your brain and try to keep an audience amused. It's not easy, as you might imagine. I once took an improv class with Keith Johnstone, a terrific teacher and guru of improv, and one exercise he did left a lasting impression.

Keith gave the stage to anyone who wanted it, to do anything they wanted to in front of the group. No limits. Actors are always being told what to do, so this was like offering street junkies pure heroin. But the audience had a job too. The second they were bored, they were required to stand up and walk out of the room. The contest was to see who could hold the audience the longest.

Since it was fun for the audience to walk out, you didn't have much time on stage to hold them—not unlike the reality of today's video environment. Bore them, and *click,* they've surfed elsewhere. Standing on stage watching a room empty out was disheartening. After I got over the sting of failure (I thought I sang well, but the room was empty in 15 seconds) and watched others go down in flames (much more fun), it became clear that the lesson Keith was teaching was not "Do we have the talent to keep people in the room?" but "What works? What keeps people watching?"

First we learned what didn't work. A juggler lasted about 30 seconds. A woman started to take off her clothes. It was fun for a few minutes, but when she got as far as she was willing to go, people couldn't get out of there fast enough. It seemed like the minute the audience knew that what they were seeing was all there was, they left in a hurry.

Just when I thought that *nobody* could hold the audience, one actor got up on stage and began pantomiming walking into a bathroom. He seemed tense, and nervous about the room, but he started, tentatively, to clean it. His expression conveyed his terror as he wiped down the sink gingerly, as if he thought it would bite him. We noticed that he tried hard to avoid looking past the sink, where we realized the toilet must be. For nearly five minutes the reluctant cleaner tried to force himself closer and closer to the toilet, always finding something else to clean first, as his fear built and built. He played his approach and avoidance with the skill of a Cirque du Soleil clown, and the room was in stitches. Finally, when he couldn't avoid it any longer, he reached in to clean the toilet. And it attacked him. We watched and laughed as the toilet fought him tooth and nail, and finally won, devouring him. Applause. Nobody had left the room.

Unless you're juggling live babies, it's hard to hold your audience for long.

This actor's brilliance was to understand the power of intrigue. Every minute of his performance was a tease, carefully constructed to tell us so much, and no more. By giving us enough of the story that we knew something was about to happen, but not enough to know what, he compelled us to stay and see what did. What made people stay was the promise of something more to come.

Intrigue is the most powerful currency in modern entertainment. To intrigue means to leave them wanting . . . and wondering what happens next. Resist the temptation to put everything at the front. Never explain. Tease us, and you'll keep us interested.

J. J. Abrams' TV show *Lost* was all intrigue. For six seasons, you never knew what was going on or what would happen next.

The Godfather starts with the words "I believe in America," spoken by a man (and an actor) we've never seen before. It takes five minutes to figure out that he's asking the Godfather for a favor, and that there will be a price for that favor. But it's clear that something big and dangerous and strange is going on. And so we watch, to find out what it is. Francis Ford Coppola, the director, sucks us into a game of figuring out who's who and what the balance of power in the room is. Intrigue at its finest.

To create mystery and intrigue, make your shots raise questions instead of answering them.

If you're doing a how-to video, you don't need to start with "Hi, I'm Steve Stockman, and this is my instructional video on how to build a fire. I'm here at the Grand Canyon, and over there is a pile of wood I've collected."

Instead, start with a close-up of someone striking a wooden match against the side of a lean-to, carefully lighting the kindling at the base of a pile of logs. The audience immediately *wants* to know where they are, why someone is lighting a fire, and what will happen next. When you tell them nothing, they're intrigued—which makes them yours to lose. Continue to not overexplain, and you can keep them as long as you want.

Start in the Middle

In your next video, skip any setup or introduction. Just begin. The game of figuring out what's going on keeps viewers intrigued.

If you start your "surprise party" video with shots of people hiding behind furniture in the dark, we'll immediately want to know what has prompted such odd behavior. Start your vacation video with the car trunk slamming closed on a load of suitcases. BANG—we know you're going somewhere, and we want to know more.

You can also play with setup and payoff. There's an old writing rule from the theater that says if you show a gun in Act I, it had better go off by the end of the play. Showing the gun is a way to keep the viewer interested. How will it go off? When? Who will die?

The gun is just a metaphor, of course. If you're doing a ski video about people learning to jump, start with the hero going off a huge jump, flailing in midair, and—freeze-frame. Now we'll be with you through the whole film, wondering if he made it or not.

Preparation— The Secret of the Pros

You don't have to do weeks of prep, write pages of script, and hire huge crews to make great video.

But most people don't do any prep. No thinking, no planning, no imagining. They just pick up the camera and go.

Somewhere north of "nothing" and south of "everything" is the amount of preparation that's right for your project.

Pitch It

When I first started writing screenplays, I'd hear a lot about "pitching," as in "I'm going to XYZ Productions to pitch my talking shark script." The idea was to sell a movie concept by explaining it in several tightly written sentences to a bored executive who sits at her desk listening all day to people pitching ideas. Seemed like a stupid idea to me. Why would I want to do that, when I'd already written a 100-page script? Can't they just read it?

It eventually dawned on me that pitching was an exercise to help others help me. Nobody has time to listen to a long explanation—unless they already like the idea. If I could explain my movie in three sentences, the person who heard the pitch and liked it could then easily explain it to someone else in three sentences, and so on, until someone who heard the pitch liked it enough to actually read the script. And make the movie.

Video is garbage in, garbage out. If you're confused when you start, you'll be confused when you shoot, and the resulting video will be . . . confused.

Having a good pitch not only helped people tell my story, it made them *want* to tell it. Conversely, if I couldn't explain the movie without a rambling 10-minute monologue, how could I expect anyone else to tell a friend about it?

But here's the surprise: Having to pitch the movie made me a much better writer, because I had to really figure out what I was doing. And it works the same way for a video.

Video is garbage in, garbage out. If you're confused when you start, you'll be confused when you shoot, and the resulting video will be … confused. If you think hard enough about your project to boil it down to a sentence or two, it will be that much easier to stay focused enough in your execution to get it done right. At any point you can stop and compare plan to reality: "Now what was my pitch again? Is that still what I'm shooting?"

Think of it as your first step in the planning process for any video more complex than "kids bouncing on a trampoline." The right pitch helps you attract collaborators and excite potential viewers. It can help sell friends on helping, bosses on letting you have the time, or subjects to sit still for an interview.

Your goal is to summarize the video you're planning to make in a sentence or two. Most are pretty easy: "Sarah's first visit with Grandma and Grandpa" is a pitch that should get your dad interested in watching—and it suggests a storyline to the parental visit that will help you focus your shooting.

More complex pitches are easier if you use story format: beginning, middle, and end. "It's a story of a conductor who thinks that his wife is having an affair behind his back [beginning]. As he conducts a symphony, he fantasizes more and more absurd ways to deal with her [middle]—only to find that executing them in real life isn't as easy as he thought [end]." (*Unfaithfully Yours,* a 1948 film from writer/director Preston Sturges.)

TRY THIS

Practice Pitching

Head for YouTube or Vimeo and look at a couple of much-viewed videos. Can you pitch them?

Do the same for a recent or planned project of yours. Try the pitches for your project on some friends. Do they get it?

|||

NON-STORY STRUCTURE

If there's no story, you still need something to hold your video together.

If you're shooting the school's Winter Fair fund-raiser, you could use chronology to hold things together. First, the school in the early morning, empty. Then shots of the transformation to a kid's fantasy playground. Then the crowd comes and plays. Happy kids and adults. Then it's all over and time for hugs and cleanup.

Of course, that *is* a story—with a beginning, middle, and end. Each shot you take must also have its own reason for being interesting, its own beginning, middle, and end. But it's not a hero's journey, unless you (too) broadly think of the school community as a "hero."

Another great way to build a non-story video is to hang it on another structure. The easiest one, and one that almost always works, is music. You can set any video to music, letting the music guide the shots and cuts. If the shots are well done and all on one theme, the right music will make them funny, moving, or exciting and hold the video together.

For proof, consider the music video. It may have a story that comes from the song's lyrics or it may have a story grafted onto it that's "suggested" by the song's lyrics. Or it may just be straight performance—or a mix of all three. If it's a great song, they all work, propelled forward and held together by the beat and melody of the music.

This is the pitch for my film Two Weeks: "Four siblings rush home to say a last good-bye to their very sick mother [beginning]. When she hangs on [middle], they find themselves stuck—together—for two weeks" [end].

A shorter pitch for a medical Web video series: "A team of health professionals invade a diabetic's home for a much-needed health intervention and home makeover."

Don't worry about form unless it helps you. The real goal is a very short, intriguing way to explain your video, fast.

Know Your Video: Part 1

W hat *is* your video? One way to start to answer this question is to tell us your *genre*. Genre is the one-word descriptor that sets our expectations for the video.

Genres are most familiar to us in film, like action, horror, sci-fi, corrupt-cop-against the system, bio-pics, musicals, and sports stories. You probably know immediately which genres you love and which you can't stand. So does your audience, which is the point of thinking in genre.

Genres come with certain built-in structures that the audience expects you to deliver.

In the romantic comedy genre, two people "meet cute" and hate each other, fall in love, have enormous trouble based on an obstacle or misunderstanding, and then fall back in love again. Viewers love a romantic comedy that fulfills their genre expectations in unexpected ways, with unexpected charm. But if it doesn't end happily, expectations are dashed and millions of women walk away mad.

The advantage to knowing our genre is that we can help interested people find our work quickly, and vice versa. Genres can seem

Genre Study

Back to YouTube for more study: Click through this week's top 20 or so videos. Look for two or more of the same genre. How well do they satisfy your expectations? What makes them stand out as different from others in their genre—for example, why is one sketch comedy video different from another?

For your next video, consider what genre video you are making. What does the audience expect from you? Make a brainstormed list and keep the key expectations in mind as you plan. You don't have to blindly conform to expectations (what fun would that be?), but if you deviate, you need to be aware of the effect it will have on your audience.

limiting at first, but soon you realize that they're merely conventions—customs common in society that help you understand what the audience expects from your video. And anything that helps you understand the audience is a good thing.

Videos have genres too, although you may not be used to thinking of them that way. Instructional videos, "punked" videos, music videos, webcam rants, sketch comedy, stop-motion animation—the definitions are still evolving, but they're there. As with film, video genres both communicate what your video is about and lock you into expectations. Fail to deliver on the genre expectations, and the audience is disappointed.

An *instructional video* is one genre, a *music video* another. If I need to know how to use Photoshop, I'll be impatient with a hot woman singing me a song. Not as impatient, perhaps, as in the reverse situation, but impatient nonetheless.

A *sketch comedy video* had better be funny. A music video needs to show the band and the entire song. A *wedding video* needs the "I do" moment. A *product demonstration video* should clearly show you why you'll love the product. I should laugh and cry while watching a *memorial video,* and learn how to stack boxes during a *workplace procedure* video.

The audience's expectations may seem at first like a limitation, but they can also be used for fun—if you know their expectations, you can bend them by doing something unexpected. Genre twists

||

NEVER UNDERESTIMATE THE POWER OF HUMOR

*S*aturday Night Live has been on television for more than 35 years. And for more than 35 years, roughly 15 of its 90 minutes each Saturday night are funny. And of those 15 minutes, only 2 are extremely funny.

Not good odds, you would think. But you'd be wrong. For 15 minutes of laughs, we'll happily sit through 75 minutes of filler. Laughter is to humans as cocaine is to addicts. We'll work very, very hard for the buzz. The show is still on the air because it delivers enough reward to carry us through the work of watching the rest. Just as important, those 2 funny minutes are so funny you're likely to tell your friends about them the next day, leading to more ratings next week.

Not everyone is funny. Not everything is funny. That having been said, if you can add even a moment of humor to your video, you should. It's the quickest way to make the audience want more.

in romantic comedy include a man falling in love with a cartoon character (*Enchanted*), a couple who live happily ever after, but not with each other (*[500] Days of Summer*), and a bromance between a 78-year-old curmudgeon and a Cub Scout (*Up*).

These films use genre as a jumping-off point for creativity, and so should you. For example, you could structure the usual wedding video events around postceremony interviews with friends and family talking about why they were sure Patty and John were completely wrong for each other.

You can also combine genres. A *musical instructional video* could be pretty interesting if a band sings Photoshop instructions as they're demonstrated on the screen while hundreds of duplicate copies of the same woman dance across the screen. Yale University made headlines with its genre mash-up of an *admissions video* and a *movie musical* (see it here: www.VideoThatDoesntSuck.com/examples).

Know Your Video: Part 2

Structure is everything in films. By which I mean that the way you put your video together has as much to do with its success as anything else. You can see that easily if you consider this film:

The movie opens as we fade up from black on a close-up of a giant, fiery wizard's head. "Bring me the broomstick of the Wicked Witch of the West!" it screams. Then over the flames and smoke, we hear a Brooklynese voice reminiscing: "It seemed like I had barely grown my first mane the day she slapped me on the nose. It was then that I knew we had a thing for each other." Then CUT to a point-of-view shot through the undergrowth of the forest. A tiny black dog darts out from under a tree, yapping and growling. The camera follows the dog out to a clearing where a girl in a gingham dress hauls off and *slaps* the camera. Blackness. Then we CUT to a little girl and a lion dancing arm in arm down a yellow brick road . . .

Not the *Wizard of Oz* you remember? True. The characters, the locations, and even many of the shots are the same, but the parts have been rearranged to add up to a different whole. We've restructured the film into something completely different. *Structure* gives meaning to a film.

You can restructure *The Wizard of Oz* other ways too. Imagine the film told from the perspective of the witch (that's *Wicked*) or a version (as yet unwritten) that tells the story of Auntie Em's terrible journey across early 20th-century America, searching frantically for her lost niece, Dorothy.

Different structures, different movies. And so it is with your video. You can tell the story chronologically or not. From the point of view of a gifted teacher or one of her less-gifted students. As with the girders on a building, how you arrange the underpinnings of your video has everything to do with how it finally looks.

TRY THIS

Elements of Video

If we're doing a sales video for a new pocket video camera, we know that the genre suggests that we need to sell the camera's unique features to viewers and ask them to buy. Within that set of genre restrictions, there are an infinite number of different structures. To pick one, start by brainstorming a list of possible "elements"—the building blocks of your video.

Possible Elements of the Pocket Video Camera Sales Video

- Spokesperson
- Showing the camera in use
- Satisfied customers
- The company VP/Product Development
- A happy family using the camera
- Demo of how easy it is to plug the camera into the computer
- Customer footage
- Cute animals
- Graphics
- Narration

Your combination of these elements is your structure. A guy doing a straight sales pitch/demo on a new video camera fits the genre, but so does a documentary on how the brilliant new lens technology was developed. A series of customer testimonials linked by some footage they shot using the new camera can also work. Another completely different approach is using interviews: Intercut an interview with the company VP/Product Development with a family shooting video on their vacation.

The various structures completely change the video, yet they all sell the video camera and meet genre expectations.

When You Need a Script

A successful video needs a story. If your story has more dialogue and detail than you can easily hold in your head, it needs a *script*. A script is nothing more than a written version of your video, including the spoken lines and a short description of the visual.

Actors and dialogue need a script. Any video with multiple locations needs a script. Any video you're using valuable resources to make (like money, or time other than yours) needs a script.

A script is nothing more than a written version of your video, including the spoken lines and a short description of the visual.

If you're spending a lot of valuable resources and involving a professional crew and actors, you'll want a well-written script showing every scene, every location, and every line of dialogue. You'll need it just to keep everyone on the same page (pun intended).

A script doesn't have to be a professionally formatted, feature-length screenplay. If you do want to learn how to write a movie or TV script, there are whole shelves of books in bookstores and libraries to teach you. But don't let that keep you from sketching out your video plan on paper.

Your script could be a list of scenes you want to shoot. It could be a few lines of dialogue, written out. It could be what the narrator says, with your notes about scenes you want to shoot written in. Whatever works for your project.

Writing your video ahead of time lets you do the hard work of making your story great the least expensive way possible—on paper. While you write, rewrite, and re-rewrite to make your piece stronger, the video is still all in your imagination.

If you don't like a character, delete her. If Central Park isn't working for you as a location, voilà—you can instantly move the action to your backyard. All on paper, for free. You haven't paid any money for equipment or bribed any friends to show up or talked your boss into letting you shoot in the office. Yet.

Once it's done, your script becomes a production planning tool. It's like the old carpenter's adage, "Measure twice, cut once." The script is your first chance to measure your video. It tells you what locations you need, how many actors, and whether to shoot at night or in the morning.

It's also a communication tool for you and your crew. Nobody can say "I didn't know we needed a real pig" if it's right there in the script.

TRY THIS

Script It

Script any video you've been thinking about shooting. It can be as simple as just dialogue. If you have more than one location, make it Location and Dialogue. Like this:

VIDEO FOR "MOM'S HOME COOKING" BLOG

LOCATION: Kitchen

ACTION: Mom takes a ball of dough out of a glass bowl.

MOM: *To knead the bread dough, you put some flour on your hands, then push the ball of dough away from you. Turn it like this, fold it toward you, and push again. Repeat for about 10 minutes, until the dough feels (as weird as this sounds) like your earlobe—soft but springy.*

That's all there is to a script. Pretty simple. When you go to shoot it, Mom will know what she has to say, and you'll know what your shot looks like.

If You Have Nothing to Say, Shut Up

"Less is more" applies to every single facet of video—including the words people in your video say. After all, they call it a "video," not an "audio." Here are some common mistakes you should avoid:

Describing the pictures: Fade up. An incredibly good-looking guy stands on a stunning white-sand beach. Waves lap against the shore behind him. A title identifies him as *Steve Stockman, World-Famous Director*. He speaks: "Hi, I'm Steve Stockman, World-Famous Director, and I'm here on one of the most beautiful beaches in the world." How many of those words need to be spoken? Not one. It's all right there on screen. The audience is just as smart as we are. They can see and they can read.

Instead, cut to the important information. Have the guy start with: "Enjoy the view. Next year this Australian beach will be a high-rise parking garage." Now you've got my attention—six seconds sooner than you would have otherwise. Let your pictures work for you.

Waffle words, weasel phrases, and other mushy restatements of the obvious: Let's parse this sentence from a charitable organization's video that will remain deservedly anonymous: "With more than a billion people, a booming economy, and a skilled labor force, India is a nation on

the move." What are they trying to tell us in this sentence? That India is growing? We know—they're the "out" in "outsourcing."

Stating the obvious is bad enough. But that isn't even what these filmmakers were really trying to say. Theirs was a video about an organization that helps Indians out of abject poverty—hardly the province of a "nation on the move." These are classic weasel words. The filmmakers think they're being "balanced," pointing out what's great about India along with the problems. Perhaps this makes them feel better, but all it does for the video is completely confuse its point.

Why not cut to the chase? Because something like "Despite its booming economy, India's children are sick" is very direct, and it feels scary. In real life, inside real organizations, we temper the effect of our thoughts with words like "some say," "I think," and "it could possibly . . ." It feels safer to be less assertive. On video, our normal protective padding becomes boring and incomprehensible.

Take this line from a doctor in the same video: "Just having a healthy childhood, I think, could really unleash their potential in terms of the contributions they can make to society." This is a seriously indirect statement. Any time you see the words "in terms of" you know someone's weaseling. Combined with "could really unleash their potential," you've got a bowl of mush.

Video is a richer medium than print. It carries audio and visual information in addition to the story itself, which makes everything easier for us to remember. This richness makes video intolerant of repetition.

What he means is, "If these kids are sick all the time, how can we expect them to grow into India's next leaders?" I can't fault the doctor for waffling in an interview. Everyone does it. But to edit that *into* the video was a big mistake on the producer's part.

Repetition: In a book, if we haven't seen a character in a hundred pages, having her name suddenly reappear may be confusing—was that

TRY THIS

Cut Before You Shoot

Video gets stronger when you eliminate the weakest parts. It's cheaper and easier to cut on paper. Make a habit of scanning your script for things that feel redundant. Here are some tricks that help:

1. Make a list of your scenes. For each scene, write a short one-sentence description, like "Conference Room—Jack tortures a CIA agent with a paper clip" or "Lower East Side Fruit Stand: When the Don gets out to buy fruit, two men shoot him in the chest." Review your list for scenes that feel redundant. Cut the duplicates.

2. Almost anything that comes after the word "so" is repetition. Do a pass to eliminate the word and as much that comes after it as possible.

3. Have someone read your script to you out loud. In film and TV, actors gather around a table to give a script its first read, which is called, not surprisingly, a "table read." Hearing everything out loud can be painful (better now than when you play the finished video for friends!), but repetition becomes glaringly obvious.

Chrissy or Kristen who threw her husband out? To fix this, authors often include a phrase reminding us: "Chrissy walked down the stone path away from the rehab center, not surprised that her deadbeat husband's wasn't the face waiting for her as she came through the gates."

Video is a richer medium than print. It carries audio and visual information in addition to the story itself, which makes everything easier for us to remember. In a movie, even though we haven't seen any characters for 30 minutes, when we see and hear them, we remember them right away.

This richness makes video intolerant of repetition (unless that's the point: see *Groundhog Day* or *Memento*). I'll sometimes realize I've repeated myself when I see a film edited for the first time. Maybe an actor's performance made two scenes play the same emotional beat. Maybe I just missed the similarities when it was on paper. Either way, repetition gets cut.

If You Wing It, It Will Suck

No script? No problem. But no *plan*? Big mistake.

Unless you're whipping out your camera to catch a huge meteor plummeting to earth, you should always have a plan. No self-respecting pro would be caught without one. Fortunately, planning doesn't have to be time-consuming or difficult.

It turns out that many of life's events come scripted. Thinking about the "script" ahead of time is planning. Weddings, graduations, and company meetings follow an actual running order that you can get a copy of in advance. The family vacation has an itinerary. Even things that seem unplanned, like birthday parties or ball games, follow a format you've seen before. You can probably even guess accurately about events with no formal structure at all—unless it's your first time at an amusement park, a restaurant, or the DMV, you have a pretty good idea of what might happen next.

Pitch It Before You Shoot It

Search for the story in your next video—even if it's as spontaneous and unscripted as a barbecue. Start thinking about the main characters. Who's the hero? Who else is important? Look at the action—what might happen at the beginning, middle, and end of the event? What do you want to happen? If you were pitching this video, what would you say it's about? Why are you covering the event, and how do you feel about it?

Want to be really prepared? Make a written list of your answers. That helps commit them to memory, which helps you make the right choices on the spot.

As with any video, things will change once you're shooting. But that's never an excuse for not planning.

Many events, including graduations, have prescribed formats.

Anticipate the key shots . . .

. . . and you'll be much more likely to capture them.

Even for "real-life" events, there's no excuse for not planning, for not imagining, for a little while, what you might see and what you might want to shoot.

You're not going to be able to write or direct your son's high school graduation ceremony, but you can spend three minutes thinking about where he'll be standing and when, and how close you can get. Add a little time to think about the characters involved and what they're likely to be doing ("Grandma always cries at graduations"), and your video is already *much* better.

The most memorable home videos and docs tell stories. Those stories don't just magically appear in the edit room. You have to imagine them before you start shooting.

Plan with a Shot List

V ideo is a collaborative medium. It isn't just you. It's you and the people you're shooting. And your script. And your crew, if you have one. And the weather, and the event, and . . . Inevitably, all these moving parts will not move according to plan. If you're doing it all—writer/producer/director/shooter/editor—there's a lot to keep track of.

The easiest way to stay organized is with a *shot list*.

A shot list is exactly what it sounds like: a list of all the shots you might want in your video. I bring a shot list to every shoot and literally check off everything I wanted to shoot as it's completed. If things get busy or confusing, I can always go back to my piece of paper and make sure I'm shooting enough to tell my story.

To make your shot list, start by brainstorming a long list of everything you might want to shoot. No wrong answers—write down whatever crosses your mind. Remember that a shot is a noun plus a verb. "The bride cuts the cake" is a shot. "The bride" is not.

A shot list is exactly what it sounds like: a list of all the shots you might want in your video.

For a documentary shoot, like a family reunion, you might list all the relatives and what you might want to ask them in an interview. Also consider: What activities will they be doing? What's likely to happen at the event that's funny? Or touching? Or inspiring? Add those things to the list. Continue the list with questions like: Where could you be with the camera that would be fun? Are there any special details you need to shoot to tell the story well? A close-up of a burger frying? The moment great-grandma and cousin Eve see each other for the first time in 20 years?

To make a shot list for a piece of sketch comedy, noun-verb your way through the script.

With scripted material, you can repeat the same scene over and over, shooting a different person or angle each time. This is called "coverage." (See "Shooting a Scripted Video," page 183.) To make a shot list for a piece of sketch comedy, noun-verb your way through the script. "Cindy knocks on the door." "John hides behind the couch." "Cindy says she wants the rent and uses her key to open the door." "John breaks down and confesses he loves her." Then brainstorm different angles—shooting the big love scene from John's point of view, say, then Cindy's.

Keep listing until you run out of ideas. If your list is much too long for you to actually shoot everything on it, congratulations! You've done a great job. Now choose the shots that really excite you. That's your shot list.

One of My Shot Lists

Shot lists are such an important tool that it's worth going through the process of creating one in detail. Here's a script for a 30-second TV commercial I directed for a classic-rock radio station. The shot

list that follows is more detailed than you need for, say, a birthday party, but the process is exactly the same:

KZPS, Dallas
Opera Craving : 30 Version 1.1 Shoot FINAL

Open on a medium close-up of a character-type man, about 33, sitting in the audience of an opera. He is dressed in what is clearly his best suit, and he has a carnation on. This is a big event. Next to him sits his wife, also in formal dress. Around him the other patrons are wearing either fancy suits or black-tie.

We hear the singing of some histrionic Wagnerian opera. Nothing familiar. The man looks bored. Everyone around him is raptly attentive.

CUT TO: The stage. The players are oversized, stereotypical German-opera types, wearing horns and fur as they sing.

CUT BACK TO THE GUY: He is falling asleep. His wife glares at him. He sits up.

VO: Sometimes you get a craving for great classic rock.

The man opens his jacket. Looking around to make sure he is not noticed, he slips on his headphones.

ECU [extreme close-up]: Digital radio close-up as he turns it on to 92.5. A great ZZ Top hook kicks in.

VO: 92.5 KZPS plays 45 minutes of commercial-free classic rock every hour . . .

CUT TO: The guy's face. His boredom turns to surprised amusement.

CUT BACK TO THE STAGE: The singers now have beards and hats, and look exactly like ZZ Top. They lip-synch and play to the song.

CUT TO: The guy, smiling and sitting back.

CUT TO: Another hook. Onstage we see the opera singers. Two of them are foreground, singing and playing guitar. The singer has really long hair, like Robert Plant. The woman flies through the back of the scene holding on to a Zeppelin.

CUT TO: The stage, still later. Another hook, this time a finale from the Who. The opera singers are windmilling and smashing their instruments.

VO: When you need classic rock, only one radio station gives you 45 minutes commercial-free every hour . . .

CUT TO: Our man as he stands and applauds, holding up his lighter. He whistles. Sudden silence. The people around him are still sitting. They stare. The singers on stage stop, now returned to normal, and stare as well.

CUT TO: The guy sheepishly sits down. His wife covers her face in shame. Logo/Positioner up. Another hook kicks in as we hear the announcer:

VO: 92.5 KZPS. Dallas Fort Worth's *only* all-classic rock station.

From this script, I brainstormed a long list of shots. For each line or action I tried to think of several different ways to shoot:

Brainstormed list:

- Exterior establishing of theater
- Man and wife in the crowd at an opera
- He is bored to tears . . . she loves it
- His wife takes his arm and smiles at him
- Guy nods off . . . his wife elbows him. He wakes up
- Reverse over the guy's shoulder to reveal the opera
- Close-up of "river" reflections
- Fat lady sings
- The man *sneaks* headphones on
- Turns on Walkman
- Close-up of radio frequency coming on
- Close-up of headphones being pulled out of coat
- Close-up of guy checking to make sure wife's not looking
- He turns to look back at the stage, eyes open in surprise
- Waist up—the opera singers sport ZZ Top beards, move in sync to song
- The guy smiles to himself—loves opera!
- Pinches self
- Checks wife—hand in front of her face?
- Turns up radio
- Sits up straight, leans forward
- Extras not looking at him, just the opera
- Zeppelin glides across stage with singer attached
- Matching dolly glide by audience in reverse?
- Lead singer lip-syncs to Zeppelin
- Explosions at music peak—CU, med close too
- Breakaway to guitar as smashed on stage

- Townshend windmill
- Daltrey mic swing
- Kicking over mic stand
- Kicking over the drums
- Guy flicks lighter and stands up
- Freeze three-shot of opera singers. They stare up at guy
- Conductor stares too
- Which shots take logo?
- The guy realizes he's the only one hearing the rock. Sits down and pretends nothing happened
- Wife reactions, various
- What about alternate action with guy throwing Frisbee?
- Frisbee lands on stage, singers freeze, look up
- Guy offers his wife a Frisbee
- Music choices: ZZ Top, the Who, Led Zeppelin final?

TRY THIS

List It

A shot list for a party may be five must-have shots long. The list for a three-minute cooking demonstration may exceed 40. This is your tool—its length and complexity depend on your needs.

Here are the steps as you might apply them to a cooking demonstration.

1. Look at the story (in this case, the recipe). Brainstorm a list of shots you *might* need. Make it a long list. Consider: Which steps of the recipe do you need to see demonstrated in close-up? Which ones can the host simply talk through? Which are both? What angles do you need to see the cooking operations? Stirring in a tall bowl might look better from above, chopping better from the side.

2. From that long list, select the ones you want to shoot. Put them in the order of the final edited video. Did you forget anything?

3. Reorganize your list in shooting order. In a cooking video, that may be the same as the chronological order of the video, or you may shoot, say, the opening last so you can show the stunning final cheesecake "before" you bake it.

Next, I selected my favorite shots and made a master list of what I needed on the day. Before the shoot, I rearranged my shot list into filming order. On a big film set, you rarely shoot in the chronological order of the story. Characters may return to a location several times in a movie, for example, but it's too much work to keep moving the film crew. Instead, you rearrange your shot list so that you're shooting in the order that will take the least amount of time.

In this case, we were shooting in two opposite directions—the stage and the audience. Each had different actors and lighting, and we would never see them at the same time. Instead of having to move equipment and heavy lights around every shot, we did all of the audience-facing shots first, did a big move, then all of the on-stage shots. The shots were assembled in the right order later in the edit room.

Armed with this list, we were able to try different ideas that came up on the spot without getting too lost (and risking missing something critical). You can see the finished commercial at www .VideoThatDoesntSuck.com/examples.

Here's the shot list in shooting order:

SHOT #	DESCRIPTION	SPECIAL NOTES
1	**Guy Bored** We find a man and wife in the crowd at an opera. He is bored to tears . . . she loves it. Alt Action 1: His wife takes his arm and smiles at him. Alt Action 2: He is nodding off. His wife glares at him. He is alert.	
3A	**Turning on Radio, Wide** The man *sneaks* a radio out of his coat pocket and puts the headphones on. Checking to make sure he is not noticed, he turns it on.	No fiber-optic radio light required for this shot.

SHOT #	DESCRIPTION	SPECIAL NOTES
6	**Reaction to Rock** MCU: The guy is now enjoying the opera. He settles in. Pickup: Alternate angle. Pickup: Guy checking out his wife again. Pickup: Guy turning up his radio louder, sitting up straight, and leaning forward.	
9	**Wild Applause** Our guy stands, holds up his lighter, and goes wild. People stare.	
11	**Back to Normal** The guy tries to sit down and pretend nothing happened. His wife is horrified.	Frame for logo graphic to be added—lower third.
12	**Alternate Ending 1: Throws Frisbee** The guy stands up, wildly excited. He throws a Frisbee toward the stage.	
14	**Alternate Ending 3: Back to Normal . . .** The guy offers Frisbees to others in the crowd. He sits.	
3B, C	**Turning on Radio, Tighter** As above, CU [close-up] following the radio, through turn-on—with fiber-optic light effect. Also, as above, CU following the headphones.	Fiber-optic lighting cable glows digital readout.
4	**Eyes Wide** CU. The guy checks out his wife to make sure she didn't catch him with the headphones. Turns to look back at the stage, his eyes open in surprise.	
2	**Over-the-Shoulder Opera** Reverse over the guy's shoulder, crane up to reveal the opera in its full glory.	Music playback for sync. Check for sync point.
5	**ZZ Top** Waist-up trio: The opera singers are now ZZ Top.	
7	**Cut to Zeppelin** One opera singer is Robert Plant at the mic, one plays guitar. The woman singer is seen gliding across the stage hanging on to a giant Zeppelin.	Balcony pan possible?

SHOT #	DESCRIPTION	SPECIAL NOTES
8	**The Who** The opera Vikings break up their instruments. Action: Townshend windmill. Daltrey mic swing and knocking over mic stand. Smashing a guitar. Kicking over the drums.	Cornstarch air guns fire here.
10	**Opera Reaction** The opera has come to a complete halt. They stare up at the guy.	Shot from orchestra level. Room for logo under.
13	**Alt 2: Opera as Frisbee lands** The Frisbee lands at the feet of the opera singers, in the middle of a phrase. The singers come to a complete halt and look up toward the balcony.	Shot from orchestra level. Frame for logo under.

Setting the Stage

Thought about your video?
Great—you're way ahead of most people.

Have a plan for what you're going to shoot—
or at least part of one? Perfect.

Now . . .

What do you need before you can actually shoot?

Storyboard with Your Camera

A *storyboard* is traditionally a frame-by-frame representation of what your video is going to look like. Storyboards show the placement of actors, camera angles, and indicate the action. Creating storyboards is a great exercise in planning your video. It's also an easy way to explain what you're doing to others (actors/bosses/skeptical relatives).

In films and advertising, storyboards are drawn by brilliant and very talented sketch artists who talk through the story with the director and create the images by, I'm pretty sure, magic. The illustrations in this book were drawn by Renee Reeser Zelnick, and they look pretty much like the storyboards Renee has drawn for my directing jobs.

If you draw, you can do your own storyboards. If you don't, you can hire a brilliant and very expensive artist to draw them. A third option is to do them with your camera.

If you draw, you can sketch your own storyboards. Even if you don't draw, stick figures and arrows can be enough to get the job done. There are also software programs that help you storyboard, providing cutout people and backgrounds you can stick down in the frame where you want them. One of the easiest ways to make a storyboard is with your camera.

In ancient times, directors would walk through their scripts

with still cameras, making whoever was standing around pose in place on the set. The director would shoot different angles until they found one they liked. They'd lay out the best stills on a big whiteboard that they could lug to the set. Before setting up each shot, they'd consult the board to make sure they remembered what they were trying to do.

In these more modern times, professional directors still walk through their shots ahead of time. But now you can keep your camera in your pocket and flip through the reference stills that way—or load them onto an iPad for easy sharing with others. If you want boards, it's easy to lay them out on the computer and print copies for everyone.

You can even use your camera to "pre-shoot" your video. Use your actors (or stand-ins) and walk through the action and dialogue at your location, then rough-edit the shots together to see how your video might look.

TRY THIS

Instant Digital Storyboards

Walk through your set in advance with your video camera (or your still camera, or even your cell phone).

Grab a friend or two and go to the synagogue before the wedding or the auditorium before graduation. Put your friends where the bride and groom or valedictorian will be, and find a shot you like. Watch them move through the likely action and shoot some more.

When the time comes to shoot for real, these digital photos or videos are a quick and easy reference for the ideas you liked. Even if you change them when the time comes, doing the exercise will have given you more and better ideas for your shoot.

Shoot the Ones You Love

There are two kinds of people in the world: the ones who are interesting on-screen and the ones who aren't. Your job is to show us the interesting ones. Who decides whether or not they're interesting? You do. Always shoot the ones you love.

Even if you're shooting in a "found" situation you don't control—on the street, for example, or at a family function—you still get to "hire" the cast by deciding where to point the camera. Who catches your eye on the camera's screen? At the political rally, is it the overly scripted candidate, or the frantic press secretary whose schedule is going to hell? At your daughter's birthday party she's obviously the star, but which of the adults trying to get her attention are more compelling on camera?

In a scripted piece, think about your casting like the pros do. Professional directors know that 85 percent of getting a great performance on video is casting: putting the right

"Cast" a Documentary Shoot

You obviously can't cast your cousin's wedding. But when you get there, before you start shooting, you can use your eyes and ears to find the good stuff. Zoom your attention in on individuals and interactions. Look around. Listen. What's going on that's interesting?

Take time out during the shoot to put the camera down and look around. Follow your curiosity to discover the real stories—who came with whom, how are they dressed, who's mingling and who's not.

Trust your instincts and spend more time on things that draw you in. Move quickly off things that don't. If you're bored, so is your audience.

Cast a Scripted Video

In Hollywood, you find out how good the actor is before you shoot by auditioning them. The director "reads" actors, letting them play the part while capturing the audition on video. The director gives the actor some direction, answers questions the actor may have, and listens until he's heard enough.

You can do exactly the same thing. Before you commit to an actor, have them read from your script and/or try the action you have in mind. If they can't do it for you in a casual audition, they aren't going to be magically better the day you shoot. Be tough when you choose, and you'll save yourself a world of trouble later.

Videotape the auditions. Some people look amazing through a camera lens in a way that they don't in real life, and vice versa. If you're talking to a lot of people, you may also forget important details without a handy reference tape.

Any performer you have to direct too much ("Smile when you say 'Great pizza'") is the wrong performer. If they don't get it the way you want it after a couple of tries, thank them respectfully and move on. The 20th take won't be any better. Don't feel sorry for actors you reject. It's like dating—they may be great people, just not the right people *for you*.

This process can take a while, but don't settle for less than what you need! I once looked at 400 audition tapes of real people for a testimonial-style commercial. I hired 25 of them, and we used only five in the finished commercial. But those five were . . . spectacular.

If you do get stuck with an actor (say, your company president in a company video), an informal "rehearsal" will help you see what she can and can't do. Rewrite your script and cut the stuff that she can't handle. If you can't cut parts, try giving them to someone else by adding a character or a voice-over to take on some of the heavy lifting.

person in front of the lens. (For the math nuts wondering about the other 15 percent: 10 percent is knowing when to shut up and stay out of the performer's way. The last 5 percent is being ready to support and inspire the actor as needed.)

If you don't have the right performer for a part, you're already 85 percent screwed—which is why I spend *a lot* of time on casting. Way more important than "Are they good-looking?" is the question of "Are they intriguing?" Great actors make us want to know more about them. They pull us into the video.

Let your inner voyeur out. Who makes you want to watch?

Make Your Star Look Great

(Part 1: Figuratively)

I magine that I asked you, right now, to go on stage in front of an audience of 500 paying customers and juggle six flaming pins. Problem 1: Most people aren't comfortable running up on stage in front of 500 people. Problem 2: Of those who are comfortable, only a tiny subset can juggle six flaming pins. Problem 3: Of those who are comfortable juggling fire in front of a crowd, only a small subset of them would be comfortable doing it without a little rehearsal first.

It turns out that a fair amount of skill is required to look great on video. People who can do it well are called "actors."

Yet we often ask people to appear on video doing things they are uncomfortable doing, don't have the talent for, and are unprepared to try. The results are tragic—your victim is caught on video either being incredibly uncomfortable or cheerfully being absolutely awful. Either way, the viewer is gone.

A friend forwarded me a video done by a publisher to promote a new book. The author seemed personable and knew his subject, but for some reason they had him reading to us from a teleprompter. His delivery was barely adequate. I don't fault the author: The ability to appear natural while reading off a teleprompter is a skill that requires practice. I blame the video producer for committing the sin that ends careers in Hollywood: making the talent look bad.

It turns out that a fair amount of skill is required to look great on video. People who can do it well are called "actors." Actors who do it very well are called "stars"—whole films, websites, or TV shows are profitably mounted around them. Stars are very clever about managing their appearances on video. They know what they do well and what they don't do well. They work incredibly hard to avoid doing the latter.

A nonstar doesn't know what makes them look great on video. When you suggest reading from the teleprompter, they say, "Sure!" and give it a go. Part of your job is to keep them from doing that.

Think about your subjects before you shoot, and figure out what they can do well. If they can't act, don't make them. Interview them, and let the interview segments carry their message. If they can't talk at all, shoot them doing whatever it is they do and let someone else talk about them—a voice-over or another interviewee.

Make Your Star Shine

Meet with your talent ahead of time. Review your shooting plan and ask them how comfortable they are with what you're asking them to do. If they're not sure (or wrong . . . it happens), make your own assessment. They're putting themselves in your hands—take charge! Find out what your talent isn't good at—and then don't make them do it.

|||

YOU CAN'T FAKE THE TRUTH

Thinking of faking a hidden camera "punking" for YouTube? Yes, I'm talking to you! Sorry, you can't. And when I say you can't, I'm not saying "you may not." I'm saying you literally *can't.* Here's why:

Stage, film, and video are consensual media. They rely on an agreement with the audience— even though we know what you're doing is fake, we're going to go along with it as if it were real. For 90 minutes or so, we'll suspend our disbelief and pretend that there are no technicians standing just off camera with a giant fan making that wind, that aliens really exist, or that people really do break into song when they get emotional.

We suspend disbelief for a fictional drama with great actors. We know it isn't real, the filmmakers know it isn't real. Everyone's fine with that. We'll also suspend disbelief for a documentary or "reality show" where the participants are really reacting and unscripted. We know it was heavily edited and maybe (!) didn't happen in exactly the order we're seeing it, and so do the filmmakers. But we also know that it all more or less happened and that the people we're seeing are real.

What you can't do is tell the audience you're doing documentary and then fake it, unless they're in on the joke (see *The Office*).

Once you tell the audience it's really, really real, they *un-suspend* their disbelief. They now expect to see not *acted* reactions, but *real* reactions. Even though they can't consciously express it, they know what real reactions look like. They live them every day.

Video is a lie detector. It reveals the hundreds of cues we use to decide if someone's telling us the truth or not. That's why even when they're working with an audience that's agreed to suspend its disbelief, the top actors in Hollywood work hard to find truth in their performances.

Great actors study how people really move and react, and use every acting trick in their repertoire to mimic even normally unconscious facial moves. Skilled directors coach, support, and even manipulate their actors until their performances feel real. Then they edit the performances, mixing close-ups with wide shots and adjusting timing to make them even realer.

All that work—even though they're lying, with the audience's consent.

When you lie without the audience's buy-in, you break the rules of suspended disbelief. Your audience is now suspicious and quick to anger. They don't like being lied to.

Before you try to present a fake as true, consider: How good are your actors? How good are you? What are your chances of fooling the audience with fakery when they're looking for truth? A team of talented pros would have trouble pulling it off.

Location, Location, Location

Every video needs a "where." Sometimes you get to choose that "where." You can shoot a comedy sketch in a friend's restaurant or pick the backdrop for your webcam rant. In other cases, the where is provided for you: You don't get to choose where your kid plays his baseball game.

In both situations, there are choices to make:

If your location is chosen for you: Take a lesson from wedding photographers. They don't get a vote on where the happy event transpires, but they have a lot to say about where the bridal party will be photographed.

> **Try out your location in the same way you would audition an actor. Take your camera with you and scout your choices.**

If the church is an ugly 1962 redbrick monstrosity, they'll hunt around to find an attractive backdrop somewhere. It could be one small part of the sanctuary, or outside the building amid the budding cherry blossoms, or a block away in the park.

When you're shooting documentary footage, conjure up your own internal wedding photographer. Choose your location according to your story needs. Shooting an interview in the refrigeration room of a brewery feels different than shooting on the loading dock.

Find a great background. Find great light. Move your subjects there if you can.

If you can't move your subject, move yourself. Any one person is surrounded by 360 degrees of background. Move around them until you find something that looks great. (See "50 Ways to Shoot One Thing," page 140.)

If you can choose your location: Think past attractive. Go back to your hero and her story for clues about where you should be shooting.

A kitchen with sunny windows, marble countertops, and Viking ranges conveys very different information than a hot plate in a run-down motel. We'll take away a very different impression of a 40-year-old man wearing a $2,000 suit if he's behind the wheel of a Mercedes than if he's eating toast off a grimy plate on his bed. One's a power broker, the other, perhaps, a pretender. And if we see the same man in both locations, he could be leaving his lover's house in the morning—or he could be driving someone else's car. Location both asks and answers questions for the audience.

Think about your location as a character in your video. Finding the right one is worth the time. You should love what you're seeing when you look through the camera.

Don't forget practical location issues: One of the first things a good producer wants to know is whether you can control the location for the length of time you need to shoot. If you're borrowing an apartment (or even shooting at your house), will you be uninterrupted for however long it takes?

What about noises nearby? I once checked out a location on a Saturday and loved it. When we returned to shoot on Tuesday, a brand-new house was breaking ground next door. Our producer

Pointing the camera in another direction yields a totally different background. In the finished video it looks like you're somewhere else.

managed to stop the noise through the strategic use of cash, but had we been a no-budget production, we would have been in trouble. Music from the apartment next door and barking dogs can put you in audio hell for hours.

You'll need good light, and if you're bringing lights, a way to get them to the location. Can you drive right up to it? Are there stairs? Is there power?

How the character dresses is another location issue. If your actor walks into the house shivering, wearing gloves, a snowy overcoat, and a scarf, a view of bright fuchsia flowers out the back window might ruin the illusion.

Audition Your Location

Try out your location in the same way you would audition an actor. Take your camera with you and scout your choices. Shoot a few shots at each location from the same points of view that you think you might use in your video.

If you can get a friend to go with you, put them where the characters will be and mock up a few shots. Review the photos or video to make your final choices.

A guy in a suit looks one way behind the wheel of a Mercedes...

... and totally different in a seedy motel room.

The Right Camera

I n most cases, your camera is the least of your worries. You can shoot a compelling feature film on an HD smart phone if you have the patience.

Using too much camera for the job can make your video worse. An iPod Nano may be perfect for shooting your grandfather reminiscing about the mid-20th century. (Plus, it's right there, in your pocket or purse, or you can steal it from your son . . .) A bigger camera might make grandpa nervous and clam up. There's no point in lugging more camera than you need.

You also shouldn't carry more camera than you understand how to use. The myriad programs and switches on a "semi-pro" model are more confusing than anyone other than a professional director of photography needs to worry about. If you've got one and have explored it enough to get it up and running quickly, hats off to you. If not, go with something that you understand. A pocket video camera will easily get you through most family events, and any camcorder with a 10 × zoom will handle the rest.

If you want more, don't buy more camera than you're willing to take the time to figure out.

TRY THIS

Test-Drive Your Equipment

When you're in the market for a camera, a well-equipped video store will give you a chance to handle the different choices. Look for models that are easy for you to figure out at whatever level you're at. Tech nerds should be able to understand the interface on the complicated ones easily, and the rest of us should be able to use the simple ones within minutes of picking them up.

If you already own a camera, but barely know how it works or it makes you nervous, see "Play with Your Equipment" on page 102.

The Real Secret to a Great ~~Business~~ Video

Ask any Hollywood director what he does all day on the set, and you'll hear the same response: We answer questions. Which color do you like? How's this outfit? Where should we put the camera? How was that dialogue? Do we need another take?

Directors get paid to give answers. Is their opinion so much better than anyone else's? Sometimes, yes. If you spend a lot of time studying and making film and video and you're not an idiot, you're bound to make better decisions than someone who doesn't. And there are a few—very few—true geniuses who see things the rest of us can't.

But if we take experience and genius out of the equation, the answer is no, their opinions *aren't* better. They get listened to simply because they're willing to commit. They're willing to say what they think and assert that their opinion on something as subjective as a color is *the* right opinion.

> **If it's your video, you have to commit to your own standard of excellence. You can't settle for "good enough." You can't design by committee. You have to make your own choices. To love the good parts and cut the bad.**

Contrast that with what usually happens in business—somebody asks a question, and nobody leaps to answer. Or if there are answers in the group, they get discussed and evaluated until the group comes to a conclusion. Sometimes they don't really know what they think. Sometimes they're just covering their butts. Either way, it's groupthink—and groupthink kills creativity.

The director stands up and says, "Here's what we're doing. Go." And if you want to make a great video, so must you.

Art—and video is an art—requires passion. It requires emotion. It requires commitment and a willingness to get up and do what's in your heart, regardless of what others will say. It's hard, and if everyone could do it, there would never be a non-hit song or a non-bestselling book. Studios would never release a bad movie, and every video on YouTube would have the same huge number of hits.

If it's your video, you have to commit to your own standard of excellence. You can't settle for "good enough." You can't design by committee. You have to make your own choices. To love the good parts and cut the bad. You have to make decisions and live with them. You have to *know* that if you love it, the audience will love it. And you have to accept that the reverse is also always true: If you're bored, they will be too.

Creating your business video, as contradictory as this seems, is an art. If you approach it like you would a report, make it inoffensive and just good enough, nobody will watch. The more it pleases *you,* the better your chance for success.

TRY THIS

Apply the "You Test" Early and Often

Throughout your video project, ask yourself: What do *you* really think of what you're doing? Do *you* really love it? Do you have ideas to add, or see things that just aren't working? Forget the colleagues, forget your spouse, forget the pressure just for a moment. If *you* saw this video on your computer, would you watch the whole thing? Repeat this test often at every stage of creating your video.

How to Shoot Video That Doesn't Suck

You've thought. You've planned. You've assembled the pieces. Now it's time to put it all together.

The prep you did will support you, but the key to shooting is to practice. As you do, follow your instincts and learn what looks good to you.

Ready? Let's shoot.

Edit with Your Brain

E diting in-camera is the art of shooting your shots in order, to exactly the length you want them. Your video is finished when you're finished shooting. It's the way most people shoot home videos, documentary Web videos, or any situation where they don't have time (or the inclination) to edit.

Most people use in-camera editing without thinking about it because it's easy. From now on, I'd like you to apply the technique *intentionally*. Editing in-camera trains quick thinking and better shooting, and it's a lot of fun. Do it well, and you'll be able to generate high-quality, compelling video with a minimum of effort.

Thinking ahead as you shoot gives you a feel for the flow of a video that you won't get any other way.

At a wedding recently, the groom handed me a video camera and asked if I would shoot some. I've been to a few weddings and know pretty much how they go. By thinking one step ahead, I could get a shot or two from each phase of the celebration. I could position myself where I knew people would walk and let them come to me. And because I knew which actions were likely to occur (cue the four-year-old ring bearer walking up the aisle and forgetting where to go next), I could fake my way through the beginning, middle, and end of shots. The result? A pretty good

10-minute wedding documentary fresh out of the camera. It looked professional, and increased the odds that I'll get invited back to this family's catered events. Always a plus.

Refining your editing in-camera technique will make you better at scripted video too. Focusing on the action in shots gives your work more impact. Thinking ahead as you shoot gives you a feel for the flow of a video that you won't get any other way.

TRY THIS

Practice, Practice, Practice

Find real-time events you can document, like birthday parties, company gatherings, or public ceremonies. Cover your event by shooting very short shots, not more than five or eight seconds each (less is fine too!). Follow the chronology of the event, letting it lead you to what happens next.

Use your gut to feel your way from the beginning to end of each shot. Pay careful attention to what starts the action and what ends it. When the shot feels over, CUT and go to the next one. When you're done, play the whole thing back at once. Odds are you'll have a very respectable video, requiring little or no editing. The more you do this, the better you'll get.

EXERCISE: TELLING A THREE-SHOT STORY

Shot 1: The hero approaches.

Shot 2: She waits for a break in conversation.

Shot 3: She introduces herself to the boss.

Try this anywhere you can shoot freely. A big function like a dance or dinner is perfect.

Look around until you find someone doing something interesting—or about to. It should be a simple action, like a child eating ice cream or an exec introducing herself to the boss.

Think about the beginning, middle, and end of the action, then shoot it in three short shots. Don't worry about audio—what they say isn't important. You want visual action. Here's an example:

You see a woman walking across the room with some determination. Grab the camera and record SHOT 1: The woman arrives at a group of three others talking. Hit "pause," move closer, and record SHOT 2: She waits, looking from face to face. Closer still and get SHOT 3: She sticks out her hand and shakes with the boss.

Now look around for another victim. You don't need a particularly unique or interesting action—this is just an exercise. If a waiter is passing hors d'oeuvres, you'll see him repeat his action over and over: (1) Move to new people, (2) pause while they pick up a skewer, (3) offer a napkin.

Keep finding actions, shooting three shots, and moving on. Do as many as you can—one every minute or two. Don't worry if some aren't "good"—you're doing this to develop the habit of seeing in story. Do try to look for motion or emotion for each shot.

Once the event is over, watch the playback. How did you do? Did you get better as you went? You may be surprised to find that even though you were shooting seemingly boring little actions, the montage of people turns out to be a halfway decent, pretty watchable film of what went on.

Focus Your Shots

I'm not talking about keeping your shots *in* focus—the camera will do that for you. This is about focusing your brain (and then your camera) on what you want the audience to see. With the same characters, action, and setting, a shot will be totally different depending on who you choose to focus on.

We've already said that the "hero" of a shot is the person or object doing an action (see page 38). Every shot needs a hero, or the audience won't know where to look in the frame. But a single situation could have any number of heroes. For example:

Imagine a shot in an office at the First National Bank in which a man tells a woman that she can't have the mortgage adjustment she needs to avoid bankruptcy.

Focus on the hero. In this shot it's the banker.

You might think it's obvious that the man is the hero and the shot is about "Man says no." (Remember, shots, like sentences, have a noun–verb structure; see page 46.) After all, he's doing the talking. But you could keep the same script, the same set, and the same moment and create shots in which he

Same scene as the previous page, but in this shot the hero is the woman.

The hero of this shot is the banker's hand, caressing a bottle of whiskey.

isn't the hero. It all depends on the needs of your video.

Suppose the video's story is about this same woman moving to Nashville and breaking into the big time as a country singer. Then our shot might be about "Woman gets an idea." Instead of focusing on the bank manager, we'd see the woman's face as he talks. The shot would show her moment of inspiration—realizing bankruptcy will change her life.

If the video is about the banker's descent into alcoholism, the shot could be about how he's too drunk to know how much harm he's causing this poor woman. In this case, the man's *hand* might be the hero of the shot as it caresses a whiskey bottle in his desk drawer, out of view of the woman.

An object can be the focus of the shot too. If you're making a disaster movie, the banker's still talking and the woman's still listening, but the "hero" is that giant crack in the floor heading toward them both. Then the shot is about "Crack widens."

Picking the hero of your shot and the action they're taking is key to audience understanding. If you don't know who or what the shot is focusing on, the audience won't either.

TRY THIS

Keep Your Eyes on the Prize

You can practice this one in your next "real" video shoot, or carry your camera to work or school with you and roll off some shots.

Identify the hero of your shot before you roll. Is it the guy at the library table, or is it his hand turning a page? What action are you looking for, and what does it say to you? If he puts his pencil to his mouth and chews, that's one shot. If he looks at you and smiles, that's another. "Fingers tapping" is a third.

Practice identifying the hero and his action by shooting several different shots of each person you find.

Know your hero and action before you hit "record." They need to stand out in the frame. Here are a few ways to make sure the audience focuses where you want them to focus:

• Make the hero the only thing in the frame. That way, there's no place else to look.

• Give the hero the biggest motion in the frame. If a man runs through a static crowd, our eyes will be drawn to his motion.

• Light the hero more brightly.

• Bring the hero physically forward in frame, so everything else happens in the background.

• Be zoomed in on your lens (tight) so that stuff around the hero gets a little blurry or dark.

• Use a foreground element to block motion in the frame other than the hero (see "Use Foreground," page 135).

• Give them a "strong third" composition (see "Learn the Rule of Thirds," page 141).

• Draw an arrow pointing to the hero. (Just kidding. Don't do that.)

Play with Your Equipment

W hen I was six and my dad gave me a Hawkeye Instamatic camera, he pointed out the manual and told me to read it carefully. Which I did, because I was very proud of my camera and wanted to be good at taking pictures.

The most recent video camera I bought came with a few pages filled mostly with legal disclaimers warning me not to try to recharge it in the shower. The latest computer we bought didn't come with anything resembling a manual. And my kids wouldn't read it if it did.

You can't break your camera by playing with it. You can't break your computer editing software by playing with it. And you won't know either well enough to use it *unless* you play with it.

The world has moved on. Now complicated equipment is designed to be "intuitive" and the help is all online, frequently generated by a community of other users. Manuals, when we do get them, appear to be written by people whose first language isn't English and whose second language may not be English either.

While I remember the Instamatic fondly, and still look up to my dad, the demise of the big instruction manual doesn't bother me much. I'm very comfortable with technology. But many people aren't.

TRY THIS

Befriend Your Camera

If you don't know your video camera well, take it out now. If you have a "quick start" manual, pull that out too.

If you can start recording, stop recording, and play back, that's all you really need to know. Point, shoot, and assume that the camera will take care of you. That's what it's designed to do.

If you want to learn more, start by figuring out how to access the menu. Scroll through the commands and try them for yourself. You can ignore things like "sepia" and other in-camera functions that change the look of the recording. You can turn your digital zoom off (see "Turn Off Your Camera's Digital Effects," page 104).

Try to find the switch for manual white balance, which you may need someday. If a function's purpose isn't obvious, shoot a little and see if you can figure it out.

Don't worry about breaking something. If your camera has an electronic menu, it also has a setting somewhere called "reset defaults" that will reset things to exactly the way they were out of the box. You may have to go online to figure out how, but trust me, there's a way.

You should do the same with your editing system. Whether it's in-camera or on your computer, you can't break it by playing with it. You *can*, in some cases (and with some badly designed cameras and software), accidentally erase or change the video you're playing with. To prevent that, use "save as" to make a copy of your movie file and label it something like "copy to play with." Then do just that. (Feel free, of course, to read the manual and figure out how not to inadvertently erase things.)

At its heart, an editing program works like any other program on your PC: cut, copy, paste. Sticking just to these functions, you can edit your video. You don't need special effects, or titles, or zooming, or slow motion, or any of it. Start with the basics, and someday—if you feel like it—maybe you'll try something else.

I won't mention my lovely wife by name (she knows who she is), but the woman is a Luddite. I can spend hours playing with electronic toys, but she won't. Either she just wants to do what she wants to do at that moment and be done (without having to slog through learning a new toy) or she's worried about breaking the machine. I can't fault her for the former, but here's the news on the latter:

You can't break your camera by playing with it. You can't break your computer editing software by playing with it. And you won't know either well enough to use it *unless* you play with it.

||

TURN OFF YOUR CAMERA'S DIGITAL EFFECTS

In professional video, there's no such thing as a digital zoom.

The optical zoom works like any camera or telescope in history, using precision glass lenses to bend light and increase the size of the image, making things appear closer. The digital zoom is a marketing shuck and jive, a cheap chip effect they stick into the circuits on your camera so they can advertise "120× zoom!" and make you think you're getting something cool. You're not.

Digital zoom on a video camera is exactly the same as blowing up a picture on the computer. Blowing up a picture digitally makes it bigger and fuzzier, filled with tiny digital boxes created as the camera digitally invents data it can't really see. If you like this effect—and you shouldn't—you can always add it later.

Any tricks your fancy digital camera can do to mess with your picture, most editing software can do too. The difference is that if you let the camera do it, it's permanent. You can't undo it if that's the way it was recorded in the first place. If everything was shot in "kaleidoscope," that's it. There's no magic "un-kaleidoscoping" button on the editing software.

Unless you have a clear and compelling reason not to, stay away from your camera's digital effects. This includes posterizing, night-vision, sepia, pixilation, and especially the digital zoom.

Keep Your Shots Short

I f you remember one thing from this book, make it this: Shorter is almost always better. It's true in overall video length, and it's true when you think about individual shots.

Watch most movies, TV shows, or music videos, and you'll rarely find a single shot that lasts more than 20 seconds. Most are much shorter. Shorter shots engage viewer interest better—multiple shots covering the same elapsed time convey more information.

Cutting makes us pay attention. Each cut to a new shot forces our brains to figure out what we're looking at and what it means. We're more engaged in what we're watching because we have to do a little work to understand it. We're more actively taking in information, participating in what the video has to offer.

New angles allow the videographer to convey more information. If each shot has a strong focus, we can call the viewer's attention to a lot of information. These little parts add up to a deeper, richer whole.

For example, watch the camera work in the famous milk commercial that made Michael Bay's career: Each short shot gives us another hilarious detail about the hero and his

> **Cutting makes us pay attention. Each cut to a new shot forces our brains to figure out what we're looking at and what it means.**

location, finally causing us to understand that he's in an Aaron Burr museum, about to miss out on a huge cash prize. Watch it at www .VideoThatDoesntSuck.com/examples.

Moviemakers sometimes use long shots (see, famously, the opening of Robert Altman's 1992 film *The Player*), but these are meticulously planned by Hollywood's top crews and acted by Hollywood's top talent. They can take days to rehearse and shoot. They're designed to call attention to themselves because they're so long.

Once you've mastered shooting short shots, you can give a long one a try. Until then . . .

TRY THIS

Count to Five and Cut

Next time you're out shooting, keep your shots under 15 seconds. Under 10 is better, and under 5 works most of the time.

Zoom with Your Feet

I nexperienced theater performers tend to stay way upstage—closer to the back wall of the stage and far away from the audience. Why? Because the audience is staring at them, waiting for them to do something interesting. Only a very few humans are wired for being the center of attention in front of hundreds of people.

This fear of being the center of attention also plagues videographers. They're reluctant to get in the way, or feel like everyone is looking at them and their camera. To be less noticed, they stay far away from their subjects and try to use the zoom lens to compensate.

Unfortunately, the more you zoom, the more your picture shakes. You can prove this to yourself by going all the way wide (no zoom) on your video camera. Holding the camera in your hands, point at something just a few feet away. It looks pretty steady. Now find something across the room and zoom all the way in. Hold the camera the same way. Every time you breathe, you'll see your picture rock like the deck of the *Enterprise* during a Klingon attack (in fact, in the original *Star Trek* series, that's how they made the ship shake).

A video camera's autofocus also hates zoom. When you're wide (no zoom), the bridesmaid standing a couple of feet behind

An Hour in the Life, Part 1

"An Hour in the Life" is a great exercise that will get you more comfortable with close-in shooting.

Get permission from a close friend or family member to document an hour in their life. They don't need to do anything special. Work, homework, yard work, shopping. It's all good for this exercise. For the hour you're shooting, roll short, 5-to-10-second shots whenever anything interesting happens.

Before you start, widen your zoom lens as far as it goes. Your goal is to shoot for an hour without touching the zoom control.

Vary your shots often by changing your distance from the subject. Experiment with a full range of choices—from extreme face-fillers to head-to-toe body shots. Keep your shots static, shooting only once you're already in position and framed up.

When you're done, review your footage. You should have two or three minutes' worth. How does it look? As important for this exercise: How did you feel getting it? Repeat until you're comfortable enough to shoot close to your subjects in public.

your grandfather will still be in focus. So will the back wall of the church. If you zoom way in on your grandfather from across the room, the bridesmaid, the church wall, and anything else not on the same plane as your grandfather will be blurry. When your grandfather moves toward or away from you, the autofocus will be much slower to refocus on him because it's doing a lot more precision work.

On the audio side, zooming from more than three feet away makes anything you record with your camera's microphone sound distant and noisy. (Yes, you should be using a separate mic—see page 150—but sometimes we forget.)

It's better practice to keep the lens wide and stay close to your subjects.

People may notice you, especially if you block their view. Naturally, it's best to be considerate, as fistfights are frowned on at family events. But barring knocking Aunt Sophie on her butt or making it so the mother of the bride can't see her daughter say her vows, get close. Focus on what you're seeing in the monitor, and don't worry about what's going on behind you.

If you've ever watched professional news camera people, you'll notice that they don't care about being rude. If they don't get the shot, they don't eat. I prefer to err on the side of politeness. If you get in someone's way, you should absolutely apologize and move. After you get the shot.

Don't Shoot Until You See the Whites of Their Eyes

It's a dance recital, and seven-year-old Emma is in the third row as the girls run out onto the stage, facing a hundred anxious faces and flashing cameras, and tap their hearts out. A nice wide shot of the stage shows all 21 girls shuffle-stepping away. But later, when you look at the playback, it seems dry. None of the emotion of the moment—the fear, the shyness, the triumph as the applause swells—seems to have made it to video. The reason? You were too far away and too wide to see their eyes.

Faces are the billboards for all human emotion. There are times for a sweeping panorama of glorious African plains. And we all love a good car chase. But we don't care much about either unless we see how they involve people.

We need to see the face of the Kruger National Park ranger worriedly scanning the horizon. We need to see the detective's determination as he guns the engine and the thief's evil grin as he sticks his gun out the side window. If we can't see someone's face, we don't know how they feel. We don't know how *we* feel.

The Eyes Have It

Review the "Hour in the Life" you shot from the previous chapter (or shoot it now . . . we'll wait).

Look specifically for shots where you can and can't clearly see the whites of the subjects' eyes. Notice how different they feel. Take a look at the tight close-ups of the person's face. Notice how emotion and intimacy are communicated by something as subtle as the reflections off the eye's surface.

Faces connect us to others. Much of the "aaaawww!" we feel for a baby or puppy or piglet comes from looking at their faces and watching them look back. The eyes truly are the window to the soul. (Today we might say "the eyes are the monitors to the soul.")

If you can't see your subject's eyes, you're missing most of the communication cues we use when we interact. The tenseness that says "Be careful." The crinkle that signals a smile. The shiftiness that lets us know someone's not telling the truth. It's all there in the eyes. Without the eyes, your audience can't get to know your hero and won't invest in viewing your video. A big wide shot of a guy walking across the street communicates action, but it can't communicate emotion.

WHEN YOU ABSOLUTELY, POSITIVELY *HAVE* TO ZOOM

In the rare instance when you can't physically move closer to your subject, get as close as you can and then, yes, use the zoom to get closer.

To avoid camera shake, put the camera on a tripod or monopod (as you might guess, a one-legged stick to support your camera. Monopods are lighter, easier to carry, and simpler to use than a tripod, and are available at any camera store and online). Almost all video cameras have a standard-size hole on the bottom for the tripod or monopod to screw in.

If you find yourself "pod"-less, lean up against something solid like the floor, wall, a column, or a tree and brace your body and camera arm against them as much as possible. Take slow, even breaths. This will stop your picture from shaking.

Important note: Nothing in this chapter should be construed as giving you permission to zoom *during the shot*. See "Zoom with Your Feet," page 107.

Set the Shot and Hold It

Y ou gotta walk before you run, and in video, you gotta learn how to compose a shot before you start waving the camera around. But don't worry—a static camera doesn't mean a boring video.

There are some 90 cuts in Hitchcock's famous *Psycho* shower scene, and in all but four the camera stays dead still. (Count for yourself here: www.VideoThatDoesntSuck.com/examples. I did.) We're pummeled by a brutal, nonstop murder scene made up almost entirely of beautifully composed—and completely static—action shots. The viewer's sense of relentless, kinetic brutality comes from the cuts between them.

To choose a more modern example, look at Beyoncé's "Single Ladies (Put a Ring on It)" video, which has, as I write this, more than seven million views on YouTube (www.VideoThatDoesntSuck .com/examples). Most of the video consists of static camera shots of Beyoncé and two other women dancing. What camera moves there are are slow, mostly to keep the women in frame as they dance. Yet the video, like the song, bounces along with great energy.

If you watch professionally shot film, you'll be surprised at how often the camera stays still. Shooting with a static camera means the

Four sequential shots from the *Psycho* murder sequence where the camera almost never moves.

Cuts build tension and add motion.

action in the frame pops out and says, "Look at me!" If the frame is an empty desert highway and a car appears in the distance racing toward us, our eyes will be on that car.

In contrast, if the camera's moving shakily around the desert and happens to glimpse a car, we don't know whether we were supposed to pay attention to it or pay more attention to the camera's movement. There's more input for the eye, and more chance of confusion.

Placing the camera intentionally forces you to think about what you're shooting. You can look at what's in the shot and think about where the viewer's eye wants to look. You have time to make sure it's well lit, and well thought out. The images will be stronger and have more impact.

Can you do a great moving shot? Sure. But when you do, it also has to be intentional, thoughtful, and simple. Those principles are easier to learn if you practice not moving the camera first. We want to learn to stand steadily before we start walking around.

A still camera focuses attention on the action in the frame—in this case a figure blurred behind the curtain.

Ripping curtain aside on the cut provides a visceral jolt—but still the camera doesn't move.

TRY THIS

An Hour in the Life, Part 2

Try another "Hour in the Life" exercise. As before, you'll need a subject who won't mind you following them around for a while. Pets tend not to complain.

As you shoot your hero in action, practice setting a static shot you like *then* pressing "record."

Each shot should hold for three beats: beginning, middle, and end. Then move on to the next shot. Let's assume the family dog is the only one who'll let you follow him around. Set your shot, then call the dog. Beginning of the shot: Dog comes around the corner. Middle: He walks toward camera. End: He sniffs the camera and licks the lens.

These aren't whole videos, just shots. You're looking for 1 to 10 seconds of a complete action. Practice finding those action beats. On playback, look to see what works. Not all your shots will be brilliant (especially with someone as tough to work with as a dog), but you should see a certain authority—like you might get from a great still shot—that you don't get when you wave the camera around.

|||

UNITY AND *WHERE THE HELL IS MATT?*

Aristotle was the first to note that great drama has three unities—of time, of place, and of action. "Unity" is another way to suggest a pure focus on one thing. A play might take place over one day (unity of time), or in a single house (unity of place), or around a single event (unity of action). Unities keep the audience (and the writer/director) clear on what story they're telling, making those stories more focused and powerful.

You may think we're getting a little high-brow in our analysis here, quoting Aristotle and all. But there's a lot you can do with the idea in your video. For proof, take a look at a great video with multimillions of hits on YouTube: *Where the Hell is Matt?* www.VideoThatDoesntSuck.com/examples.

There's a lot right with this video, a rare and brilliant exception to the found comedy, stunts, and (metaphorical) train wrecks that dominate the YouTube world. The video follows one average guy around the world, cutting from place to place, as he dances—badly—with whoever happens to be there. It has a great intent, a terrific hero, and a simple but effective plot.

It's also a masterful use of the concept of *unity.*

Video can have even more unities, and Matt uses them to make his piece stronger.

Unity of Camera Movement: All the shots are locked—the camera never moves. Your video could all be handheld, all shot in slow motion, or all shot from the floor—to different but equally unified effect.

Unity of Composition: All the shots are head-to-toe on Matt and most of his dancers, and he's always centered in the frame. Interestingly, he's not always front and center. If he were, the video would be about a goofy guy dancing. Instead, because you can't always find him right away, the video is about the group dancing. Which carries its message of the unity of mankind much more clearly.

Unity of Graphics: Titles are always in the same place and the same font, and used the same way.

Unity of Action: It's about Matt dancing (usually doing the exact same steps) in different countries with various people—and that's all.

Unity of Song: The editing and mood are unified through the consistent, soaring rhythms of "Praan," the song that plays throughout.

The easiest way to see the power of unity in video is to imagine how much less effective this video would have been if it were edited to a bunch of different song clips or if the camera moved during the shots.

One of the most powerful things about unities is that you can generate emotion by playing with them. We feel good when Matt breaks out of his own unities in unexpected ways, like the scene in Tonga, where the wave sweeps over him, or in New Guinea, with the painted tribesmen who aren't dancing like him, or in India, where he suddenly changes his goofy dance style and does a real moment of choreography.

Know When to Move

Nothing bores people more than random camera moves. We see something interesting and hope that we'll get a better look, but the camera passes by on its way to who knows where. As soon as we understand that the cameraperson had no idea what they were doing, that we're *never* going someplace interesting in the video, we're gone. Moving has no value unless it means something.

On the other hand, a static shot has a certain presence and power. It works. "Yeah, great," I can hear you saying, "I shot 30 videos without moving the camera in a shot. I get it. Can I shoot a moving shot now?" Well . . . maybe. Before you move, consider the Hippocratic oath: "First, do no harm." (Okay, that's for doctors, not videographers, but you get the point.)

If you move closer to a person's face during a shot, you're inviting the viewer to notice the details of the subject's reaction to what is being seen.

Before you move the camera during a shot, the first question you should ask yourself is "Why? What motivates the move?" Camera moves should always be intentional. Purposeful. If you know why you're moving, you'll do a better job of conveying that confidence to your audience.

Your wedding video viewers will appreciate it if you travel down the aisle and keep the bride in the frame.

The biggest reason to move the camera is to travel with your hero for the length of the shot. If your hero walks, you walk with her. If she ducks down, you duck down to keep her in frame.

Another reason to move is to emphasize a particular action. If you move closer to a person's face during a shot, you're inviting the viewer to notice the details of the subject's reaction to what is being seen. Similarly, you might move in on a magician's hands during a card trick.

If you can, practice the move once or twice to make sure it looks the way you want it to.

SIMPLE AND ELEGANT VS. COMPLICATED AND AWFUL

I'm a huge admirer of James Cameron (*Avatar*), Baz Luhrmann (*Moulin Rouge*), David Fincher (*Benjamin Button*), and Peter Jackson (*Lord of the Rings*). These guys take on spectacularly complicated enterprises, inventing new technology as they go, employing crews in the thousands, and ending up with films where each finished frame is a complex masterwork.

I admire them, but I'm not them. I just don't think that way and, I'm forced to admit, I don't have their skill. For the rest of us, those of us who can't create spectacularly complex and grandiose video, I offer this advice: Strive for simplicity and elegance in all things video.

You don't need a swooping crane shot that lands perfectly centered on your main character's eyeball. You don't need 100 extras in the background. Better video comes from focusing on the essentials and doing whatever you do very well.

Focus on your hero's story, and try to tell it in the simplest, most elegant way possible. Brilliance is encouraged but optional. Competence, however, is mandatory.

TRY THIS

An Hour in the Life, Take Three

Let's do one more "Hour in the Life" exercise, if your family hasn't disowned you.

This time, experiment with these camera moves during your (still short) shots. Practice a few just to get the feel of them at first. As you get used to the way they work, you can use them more intentionally—to help add information to your shot.

WALK CLOSER: Holding your camera carefully, walk as smoothly and slowly as you can toward your subject. Make sure you keep the hero of the shot (person or thing doing an action, remember?) as the focus of your frame.

WALK FARTHER AWAY: You'll be going backward, so be careful.

FOLLOW YOUR SUBJECT: Tilt (up and down) and pan (move side to side) to follow your subject's movement, keeping her head just inside the top of the frame.

MOVE UP OR DOWN: This is called a "boom" shot. On a film set, we might use a dolly (a rolling cart with a silent hydraulic lift) to raise or lower the camera during the shot. Without one, the smoothest way to boom up or down is to hold the camera in place and bend at the knees to raise or lower your body. You can use your arms too, but your move will be smoother if you don't.

You can combine moves as well (boom up while you pan left, for example). Play around and see what you like.

Review your footage. What works for you?

See the Light

T he first comment from most visitors to a film or TV set? "Boy, everything's a lot smaller than it looks on TV!" Which, while true, has nothing to do with this chapter.

The second most common comment? "Wow, you guys sure spend a lot of time standing around!" This is also true. The standing around is the technical time required for everyone to get ready for the next shot. The makeup has to be right. The set needs to be perfect. But most of the time spent is for lighting—anywhere from 15 minutes to 8 hours to light a single shot that might last 6 seconds in the finished film.

On a feature-film set there are between 12 and 25 grips and gaffers worrying about how well lit the set is. (Grips move lights; gaffers plug them in and point them.) Above them all stands a highly paid cinematographer whose main job is to make sure the lighting looks right. Why? If your scene isn't lit, your audience can't see the action and will have no idea what's going on. And if it's lit wrong—super-bright for a tense sunset horror scene, for example—it works against your mood. Without the right light, you can't tell your story.

You won't need a team of gaffers to light your video. Modern video cameras take care of exposure (light and dark) automatically. But sometimes that automation gets it wrong. Or more precisely, we do things that tell the automation to light for the wrong thing.

Classic Error #1: Shooting a person indoors during the day, in front of a window. The camera, doing its job, finds the brightest light (the window) and automatically decides that's "normal." It adjusts the overall picture so that everything in that bright light looks good. The house across the street looks amazing, but the people in front of the window become silhouettes.

Light behind the subject creates a silhouette.

The fix? Put the brightest light on your set *behind* you (and the camera). Since you can't move the window or the sun in this case, switch places with your subjects. With your back to the window and them facing it, the daylight is now lighting them instead of you.

Geek Note: If you have a camera with manual exposure controls, you can shoot someone in front of a window by adjusting to expose for your subject's face. This will bring the over-

Not enough light and the circuitry in your camera strains to produce a washed-out image.

all light level of the shot up, and the window behind will bloom a bright white, with no detail at all. It's a cool look but very stylized, and takes some doing.

If you want to see what's out the window *and* your subject's face, you have to shine a very bright light on the subject, dim the window (by coating it with something like the tint they use to darken car windows), or both. Bringing the interior and exterior light levels closer lets the camera see them both.

Just right: Lots of light shining on the subject.

Classic Error #2: Shooting in overly low light. The more light you have, the crisper your pictures. (This is a physical property of all lenses, including your eyes. It's why some people need to wear glasses to drive at night, and older people can read without their glasses outdoors during the day.)

Video shot with inadequate light fades into a kind of grayish, grainy mess. There are two possible solutions. If you're indoors, the easiest solution is to turn on all the lights. If you can't add light, try turning your subject toward whatever light there is and moving closer. That may help the autoexposure pick up what light there is and clarify your subject.

In all lighting situations, the viewfinder is your friend. If you can't see what's going on in that little screen, the view won't magically improve when you post it on the Web.

Lighting your video isn't optional, it's mandatory. And never, never, never use a badly lit shot in your finished video.

With practice, you can use light more subtly to help you tell your story. Changing the light changes the mood of the shot. A gray sky *feels* totally different from harsh sunlight. Firelight sets a different mood than the light from a floor lamp. You can play with light for a lifetime and never master it, but you will get better.

While you're learning, make sure we can see what's going on in your next video.

TRY THIS

A Lighting Line in the Sand

Imagine a line between you and your subjects. Keep the light shining *from* your side of the line *toward* your subject. That means the light should always be behind you. Sometimes it will be right behind you, sometimes off to one side. But always coming from your side of the line.

In general, add as much light as you can to most scenes. If it's even a *little* dim to your eye, it's *way* too dim for your camera. Turn on the room lights. Pull over a floor lamp, a desk lamp, or even a flashlight. For bigger shoots, rent or buy video or photographic lights. They're small and portable, and you can set them up as needed.

Throw Caution to the Wind

What do House, Homer Simpson, Tony Soprano, and Freddy Krueger have in common? In real life, we wouldn't want to live next door to any of them. But we love to watch them annoy, save, frustrate, smash, or kill other people on television and the movies.

In video we embrace the conflict and danger we would prefer to avoid in real life. Nice people nicely doing nice things to each other is boring. We don't want our car to run out of gas on an empty road at midnight during a full moon on the Scottish moors, but we certainly want to see it happen to someone else in a movie.

> **We filmmakers have to work against our instincts. We need to move toward the discomfort instead of running away from it.**

This doesn't mean you can't shoot nice people, or that the First Communion video will be worthless unless Aunt Pat punches out the priest. If everything everyone shot featured screaming conflict and awful people, the world would be wall-to-wall reality-TV shows.

But it does mean we filmmakers have to work against our instincts. We have to fight to keep shooting something even when it makes us uncomfortable. We need to move toward the discomfort instead of running away from it. Is there tension in our script?

Be Uncomfortable

Clasp your hands in front of you (oh, go on—try it. Nobody's looking!). Now shift your clasp so that the lower thumb moves to the top and all the other fingers change position too. How does that feel? Uncomfortable? You bet. You've been clasping your hands the exact same way since you were about a month and a half old.

This is analogous to the mental discomfort you'll feel when a shoot-the-truth vs. cover-your-ass conflict arises. Your brain will feel crampy, just like your hands do now. If you practice doing this often enough, though, your hands will get used to it. So will your brain.

Okay, you can let go now.

Is the hero in difficulty? Is there suspense about what will happen next? If not, how can we add it in?

Those moments where you think to yourself, "If I shoot this, will I get in trouble with Mom/get fired/be shunned by my friends?" Shoot them. You can always edit things differently or edit them out before you post the video on your website. But if you don't shoot the things you see, you won't have the choice.

Audiences pay to see the guy on the tightrope, not the guy selling popcorn in the stands.

Aim your video at what makes you uncomfortable. Conflict and trouble are where all the good stuff lives.

GREAT BRAINS MAKE GREAT VIDEO

One of the keys to getting someone to pay attention to your video—one of the best ways to entertain—is to have something interesting to say.

A great example is the TED website (www.ted .com). "TED" stands for Technology, Entertainment, and Design, and it runs conferences all over the world. At the site, you'll find hundreds of 18-minute talks filmed during the conference, shot with (I'm guessing) three cameras and then edited together in a very simple, straightforward style.

Without added effects or fancy graphics, these people are fascinating. Their ideas are so strong that they'd be just as interesting if their videos were produced on a webcam from their kitchen table.

TED's videos suggest that great ideas, even presented simply, hold our attention. Lack of fancy equipment or money is no excuse for subjecting the world to more bad video.

When you release a video, you owe it to your audience to give them a good time. To change their world. To open their eyes. To make them feel. If you do, the fact that you had no money won't matter. And if you don't, all the money in the world won't make any difference at all.

Make Your Star Look Great

(Part 2: Literally)

If you watch a black-and-white 1940s-era film with a big female star (Ingrid Bergman, perhaps, or Bette Davis), you'll eventually get to a very dramatic scene—a love scene, or a death scene, or a betrayal scene—featuring the star in dramatic close-up. If you look carefully at her face, you'll notice that it's brighter than anything around it—almost glowing.

This is called *key light,* and its purpose is to make the actress look more beautiful than any human being can possibly be. By lighting her face with a bright soft light, the director of photography hid shadows and lines and made her look young and angelic. The light pulls your attention to her face—her eyes glow, and every subtle eye movement speaks volumes of emotion.

This look was so important to the big stars that many of them brought their own lighting specialists to the movie set with them. They knew that faces pull people in. The more interesting those faces were, the more people they pulled in, the bigger the star.

Channel Your Inner Stylist

Next time you look through the lens at someone, let your inner beauty consultant out. Everyone (men and women!) has something attractive about them. It's your job to find it and get it into your video.

Say you're shooting your sister. Sure, you probably have issues, but put them aside and consider: What are her best features? Does her hair look better up or down? Does that dress make her look fat? Does she look like your sister on her best day, or is the lighting or camera angle making her look bad? If she looks pale, green, or dark or scary, don't shoot.

You may never have thought seriously about what your sister looks like, but if you're going to put her on video, it's your job not just to think about it but to help her look great.

Ask her to take off her hat, wear her glasses, or blot her lipstick. Suggest powder for her shiny forehead. Move to another angle, get closer or farther away, bring a lamp closer, ask her to shift position.

Try whatever it takes to make your video's hero look like a star.

That's still true, of course. Even though actresses don't tote special lighting folks around Hollywood much anymore (it's way too expensive these days, and the look of film has become more naturalistic), big stars regularly negotiate to have their own hair and makeup people on the set.

You may not have lighting, hairstylists, or makeup artists, but you're the one responsible for making sure your subjects look great on camera. If you don't, you're doing them a disservice and making your video that much less watchable.

Before you shoot: How does your hero look through the lens? Not everyone can be Megan Fox. Everyone has their good days and bad, their good angles and, um, less good. Trust me when I say that you don't want to be looking up grandma's nose when she makes her big speech at the rehearsal dinner. And people eating almost never look their best.

Subjects feel more comfortable knowing that you've worked to make them look good, even if just a little. And comfortable people naturally look better on camera. You may not see a big physical difference when the makeup goes on, but it will make a woman used to wearing it more confident on screen.

Show Us Where We Are

What do the huge atrium lobby of the Seattle Grace Hospital in *Grey's Anatomy,* the hills of Korea in *M*A*S*H,* and Jerry Seinfeld's New York apartment building have in common? They're all *establishing shots,* letting the viewer know where the next scene is about to take place.

You see these shots all the time in movies, television—and well-done videos. The previous scene ends and CUT to a three-second helicopter shot past the snowy brick buildings of Princeton University and CUT to House's office, where Hugh Laurie is ranting midargument.

Everyone has to be *somewhere* and *somewhen.* Establishing shots show us the place, season, and time (night or day). They help us understand your hero and your story.

If you're shooting your vacation in Washington, D.C., why not show us a big wide shot of the Mall before we join you for a walk through the Lincoln Memorial? If you're in Las Vegas, you can grab a quick shot of the Bellagio fountains and the hotel facade before you tour the art gallery.

Establishing shots tell us where the scene that follows takes place.

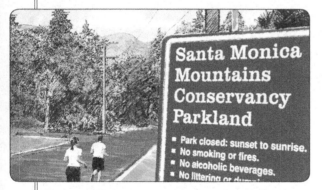

Signs or landmarks make the location even more specific. It's not just a park, but a certain park on the west side of Los Angeles.

The best establishing shots tell us where we are and make us wonder what the hell is going on.

Not every video needs a big formal establishing shot. But if you're in a cool location, you're wasting it if you don't show it to us. It takes but a moment to shoot the outside of the church, the performing arts center, or the pizza shop.

Establishing shots can be subtle: You can start a scene on the ubiquitous computer against a gray fiber wall, then cut to your customer service rep against the same gray wall as she answers the phone. Instantly we've established a cubicle in a large office space. We may never see another cubicle or the whole office space, but we've efficiently established the hero's work environment.

Adding establishing information makes any video richer. If you're doing an interview in a restaurant, why not let us see the terrific-looking bar before we cut closer for the interview? Or a shot of a waiter setting lunch on the table? If a character in your scripted video is a real estate baron heading for his sailboat, it wouldn't hurt to shoot him walking past the NANTUCKET MARINA sign.

Establishing shots can also help your video by lying for you. *M*A*S*H*, *Seinfeld*, *Grey's Anatomy*, and *House* were all shot primarily on studio sets in L.A. They use iconic establishing shots to help you imagine they were taking place elsewhere. Even

the establishing shots themselves can be fake—Seinfeld's New York apartment and the Seattle Grace lobby are in L.A., and the hills of Korea are in Malibu. So hand-paint that NANTUCKET MARINA sign and put it up on a dock on a lake in Kentucky—all's fair in love and establishing shots.

Establishing shots let you "establish" things that you could never afford to do for real. It will cost thousands to shoot in an actual office high in the Empire State Building. But why bother? If you shoot the exterior establishing shot for free on your next trip to Manhattan, you can shoot the office interior at a desk in your living room. (For more on the beauty of lying with video, see "Forget About Reality," page 131.)

TRY THIS

Go Scouting

Walk outside where you live and look for possible establishing shots in the area and fire off a few. Look for nice, wide shots that tell us where you are. You need only a few seconds for each one.

Look for the shots that carry extra information beyond just the building. What kind of car is parked out front? Is there a "FOR SALE" or political sign? Is there trash on the lawn or a car up on blocks? A dog? Establishing shots can tell us a lot about your characters.

The next time you shoot a video, look for shots that add information to what you're doing. How do backgrounds (like the bar in the restaurant mentioned above) or background action (like the waiter) add to the richness of your shots?

LIMBO DOWN

Some videos take place in an ethereal neverland called "limbo"—a seamless, glowing, solid color wash. Frequently black or white, limbo backgrounds are cheap to shoot, and they totally focus your attention on the people in front of them.

Apple's Mac/PC TV commercials are shot on white limbo. So is a great promo for a book called *Wisdom* (check it out at www.VideoThat Doesnt Suck.com/examples).

You can create your own limbo backdrop by shooting against a solid color wall, then removing that background in your computer editing program (most have a function called "keying" that lets you do this) and replacing it with a color wash.

The lower-tech way to do it: Suspend a six-foot roll of white paper (easier to get than you think—just Google "six-foot rolls of paper") above and behind your talent, with the paper rolled out along the floor to the camera. Put your actors on the paper. If you keep your shot inside the paper's edges and light it so there are no bold shadows, you won't see anything behind the actors. They'll be floating in white.

Keep Yourself Entertained

G ary Austin, another great improv teacher and founder of the Groundlings in Los Angeles, tells his actors, "Work at the top of your intelligence." Actors who play down to the audience are playing it safe instead of doing their best work and stretching. After a while, an actor who never strives for greatness never surprises himself and gets bored. And if you're bored, so is the audience.

This is also true of video. You should always be thinking about what would really entertain you, what would really be *great,* and acting accordingly. If you can think of it and you love it, try to shoot it.

Your audience is smarter than you. Always. They see the things you should have done. You're watching from the thick of things, trying to shoot great video. They're watching from the couch, focused on the screen and judging your every choice. They know when you're doing something cheap, lazy, or dumb, and they'll vote by clicking off. If you're falling asleep watching the playback of your webcam rant, you can bet nobody on YouTube will recommend it.

Your audience is smarter than you. They know when you're doing something cheap, lazy, or dumb, and they'll vote by clicking off.

Shooting a video should feel like a challenge—a fun challenge. Try things every time that you've never tried before. When you don't settle for what's "good enough" you'll surprise yourself, and your audience.

Practice Random Acts of Change

Next time you're bored shooting video, mix it up. If you're shooting at eye level, go down on your knees. Not for any reason, just to see what happens. If your shots have been long so far, shorten them (and vice versa, if they've been *really* short). If you're looking at the camera's screen, try looking through the viewfinder for a while. If you're lobbing softball questions at your interview subject, try asking something offensive.

Anything we do to randomly shake things up causes us to suddenly see them from an alternate perspective. Sometimes that new perspective will inspire you. If not, try another one.

Say No to Bad Shots

S ometimes you'll look at the little video screen on your camera and you'll hate what you see. Maybe your camera focused on a plant instead of the person you were trying to shoot behind it. Maybe the angle is boring, or you're too far away. Maybe there's not enough light.

Whatever it is, stop and fix it fast. Bad shots pull us out of your video. We're enjoying the block-party video until that long, dark interview with—who *was* that anyway?

In real life when something is blurry our brain steps in, adjusts our eyes, and corrects it. But if we're watching your badly shot video, it can't. Unconsciously, we feel the strain of our brain trying to focus the unfocusable. Consciously, we worry that the next interview might not look good either. And when it doesn't, we click off the video.

Using bad shots in a video signals a disdain for the audience, and nobody pays attention to someone who doesn't care about them. Everyone shoots bad shots now and again, but only amateurs leave them in the finished video and inflict them on others.

TRY THIS

Upgrade Your Look

Load a video you've shot recently into your computer editing program. Go through the video shot by shot and delete anything that isn't 100 percent perfect. Don't worry about how the video cuts—just take out the technically bad stuff.

Now look at the video again. You should feel much better watching it.

FORGET ABOUT REALITY

I once shot a commercial where a guy commutes to work via catapult. He kisses his wife good-bye in the front yard, climbs into the seat, and pulls a cord. The catapult flings him up and into the sky toward the camera as his smiling wife watches him sail over the city.

In reality, the actor was wearing a body harness attached to bungee cords that ran up through holes in his business suit. He was standing in front of a house facade in a studio. When three grips pushed down on one end of a seesaw "catapult," the guy flew up and over the camera, then bounced down just past it, into the waiting arms of three other grips. His "wife" looked up into the lights to watch him "sail away."

For a music video shot on location in a house, we needed nighttime and winter. We blacked out the windows and put a tent over the door to block the sunlight. Then we lit the fireplace and kept the light soft. It was August daytime outside, but inside—Christmas Eve. When we shot outside later, after the sun went down, we sprayed soap foam all over the yard to fake snow. The crunching sounds of footsteps were added later.

In any professional production, there are technicians inches outside the camera's frame with tool belts and makeup kits. Lights make the sunset glow, fans make the wind, water pipes make the rain.

It all looks real, but it isn't. Not one bit of it.

In fact, nothing you see on *any* video is accidental. Even in the most amateur video, someone made a choice about when to pick up the camera and where to point it. They made a choice about when to start and stop their edit. The more professional the video, the more consciously these choices were made.

You'll be better at video if you forget about reality. Stop thinking about what's *going* to happen and focus on what you *want* to happen. What's really in front of you doesn't matter. What matters is what you can make the camera see.

Letting go of reality can make your shoots easier. If it's a hot day and your character is sitting behind a desk in a jacket and tie, let him wear shorts so he doesn't sweat.

If you want it to *look* cooler in that hot room, send a friend outside with a hose to spray the window while you roll. Instant rainstorm.

If you need a crowd but you've got only five people, arrange them in a V shape (like bowling pins), with the point at the lens, and shoot your action past their heads and shoulders.

If you're interviewing people on the street, make your video look more interesting by facing in a different direction for each interview. The various backgrounds will make it look like you shot in different places.

If you're shooting at the company picnic and the boss gives a boring speech, you can grab a bunch of people later and shoot them as if they're watching and reacting—anything from sleeping to holding up protest signs that say "Let My People Golf!"—and cut them into the speech. True? No. Funny? Possibly.

It takes a while to get used to the freedom you really have in video. Things don't have to happen in real time in order to look right when they're cut together. They don't even have to happen in the same month. You can use or not use anything that happens on camera—and your video will be different based on your choices.

Shoot the Details

A WELCOME TO LOS ANGELES sign means one thing if it's surrounded by 50-foot columns of colored lights and something very different if it's hanging over a freeway, completely covered with graffiti.

The sweat on a man's forehead signals one thing if he's an NBA player halfway through the big game and something completely different if he's a stockbroker pitching a lame stock. Are the woman's hands calmly in her lap or nervously picking at each other as she tells her boyfriend she doesn't want to see him tonight?

As our eyes naturally take in information, we notice these details. Consciously or unconsciously, we understand the stories they tell. Whether it's a "feel" for where we are or a "gut reaction" to a person we're dealing with, visual details to guide our thoughts and actions.

We see these details naturally in real life. But to see them in video, someone has to point the camera at them deliberately. And that someone is you.

Adding shots that focus on details makes video richer and more lifelike. You may hear someone refer to this kind of extra detail footage as "B-roll." If you're editing an interview with a basketball player, "B-roll" might be footage of the player shooting free throws, or faces of cheering fans in the stands, or a close-up of his hands shifting the position of the ball.

The term "B-roll" comes from film editing, when you used to need two copies of your footage to do transition effects like dissolves. In video it's come to mean "extra" footage. But it strikes me that the name "B-roll" is a mistake. It implies that you're shooting footage that's not A level, when in fact, it could make your video really pop.

The details tell a story: Sweat on this man's forehead means he's working hard . . .

Good detail shots are like the tiny brushstrokes in an Impressionist painting. They add up to a whole greater than the sum of its parts. The more of these atmospheric details you can show us in your video, the better.

Let's get a little Zen here: Before you shoot, "become" the zoom lens. Use your eyes to take a good close look at your video's hero. What about her is interesting? "Zoom in" with your eyes. Focus on small details. Now what catches your attention? Look closer still. What do you see?

. . . whereas here it may show tension or fear.

Look at the room around you the same way. Look for details that feel right for your story. Look for opposites too—the details of contrast are always interesting. At your daughter's birthday party, what are the very oldest people doing? At the dance, what details can you spot among the eighth graders who *aren't* dancing?

Do this woman's clasped hands reveal anxiety or are they resting calmly on her lap?

God Is in the Details

Pick a place that's part of your daily life. Pull out a video or still camera and stand, sit, or lie where you normally would.

Now look around for details and shoot a quick shot of each one.

For example, I'm typing at my desk and see: A bowl of grape stems from a recent snack. A box for a microphone I keep meaning to return to Radio Shack. The spines of Steven Pressfield's *The War of Art* and Rosamund and Ben Zander's *The Art of Possibility,* which both lean against my 30-inch monitor. A Kleenex box. A stack of notecards for a screenplay I'm working on. A pile of CDs to refile. A highlighter. A spa gift certificate I got for my birthday—three months ago.

What do all these details tell you about me? I'll leave that up to you, but I'm sure it's more than a simple posed shot of my smiling face would.

Use Foreground

I'm in my office, looking out the window at a tree on a brightly lit California afternoon. At first I'm aware only of the blossoms on the tree. But then I realize that there's a lot between me and the tree. Closest to me is a desk return and a printer that intrudes on the window's lower frame line. To the right of the printer, an artist's motion model on a stand. Then comes the window's frame and a screen. Finally, through the screen, I see the tree.

If you look around you now, wherever you are, you'll see that there are different layers of awareness in your field of vision. You may have focused your attention on one main thing, but there are other things you can also see. If you're looking across a busy street at a woman walking down the sidewalk, you may ignore the cars between you and the woman, but they're there. Like the desk and printer between me and the tree, the cars live in the "foreground" of my field of vision.

To make their shots feel more real, movie and TV directors put all kinds of foreground elements in place. Extras cross close

Two ways to shoot blossoms on a tree branch: One way focuses on the blossoms . . .

. . . the other tells us something about the person looking at them.

Dinner and a Movie

The dinner table is a great place to practice shooting for foreground. As you shoot short shots of your dinner companions, let arms reaching for food cross your lens. Don't move the candles or ketchup bottle—shoot past them.

When you play back, notice how much more "real" it looks compared to posed or isolated video.

to camera so you get a hint of a moving body, or the camera floats past a faded photo of a young married couple as it discovers an old man in a wheelchair. Foreground elements can focus your viewer on what you want them to see and give you important information about your shot.

Yet often when we shoot video we move things that are "in the way" so we have a clean view of the person or thing we're shooting. The result feels subtly unnatural, because in real life, there's always foreground stuff. By losing it, we lose an opportunity to convey information and make the picture more interesting.

Give your shots more depth and dimension by adding foreground elements—or at least not avoiding the ones that are naturally there. Frame your shot so that something (or someone) is closer to the lens than your subject. Your foreground element may even be out of focus, which is great! Movies pay cinematographers big bucks to do that.

Foreground elements add space and place to your shots. When you're shooting a video "card" to send your grandmother on Mother's Day, shoot through the frame of the playpen instead of over it. Shoot your kids playing soccer past their friends, instead of waiting until there's nobody around them. Let the person carrying the lit cake pass in front of the camera while you focus on the birthday girl. In an interview, shoot over the shoulder of another person.

Let the camera see the world the way a person does, and your shots will take on much more of a real life.

Check the Background

I saw a video recently of famous comic book artists interviewed at a charity event. They spoke passionately about the charity they were supporting, and I would have been very moved, perhaps even to write a check, except that I couldn't stop staring at the giant event logo that appeared to be growing out of their heads. It was so big and so distracting that all I could think about was how incredible it was that the person shooting hadn't noticed it looming behind his subjects.

We can be so distracted by the glory of what we're trying to shoot that we forget to look at the background at all. Is there a person eating a burger behind your actor, staring at the lens the whole shot? A window mirroring the camera? Does the actor's shadow loom menacingly behind her? Is the background so brightly lit as to be distracting?

The background needs to work with your shot, not against it. Before you shoot, scan the territory—it may keep you from getting a nasty surprise later on.

TRY THIS

Background Check

After you look at your hero, practice scanning the four corners of your shot. If something in the background offends you, change it. Remove distracting background elements to focus the viewer on your hero. If the background is getting more light than it should, can you darken it by turning off a light or closing a curtain? Sometimes just taking the light off a background will make it disappear in your shot.

If you can't change the actual background, a slight camera move may eliminate annoying distractions. Or move your subject *and* yourself so that you're shooting in a completely different direction.

Change the Angle

At a retail in-store appearance in Hollywood, the costumed movie superhero steps out of the limo and walks through the store. Shot from adult height, we see the character shake hands with the store manager and mostly the tops of heads of various children as we pass by. But if we kneel down to kid level, suddenly we're in their world. We see their faces light up as this cartoon-come-to-life walks past, their anguish as they decide whether to approach, and their joy when they finally get a hug from their favorite star.

In this example, a change in filming angle has completely changed the meaning of the video. Camera angle is part of the language of film. Like the accents in a spoken word, changing the angle changes how we perceive the message. We've grown up on film and video and intuitively understand this language. Now it's time to learn how to speak it.

People tend to hold video cameras in the same place all the time: at about chest level if we're using the monitor and (obviously) eye level if we're looking through the viewfinder. Either way, we tend to shoot our subjects straight on. The result is that everything we shoot feels the same as everything else. In the world of motion pictures, monotony is not your friend.

You can break the monotony by imagining that your subject is

surrounded by a transparent sphere. For any shot, you can place the camera anywhere on that sphere—above, below, or around, in front of, or behind the subject. Suddenly you have a world of camera-placement options.

How many options do you have? I'm glad you asked. If we drew latitude and longitude lines on our imaginary sphere representing one-degree increments, there would be 129,600 intersections, and we could put the camera at any one of them and point at our subject.

Now imagine that the sphere gets larger and smaller—we could be on 129,600 places on a sphere 1 foot away from the subject—another 129,600 places 10 feet away, and another 129,600 at every distance in between. And as if that weren't enough choice, at each of these placement points we can point the camera—sometimes a little higher, sometimes lower, or left or right. Each time we move, we change the framing of the subject. One way we see her feet, another we don't, and so on.

So let's see . . . adding that up, you have . . . hmm . . . carry the two . . . oh, yes. Infinity. You have an infinite number of choices in camera angle.

Okay, there are some limits. A tree may be in the way on some angles. You may not have a physical way to get above your subject, or you may not want to get your clothes dirty by lying on the ground. Still, you have at least a gazillion different ways to point the camera. Maybe two gazillion. Which should certainly be enough to prevent a boring, straight-on, meaningless shot.

Imagine a sphere surrounding your subject. You can put the camera anywhere on this sphere—or on other spheres closer or farther away.

TRY THIS

Get Out of Your Comfort Zone

Observe your own shooting style and find the place you usually hold the camera. For your next video, whenever you find yourself coming back to that familiar place, move yourself and the camera.

Make your moves in large increments. Don't just step a little to the right, go behind your subject. Don't lower the camera a little. Lie down on the floor!

When you're comfortable with one shot, move again. Where else on the sphere can you be? Pay attention to how different shots feel. Trust your instincts on whether or not they work, and never be afraid to try something else when they don't.

50 WAYS TO SHOOT ONE THING

For more work on angles, find a cooperative, static subject. A human works best by far, but you could also set up your own still life—a doll, a bowl of fruit, a lamp—something you can move around easily, and that looks interesting to you. Have your victim sit or stand someplace comfortable, doing whatever it is they need to do. Set a watch or cell-phone alarm to time five minutes.

In that time, try to shoot 50 different 3-to-5-second *static* shots of your subject. As you frame them, think about—and change—things like distance, height, framing, angle of the camera (what if you slant it?), detail (what if you shot just one leaf?), foreground elements, and point of view (where would the camera be if you were the subject, or a dog, or a fly, etc.).

This may be hard at first. It helps to remember that there are no "wrong" shots—ignore the "bad" ones and keep going! Your goal in this exercise is to get into the habit of thinking angles and feeling what they mean. In real life you'd find an angle you like and stop and practicing this exercise will make it a whole lot easier.

Here are illustrations of a few of the 50 stills I shot using my daughter as a subject (you can see the rest at www.VideoThatDoesntSuck.com/examples). As you might expect, not every shot is great. But they're all less boring than another straight-on, eye-level shot.

Learn the Rule of Thirds

S hooting people perfectly centered in a frame is dead boring. Why? Who knows. But the "Rule of Thirds" is an ancient principle known to be true by the Greeks and anyone who's studied art since.

Some insight comes from considering how we normally see things. When we swing our heads toward someone talking to us, we don't line them up dead center of your vision. When we move, we scan our surroundings continually, our eyes constantly re-framing the view—rarely symmetrically. We look at few things in life in the dead center of our vision—so few that when we do see something that way, it looks unnaturally staged and dull.

Almost nothing in nature is truly symmetrical. Each half of a human face is subtly different from the other. Animals aren't any more symmetrical than we are. Nor are trees, rocks, rivers, or mountains. What *are* symmetrical? Machined things. Measured things. Man-made things. Things without *life*.

The very symmetry of a man-made thing tells our lizard brain there's no excitement to be found here.

TRY THIS

Don't Be a Middleman

If you're shooting a human, keep their eyes out of the middle square. If you're capturing a big landscape, put the horizon line on one of the top or bottom lines instead of in the middle of the frame. Your shots will look better, even if nobody knows why.

Our shooting instinct is to center everything. Unfortunately it's dull composition.

Imagine your frame divided vertically and horizontally by Rule of Thirds lines.

For generally better-looking video, keep the focus of your image out of the middle box.

No interaction, no danger. Our conscious translation: These things are boring to look at. So too, with symmetrical photos—and with video.

All this is just theory, but whatever the reason why, dead-center, symmetrical shots are boring.

The cure is the "Rule of Thirds." This photographic principle says that if you put the hero of your shot in the left, right, top, or bottom third of the frame, it will be more pleasing to the eye than if you center it. Even though nobody knows exactly why it works, it does.

Here's a frame divided top to bottom and left to right by thirds. The easiest way to think about the Rule of Thirds is that it's the opposite of tic-tac-toe—keep the focus of your shot out of the middle square.

Watch What You're Doing

W hen I direct, my least favorite thing about the entire process is having to watch the dailies. *Dailies* are the raw footage—no editing, color correction, sound effects, or music—that are the product of your day's shoot.

For me, watching dailies feels like a greatest--hits reel of my mistakes. With multiple takes, experiments, and screwups, most of what I'm watching is never going to be in the movie. Even the "good stuff" doesn't look the way it will in the finished film. The blue sky behind a character will later be special-effected into a snowcapped peak—it just looks wrong now. Doors don't make any noise when they slam; the colors are off. Dailies are torture to sit through.

Many people never look at the video they've shot. It just sits on tape or in a file on the hard drive, waiting for some mythical day in the future when they'll sit down and edit it.

If I'm lucky, though, after I finish berating myself for how awful it all looks, I can see some potential. In my mind (or on my computer), I start cutting out the stuff that's bad, and what's left looks (always to my complete surprise) like a finished video.

Many people never look at the video they've shot. It just sits on tape or in a file on the hard drive, waiting for some mythical day in the future when they'll sit down and edit it.

Review Your Work

Start your next video project by watching your last one. For most people, it's probably still sitting on the tape, chip, or hard drive in the video camera, right where they left it.

Scroll back through and look with a critical eye. What do you like? What can you change or improve? Be sure to look at your use of the camera itself—were you shooting the right thing at the right time? And definitely take a few minutes to look at the technical aspects of your lighting and sound. You might even jot some notes.

A quick review will help you remember the things you want to try differently this time.

Yet an experienced director knows two things: First, the only way to find the good stuff is to watch it all and make notes on what you like. And second, watching your work with a critical eye makes you a better director. (There's a third thing: If you don't watch it right away, you may never get to it. I still haven't edited our wedding video—from 1990.)

If at First You Don't Succeed, Chuck It and Try Something Else

Time is your most precious commodity. If you're shooting an event, it's going to end. Your subjects may run out of time or patience. Or the sun may be going down. Whatever the reason, video shoots always involve playing some form of beat-the-clock.

And invariably, you will run into something that doesn't work the way you want it to, no matter how hard or how many times you try. Your coworker can't deliver her line convincingly. Your brother can't land the skateboard right where it would look *so* cool. The dog just won't sit when you tell him to.

When time is your most valuable resource, repeated failure is a clue that something has to change.

Some shots seem so important to you that failure is not an option. Those are the ones that get you in trouble. When time is your most valuable resource, repeated failure is a clue that something has

Brainstorming Through the Lens

Take your camera out for a walk around town. Practice capturing action (hero/noun + verb)—a car drives by, a woman drinks coffee, a bird sings. But instead of just taking one shot of each thing, take at least three, and make big changes in your approach each time. If your first shot was from dead-on, change your angle. If the first was short, what happens if you hold it longer? What if you change your lens from tight to wide and move closer?

Observe the results of your changes: How does the action look different each time? What happens to the background?

Keep shooting past the first three shots, and try to make each shot better than the last. When you're out of ideas for different ways to shoot the same shot, come up with three more. Try talking to your subject . . . moving the camera . . . cutting the action into multiple shots . . . whatever occurs to you. Just decide fast. It doesn't matter how good the shots are, just try them.

Your goal is to create a habit of mental flexibility. When you're shooting, you don't want to wait until exhaustion and frustration force you to change your plan. A little creativity saves a lot of time and anguish.

to change. Good shooting requires walking the line between dogged persistence and mind-blowing flexibility. It's smart to keep a brain full of alternative ideas at all times and know when to use them.

Sometimes random rearrangement changes everything. Give the line to someone else, or move the camera to where the skateboard *is* landing.

Sometimes you can brainstorm your way out of the problem (see "Instant Creativity," page 30). Maybe there's another way to get the prop to work or the timing to slide into place.

I once needed a long, steady moving shot of a couple on a dirt road at sunset. Unfortunately, our dolly (a handcar on a track that the camera rides to keep moves ultrasmooth) was still at our last location. The sun was setting, and it wasn't going to wait.

Just when I thought we were in serious trouble, a grip asked if we could use the car as a stand-in dolly. We let some of the air out of

the tires of an SUV, mounted the camera out the trunk, put the car in neutral, and pushed it slowly along as the actors walked behind us doing their scene. The suspension smoothed out the shot just perfectly.

But sometimes you're just screwed. Then your best course of action is often to give up. If that speech is too long for your coworker to read, stop forcing it: Break the lines up into smaller pieces she *can* read, and cut them together later. If your friend can't drive the car right into the parking space after 10 tries, shoot him driving toward it, then cut to a close-up of him shifting the car into park while someone else rocks it a little with their foot.

Problems always crop up in video. Sometimes the universe seems to conspire to prevent you from getting your shot. Get used to looking the universe in the eye and backing it down with a good idea. And when you can't—give up. The shooting day will be over soon.

Let Luck Work for You

I n the opening scene of *The Godfather,* Mafia don Marlon Brando sits in his study during his daughter's wedding reception, hearing good wishes and requests for favors from the guests. Brando lovingly strokes a cat on his lap as he discusses whether or not he should kill some young men who assaulted one guest's daughter. The contrast between Brando's calm petting of the cat and the realization that he can order two men killed makes Brando's Don Corleone monstrous—and fascinating.

Think of shooting the way you'd think of a cross-country road trip—if you don't pick a destination and plot some kind of course, you're never going to get there. But what fun is a roadtrip without detours?

As *Godfather* geeks know, the cat isn't in the script. (If you haven't seen the movie, you must. Seriously. But only guys over 35 need to be geeks about it.) It was a stray on the soundstage when the scene was being shot. Brando picked it up, director Francis Ford Coppola went with it, and that was the way it went down in film history.

A happy accident. A director who accepted the luck instead of being too locked into his previous thinking about the scene. Brilliant.

There's a line somewhere between rigidly sticking to your vision and making it all up as you go. Think of shooting the way you'd think of a cross-country road trip—if you don't pick a destination

and plot some kind of course, you're never going to get there. But once you've planned a route to California, why not veer off toward Yellowstone on the way? You can rejoin the route a little later, having had a much better time.

It's the same with video. Trying to shoot a company meeting without a plan may cause you to miss *everything*. You'll be switching rooms when you should be shooting, you'll miss the big speeches, and you'll be at the wrong party later. If you have a shooting plan, you'll know exactly what you'll miss when the guest speaker suddenly becomes available for an interview, and you can make an intelligent decision about where it will take your video.

TRY THIS

Find Your Balance

There are two kinds of people in the world: people who like to wing it and people who live to plan.

Figure out which one you are and practice doing the opposite when you shoot. If you're an improviser, practice planning and *then* improvise around your plan. If you're inclined to be rigid, practice letting the opportunities come to you. Doing what doesn't come naturally will help you find the balance that makes luck your new best friend.

Dial Up the Dialogue

Good sound starts with well-recorded dialogue. Adding even the best music won't help your video if the audience can't understand the words you captured when you were shooting.

Your video camera's built-in microphone picks up everything between it and your subject. The farther your microphone is from the subject, the more extraneous noise fills the gap and the farther away you *sound*. The worse the noise between you, the bigger the problem.

If you're interviewing a guest at a wedding from five feet away, it's easy to adjust your zoom lens so that she's perfectly framed and looks terrific, but there's no such thing as a zoom mic. Mics don't focus the way lenses do. Five feet of space at a noisy wedding reception will fill the soundtrack with loud crowd chatter. Your subject will look very close but sound very far away. That disconnect makes the interview hard to watch.

The first rule of using your in-camera microphone is: sometimes you can't.

Worse, your camera probably has an "automatic gain control." That's a circuit that adjusts the incoming volume from the mic so that it's recorded at a strong, constant level. Unfortunately, it can't

tell crowd noise from your interview subject. The more noise it hears, the more noise it boosts, further burying the sound you wanted.

You've probably seen videos where the person talking sounds as if they're in a tin can. The echo makes the subject almost impossible to understand. Most rooms have some kind of echo, but our stereo ears and smart brain adjust for them in seconds (analogous to the way our eyes adjust to bright light). Unfortunately, a mic can't adjust. The automatic gain control piles on and the echoes are boosted and combined with the voice to make a hollow, muffled sound.

The first rule of using your in-camera microphone is: sometimes you can't. If you're in a super-quiet environment and very close to your subject, it may be just fine. Don't use it in any place with noise or less-than-perfect acoustics or if you're not within a couple of feet of the person you're shooting.

> **TRY THIS**
>
> ## Get Mic Smart
>
> Monitor your sound the way you do your picture. Take a set of headphones and plug them into your camera's audio jack so you can listen to what the camera's recording while you shoot.
>
> Use an external mic to get good sound. If you're in a very noisy or echoey space, move somewhere else. And if you're stuck with just your built-in mic, stay very, very close to anyone you want to hear well.

Instead, use a *lavalier mic* for one-on-one interviews. Lavs are the little microphones that clip on to someone's shirt and (with a wire or wirelessly) plug into your camera's audio input.

If you have more than one subject and they're reasonably close together, mic them using a *boom mic*. Boom mics hang off a pole that the operator tilts in the direction of whoever's talking. You'll need an assistant to help. If you have more than two people talking and you want to get fancy, you can run more than one lavalier or boom mic through a mixing board into your camera.

Many people think shotgun mics "focus" on a smaller area of sound. The people who sell them would like you to think that you

can pick up perfectly clear conversations from across a football field. Unfortunately, shotgun mics still pick up ambient noise. They may give you a cleaner sound than your built-in mic from far away (good ones pick up a little less noise from behind and to the sides of the mic), but you're still far away, and it will sound like it. Better to be closer, and get your mic closer too.

MAKE SOUND DECISIONS

Video is about picture. That's because for humans, life is about pictures.

We rely more heavily on visual cues to navigate the world than on any other sense, including audio. My friend Jay Rose, a sound editor and author of *Audio Postproduction for Film and Video,* will hate me for saying this (and as a former radio DJ, I hate myself just a little), but video trumps sound every time.

In truth, Jay won't hate hearing me say it—he knows it. As does every sound person who's ever been on a set or in the mixing studio. Sound always plays second fiddle to video. Given the choice between shooting the picture right and getting good sound, directors always choose picture.

But (you knew there was a "but," didn't you?), we live in an era where flat-screen TVs come with great stereo speakers built in—if they're not hooked up to an even bigger home-theater sound system. Most laptops come with good built-in speakers or get plugged into an external system like the one I'm listening to right now. And iPods and their ilk come with high-quality headsets that put your audio mix inside the viewer's head.

That's why smart producers spend a lot of effort on sound. They know that great sound pulls viewers into your video. Bad sound pushes them away.

Use Multiple Cameras

I f you're shooting something that you have no control over, is incredibly important, and can happen only once, it's time to look into shooting with multiple cameras. Having two cameras shooting a building demolition simultaneously doubles your chances of catching the perfect moment as the building implodes. Or it gives you two angles on the president's speech to cut between, making your finished video that much more professional.

Sending two (or more) people to cover a hip-hop concert gives you twice the footage, twice the interviews, and scores of little details and points of view you wouldn't get otherwise.

You don't need a big crew to make this work—just two people and a camera for each. But there are a few things to keep in mind:

White Balance: When my wife and I wanted to paint our living room ceiling white, we learned that paint manufacturers crank out hundreds of different "whites." We took home swatches of eggshell white, Navajo white, off-white, medium white, putty, and 50 others to choose from.

> **Having two cameras shooting a building demolition simultaneously doubles your chances of catching the perfect moment as the building implodes.**

If you had seen a wall painted with just one of these colors, you would have called it white. But if you looked at the swatches next to one another, you could see that they weren't all pure white—some were bluish, some had a pink-red or pink-orange tone. Some were vaguely green. Only one of them (insisted my graphic designer wife) would correctly match our wall color. It took a week to figure out which white was right.

Your video camera has to make the same choice, and it normally does so automatically, without you having to do a thing. It sees a large patch of brightly lit surface and calls it white. Then it adjusts the rest of the colors in the frame to match. Sometimes the frame is a little bit orange, sometimes a little bit blue. Not so much that you'd notice if all you were watching was video from the one camera.

But if you cut it together with footage from a different camera—one whose automatic white balance control chose a different patch of light to set itself to, you have a problem. You don't want the guy who looks a little blue from one angle to look a little orange when you cut to the other camera.

To solve the problem, see if your camera has a switch for AWB (automatic white balance control). If it does, turn it off. Then point both cameras at the same lit white surface and press the manual white balance button. Now both cameras are calling the same color white, and your footage should match.

If there's no manual white balance switch? It will help to use two of the same exact kind of camera—odds are better that

TRY THIS

Do a Test Run

Assemble your team and equipment for a test run a few days before you shoot. If you can, try to meet where you're actually shooting so you can get the lay of the land.

Your first goal in this meeting is to talk about the technical aspects of the shoot: where the shooters will stand so they don't get in each other's way, and how you're going to get sound to both cameras. Will you be miking your subjects? Which camera will the mic plug into?

Once you have that out of the way, shoot some test footage according to the plan. Now you'll have a few days to see if it all worked and make corrections before you go live.

they'll see things the same way. Fancier editing software lets you do some color correction if you can't get them to match perfectly.

Sync Sound: If you're recording the same event from multiple angles—say an interview where one camera is close and one farther back—you can run into sound problems. You'll want to be able to cut between the pictures, but you don't want your interviewee to suddenly sound far away . . . then close . . . then far away again.

That movie-clapper thing is called a *slate* and is used to sync sound.

To solve this problem, make one camera the "master sound" camera. Make sure your subject is well miked and sounding great, then sync the two cameras just like they did it in the olden days of Hollywood—with a slate.

The slate is that blackboard with the white-striped top that they clap in front of the camera in the movies. Movie cameras don't record sound—on the set, sound is always recorded separately, then synced back to the picture. (We still do it today even with high-end HD video cameras. They record only two tracks and we'll usually need more on a film set.) The sharp noise of the clapper allows the sound editor to sync the *Clap* with the frame of film in which the clapper visibly closes, thus making everything that follows in perfect sync.

You can do the same thing with a slate—or with your hands if you don't have one. Point both cameras at someone's hands. Roll both cameras, and have the owner of the hands make a sharp *clap* in front of the lens. When you edit, line up the clap sounds with the moment the hands come together in the picture, and all your tracks will be in sync. (You have to do this every time the cameras start rolling. When they stop, they're no longer in sync.)

When to Wrap

I t's fun to shoot, and every director gets carried away sometimes. But a good director knows that overshooting costs money (or time, or favors) that shouldn't be wasted. And he knows that too much extra footage makes editing more difficult.

Finally, a director knows that the ability to say "This is exactly what I want. Let's stop" is the essence of all artistic judgment.

Embrace it. It's what makes your video yours.

TRY THIS

Wrap Checklist

Stop shooting and think through this director's checklist when the end of the day approaches:

☐ *What shots don't I have that I will fail without?*

☐ *Are there shots that will* really *improve if I keep shooting?*

☐ *How much more time do I honestly need?*

☐ *What are the costs of shooting more?* (Think not just about monetary costs—there may not be any—but also the human-relations costs.)

Special Projects and How to Shoot Them

What's the truth about viral videos? How do I shoot a stunt? What about a marketing video? A how-to? An interview? This section is for the special cases—common video genres that present their own unique challenges.

Whether you want to shoot a great music video or keep your vacation shots from putting the neighbors to sleep, this section gives you ideas to help navigate those challenges.

How to Shoot the Cutest Kids on Earth

W e're talking, of course, about your children. The ones you dress up and take out to fancy—"Oh, God, NO! Not in your good clothes!" "Don't make me come back there!" "Stop hitting your sister!" Um, where was I?

Let's assume that you want to record moments with the children not only to share with their elders now but to remember fondly later. Here are some things to keep in mind as you shoot:

You'll get a lot more entertainment value out of Johnny pouring his oatmeal over Sheila's head than you will of the two of them sitting nicely and eating.

The action is in their faces: This is generally true in all video (see "Don't Shoot Until You See the Whites of Their Eyes," page 109), but more so with kid videos. You need to see their eyes to really read their reactions. Their faces change rapidly over time too. Good face shots let you see how they grow. Stay close.

Shoot them short: Sharing videos of your children is not unlike sharing videos of your vacation. They're amusing enough if you keep them short and something interesting happens. The less interesting the video is, the shorter it should be. If nothing happens at all, it should be

a photograph. Assume for the sanity of your audience that your children's mere adorableness is not, in and of itself, entertaining.

Edit them short: You don't need to be an editing pro. Use your camera's built-in software or a simple free editing program on your computer to cut the boring parts before you send your video out to relatives. They'll love you for it.

Misbehavior is more entertaining than good behavior.

Misbehavior is more fun to watch than good behavior: Nobody wants to watch a video about nice kids doing nice things nicely. That includes you 10 years from now. Don't believe me? Which family story are you more likely to tell—the one about the time you all sat down to dinner and it was perfectly cooked and everyone was polite, or the one where somebody told a joke at the table and your sister laughed so hard milk came out her nose?

You'll get a lot more entertainment value out of Johnny pouring his oatmeal over Sheila's head than you will of the two of them sitting nicely and eating. Did they dip their hands in paint and put prints all over the living room wall? Grab the video camera first, yell later. When it's time to compile the wedding video, you'll be glad you did.

Ask questions: An on-camera interview with your five-year-old about the wedding/his grandparents/the new baby/his first day of school will almost always be fascinating.

Your child is more interesting than their accomplishments: Kaya may or may not hit in her first T-ball game. If your video efforts focus on capturing a moment that may not come, you'll miss the environment, the interaction with her friends, her emotions as she comes up to bat.

It helps to think about the story. The story isn't "Matthew played his recital piece perfectly." The story is "Matthew played in his first cello recital." The former is about his musicianship. Not only is that inherently dull video, the musicianship of an eight-year-old just isn't that interesting even when the notes are right. How Matthew approached his performance—his practice, the rehearsal beforehand, his teacher announcing his name as he looks lost and nervous—is the story, and that's what will lead you to an emotional and memorable video.

You represent your children: You're shooting for them too—your six-year-old can't make her own videos. Spend a little time on friends' faces, a wide shot of the classroom, the coach—things your child, and your child's children, will be thrilled to see later.

End Boring Vacation Videos

During dinner at a fancy sushi restaurant, a business acquaintance pulled out his laptop to show the whole table videos of his recent photo safari to Africa. Twenty minutes of shots of the butts of various cheetahs, apes, and elephants as they ran away from the camera. My suggestion that stills from the video would make a cool coffee-table book called *Asses of Animals* was not well received.

Vacation videos, like the dreaded vacation slide shows from the Ektachrome era of yore, are torture to sit through. Luckily, it's a snap to make them better . . . and with work, they can be great. Next time you're on holiday do this:

Keep your shots short: If you do nothing else, pledge to keep your shots under 10 seconds long. You'll have dramatically more interesting vacation video with no extra effort.

You should also consider your vacation-to-shooting ratio. If you're sightseeing 10 hours on a typical vacation day and you shoot two 10-second shots every hour, you'll shoot 200 seconds a day. That's almost three and a half minutes of video per day, which is plenty.

If you like to edit, you can always shoot more and cut your way down to three minutes a day. But if you're as lazy as I am, you'll find it's much easier to roll the camera a couple times an hour, max. The video is edited in-camera and ready to show!

Set the video to music: You don't need to edit the video *to* the music (although you can!)—just lay the music on later. A good song that captures the mood will play off the video in unexpected ways. It will also keep it moving (see "Score It," page 222).

People are more interesting than scenery: If you're shooting HD and you're going to play the video back on a 60-inch HD monitor, your beautiful shot of the Adirondack Mountains across a beautiful lake will have the impact you want. If you're sending links to your video on YouTube, it won't.

Remember that you're documenting for your own future pleasure. The people you're with will be more important in 10 years than a tree. If you're at Niagara Falls, shooting the family on the *Maid of the Mist* is probably all the Falls shots you need. A faraway view of a river that drops off into nowhere won't add a thing. Shoot the people doing things unique to the place, and you'll get a true flavor of the place too.

Vacation videos, like the dreaded vacation slideshows from the Ektachrome era of yore, are torture to sit through. Luckily, it's a snap to make them better.

Adding a story kicks your video to the next level: You can decide the story in advance and hang all your shooting on the theme. What's the biggest, most interesting facet of your trip?

"Sarah's first plane flight" is a great hook for a vacation video. You can interview four-year-old Sarah every step of the way. "The Johnson family leaves the U.S. behind" could start with the day mom surprised the family with airline tickets, and include filling

out the passport forms, the flight attendants' funny accents, and the moment the family first stood on foreign soil. "Jeremy hunts for Mickey Mouse" might be about a very confident eight-year-old and his approach/avoidance reaction to stalking his favorite Disney star through the Magic Kingdom. Much nicer than the usual Disney dullness.

Each day of your trip could have a different story. Each *hour* of your trip could have a different story! Anything more coherent than "Here's another shot of a building" will help you make vacation videos people will actually want to watch.

Weddings, Graduations, and Other Ceremonies

S ince most rituals, by definition, follow a prescribed format, the key word for this section is "anticipation." By thinking ahead, where can you be for the best possible shots? And once the ritual is over, what will you shoot next?

It's worth spending the mental energy brainstorming the touch-points of the ritual in advance. This can serve as a shot list for the video. Let's use the wedding as an example. Brainstorming, based on weddings I've attended, I can guess we're likely to see:

- The guests arrive
- The bride and her attendants dressing (or emerging from the dressing room, if you don't have that kind of access)
- The groom arriving
- Relatives taking their seats in the church or synagogue or park or hall
- The groomsmen lining up
- An adorable ring bearer and/or flower girls
- The bridal party entering

- The bride entering and walking down the aisle
- The bride and groom meeting at the altar
- The official in charge saying words
- The vows
- Kissing
- Recessional

Later, we might see:

- The bridal/groom's party posing for pictures
- Relatives posing for pictures
- Heavy drinking
- The married couple arriving at the reception
- More drinking
- Food
- Guests sitting or standing in groups and talking (opportunity for interviews)
- The band or DJ starting to play, and the first dance with the bride and her dad
- Toasts and embarrassing facts about the bride/groom
- Throwing the bouquet and (possibly) a garter
- Cutting the cake
- The adorable ring bearer and/or flower girls falling asleep
- The bride and groom leaving in a limo or embarrassingly decorated vehicle

Rituals tend to follow the same beats in the same order.

Anticipating the beats lets you get the shot you want.

That way you'll never miss the money shot.

Once you have a brainstormed list, it may be possible to check in with the happy couple and see which of these things they are, in fact, doing, and which you don't have to worry about. You can also ask them which parts they especially want you to capture. If you can, scout your location. Try to stick your head in the church before the wedding begins. Do the same for the reception hall. Information is your friend—whatever you can learn will help your shots.

Now that you have a list of events, pick a few that you want to get ahead of and plan.

Where's your best place to be for the "walking up the aisle" shots? Where are the toasts going to be held? If the guests walk en masse from the ceremony to the reception, can you get ahead of them so we can see their faces? Where is the bride's dressing room, anyway?

Since most rituals, by definition, follow a prescribed format, the key word for this section is "anticipation."

Whatever the ritual, don't forget the backgrounds. The altar in a church, the huge crowd of graduates behind your daughter as she gets her diploma—these are things you and the participants will want to remember. Look for backgrounds with meanings for this ritual. Do your interviews in front of the synagogue, using it as background, instead of in anonymous chairs in the reception hall.

A couple of other important event production notes:

The Hero: Usually the guest of honor is the hero of the ritual video. The graduate, the newly decorated officer, the bride. If the hero of your wedding video is the mother of the groom, an insanely entertaining character who never thought her son would marry *anyone*, you'll need a different shooting plan.

Sound: Receptions get loud and there's a lot of distraction. If you want to interview people, you'll need to find a quiet(er) place very close by that still looks like part of the event. Even then, the camera mic or a boom may get overwhelmed by the noise. Carry a lavalier (clip-on mic) and plug people in for their interviews.

Light: Don't shoot in the dark. If this is a pro gig, bring a couple of small, soft lights. If you're a guest who wants a great video, use the light on your camera (which you may not have . . . but you also may have and not know it! It took me a month to realize I had one on my last home video camera—this is a great excuse to play with your equipment or even read the instruction manual).

Interviews: If you're editing your video later, you can make it a lot more interesting by intercutting interviews with the participants. The guest(s) of honor will have a lot to say about how they got there, who they'd like to thank, and what happens to them next. Guests will have a lot to say about the honorees. You can use interviews off-camera too, allowing them to "narrate" the event in voice-over.

If you're not editing, interviews are tough to keep short and interesting on the fly. People ramble, interrupt each other, and give so-so answers, none of which you really want in your video. Sometimes asking interviewees the question the first time off-camera can keep things tight—sometimes not.

Shooting a Great Music Video

M usic videos allow you to be at your most creative—or your most disorganized. The easiest way to think about shooting a music video is—Hip Hollywood Lingo Alert— in layers of coverage. *Coverage* is literally how you cover (shoot) the action in the video. You have a lot of coverage if you did every action six times and shot it from six different angles each time, and not much coverage if you did only one take. You can also use *cover* as a verb, as in "I covered her [filmed her] singing the song from beginning to end."

If you cover the entire song all the way through in several different ways, you can then edit between these layers to create a montage in the finished piece.

For example, you might cover the entire song:

As a "live" performance: The band performs before a live audience or on a set.

As a performance in odd places: The artist sings and/or plays, but instead of being on stage, she emerges from an egg-shaped pod in a steam bath. Or something.

As the story of the song: You create a story based on the lyrics of the

song. The story has a hero (who may be a band member), a beginning, middle, and end.

As a series of images inspired by the song: You're not shooting the literal story of the song but rather linking images or stories suggested by it.

You can also create layers of animated animals, singing babies, dancing politicians, nuns singing on other planets, or whatever your imagination suggests. The key is to shoot good coverage of each.

Each layer should be shot to live playback of the song on set—the same version you'll be using as the soundtrack of your video. That keeps your performers moving on the beat, and singing the right words at the right times. Plus there's nothing like playing a great song really loudly to rev people up.

When you play the song on the set, your video camera picks up the song on its mic. If all the video has the identical audio track recorded on it, it's easy to find where you are in the music as you edit. Syncing the video to the final audio track will be easy.

Special note about shooting music videos: Inexperienced video performers often try to lip-sync to the reference track without actually singing. I'm not sure why. Maybe it's embarrassing to be singing when you're the only one on the set doing it and the mics aren't really hooked up. But it's a big problem.

Faces and throat muscles move differently when they're producing sound. People who try to lip-sync without actually singing look subtly wrong. The same is true if musicians don't really play their instruments with the usual intensity.

The solution? Have a great sound system on the set and BLAST the video's music track (the exact same one you'll cut to later, right?). That not only gives everyone cover enough to get into it without

feeling self-conscious, but it will also be picked up easily by the camera mics.

Here's how it all goes together:

Suppose one layer of the video is the band's "live performance." To create it, you shoot the band doing the song all the way through from each of several different points of view. You might focus on the lead singer from several different angles so you can cut between them. You could also do a run-through focusing on each of the different players.

People who try to lip-sync without actually singing look subtly wrong.

For another layer, you shoot the lead singer dancing down Park Avenue as she sings. You can shoot the entire song or just a portion of it this way.

And finally, another layer might be a separate storyline you've created that "feels like" the song to you—the lead singer walks through her life trying harder and harder to interact with the people she meets, but everyone behaves as if she's invisible, until a five-year-old girl finally can see her (kind of angst-ridden, but so are most music videos, right?).

In the edit room, you can jump between layers, all of which sync to your prerecorded track. Maybe you establish the story, then cut away to different music performances whenever it feels right. As the song goes on, you can return to the story or choose whichever performance image from another layer works best.

Setting this up may seem a bit mechanical, but once you have all of these great looks, you can edit together a video that's very different and very artful.

College and Job Application Videos

As both a hirer of employees and a regular off-campus interviewer for my alma mater, I can tell you that there is nothing duller than the same old cover letter, the same old story of how hard you work, and the same old story of how you went to Africa and built huts for a summer. Yawn.

What gets our attention? Interesting topics, presented in unique ways. Like the woman who applied to Tufts by videotaping dances she choreographed for her favorite math functions (check it out at www.VideoThatDoesntSuck.com/examples. It was both odd and funny. The kid who videotaped himself unicycling while playing the ukulele got into the college of his choice, I'm guessing in part because he set the video to a musical composition performed (very well—but with no ukulele) by his band.

When only 6 percent of the applicants to colleges that accept video applications use them, just making one helps differentiate you. As the trend catches on and more and more applicants submit videos, that advantage will vanish. To avoid becoming part of the crowd, you need to make your video into something really interesting and effective.

We would like to believe that no matter how rough the video is that we send in, we will be judged on its content and our smiling faces, not by the production quality. We would *like* to believe it, but it's not true. A badly made video gives as much of a negative impression of you as a poorly typed résumé and a cover letter with the boss's name spelled wrong. The medium is the message.

The same rule that applies to all video goes double for application videos: better to have no video than bad video. What you don't send can't hurt you.

To make sure you're doing no harm, ask yourself:

1. Do you feel confident about expressing yourself in video?
2. Do you have something to say that is better said with a video than with an essay, or a collage, or painted on the side of a building?

If the answer to both questions is yes, read on:

Differentiation makes you stand out: The job of any application is to differentiate you from the other applications. The video you send works for you only if it makes you stand out. In a good way.

Your video shouldn't duplicate your résumé or application—you've already got that covered with the written version. The video should be the icing on the cake.

In fact, a great application video doesn't have to be about you at all. It could be about an interest or a passion you have. It could be about a hobby, a research project, a cause, or a person you admire. Brilliantly made, your video could just show off your ability to tell a story in video—no small talent.

> **We would like to believe that no matter how rough the video is that we send in, we will be judged on its content and our smiling faces, not by the production quality. But it's not true.**

Highlight what you do well: As the great philosopher ALF (a space alien puppet who had his own prime-time series in the 1990s) once said, "The secret to life is to find out what you don't do well—and then don't do it."

If you don't feel comfortable talking to the camera, don't. You don't have to star in your application video. You could narrate it off-screen, you could interview others about you, you could use words and graphics interspersed throughout to represent your thoughts. Work to your strengths. Do only what you *do* do well on camera.

Humor will help you if you can pull it off. If you're a boss looking at hundreds of lousy applicants or an admissions officer looking at thousands, you're tired. You're bored. You're craving entertainment. A good laugh will make your day.

Remember the Hippocratic oath: The (I'm sure charming and talented but overweight) young woman who spent a fair part of her college application video in a bikini needs to rethink both her medium and her message. Had her video been about the role of appearance in society, or how she lost 200 pounds, or about how natural her limb reattachment surgery made her look, she might have gotten away with the outfit. Instead, she talked about her academic qualifications as if she were fully dressed. The result set a very odd tone for an application video.

First, do no harm.

How to Shoot Interviews and Testimonials

Interviews are staples of business video. You see them in corporate information pieces, sales videos, and commercials. Great interviews work as stand-alone videos, or they can be the heart of something more involved. Your interview with the head of R&D could show her on camera answering questions. Or her answers could serve as a voice-over for a more complex piece that includes shots of the department at work, the product in use in the field, and interviews with others.

I'd argue that interviews are seriously *under* used in home video. We often forget how interesting our kids are when they're answering questions, capturing forever their brains at age eight. Interviews can set the tone for events like college graduation, or capture stories that might otherwise be lost when the person who tells them best is no longer around. And they can be funny, especially at gatherings involving beer.

Hearing what people think of the wedding dress or reunion adds "dimension" to the other footage that you'll replay for years. People love nothing more than looking at other people.

A few ideas to make your interviews great:

Prepare: Your job is to pull information out of your interviewees, in their own words. What do you want them to say? You may already know most of what you're going to hear, but your video won't be very good if you're the one doing the talking. Whether you're interviewing someone in your company or a stranger on the street, do your homework before your interview. Who are you talking to and what will you ask them?

Casting is key: The more selective you can be about whom you interview, the better. If you're assigned the talent, you have no choice. If you're not, try to choose the people who interest you and (as diplomatically as possible) let the others go.

Make the talent comfortable: Are they sitting or standing in a relaxed position? Do they know it's okay to use their hands? For commercials, I tell people that I'm going to be talking to them for 10 minutes but will use only three seconds of what they say—and I don't know which three seconds until I edit. So I'm not going to worry about what they say, and they don't have to either—we're just having a conversation and we'll figure out what to use later.

> **Interviews are seriously underused in home video. They can set the tone for events like college graduation, or capture stories that might otherwise be lost.**

Another great way to relax people is to start the interview slowly. Bytes are cheap. Waste some memory card space while you make small talk to help them relax into the conversation.

Relax yourself: Let your interviewee set the pace. Slow talkers shut right up if you pepper them with too many questions. Human chipmunks will be bored if you don't keep up the pace. Take a few deep breaths and go with the subject's flow.

Make it a real conversation: In an interview for a Web series on diabetes, a very together, self-assured older woman answered a question about using insulin with an aside that it was easier for her to control her blood sugar since she gave up alcohol. Curious, I asked her just how much she used to drink. "Eight or nine beers a day" was the surprising answer, which led to a great interview about how her alcoholism had almost killed her. If I hadn't been listening, I would have missed it.

In a normal conversation, you respond to what the other person says. A good interview works exactly the same way. Listen well, and allow your natural curiosity to guide your questions even if (especially if) it leads to something you weren't planning on asking.

Think of your job as the "provocateur of reality"—the best interview moments are real and emotional. Don't be afraid to ask a question that makes your subject laugh, cry, or argue. When I think I can get an emotional rise out of someone, I really like using the "some people" ruse—as in asking a tattooed Harley rider, "Some people might consider anyone in a motorcycle gang a scummy low-life. At best. What would you say to that?" I still have all my teeth, and the guy's response was great video.

Eyes and eyelines: You need to develop a conversational trust with your interviewee. One great way to do it is by making strong eye contact. Have the subject look at you, not the camera, so you can talk.

The *eyeline* refers to where a person on camera is perceived to be looking. In an interview, you don't want your subject looking way off to one side so that only her profile is visible; better to have her looking right at or just off camera. If you've established good eye contact, that means your face needs to be right next to the lens—easy to do if it's on a tripod or shoulder mount.

Put your face right where you want your subject to look and make good eye contact.

Once you've set a position, use the viewfinder and see what it looks like when the subject looks at you. Is it natural? If you don't like it, move yourself and your camera until the subject looks good.

Some people can answer questions right into the lens, which makes viewers feel like they're looking right at them. Kind of cool in some videos—if they can really pull it off. Most people are more comfortable with eye contact, so they'll be looking at you, not the camera.

Are you a character in the video? Will your face or voice appear on camera? If you're Stephen Colbert or Michael Moore, the viewer expects to see you in the finished piece. If you're not, it's up to you. If you are in the piece, be sure to mic yourself well.

Sound: Lavelier mics or booms. Always. Unless you're a foot from your subject, don't rely on your camera's microphone. Any sense of intimacy will be destroyed by distance and echo in the voice track.

Think about your location: Last but not least, check your background. You're going to be looking at it for a while. Make sure you like it.

I watched a interview on a friend's website recently. He's the CEO of a consulting company that caters to high-end media companies. He's brilliant, so what he said was excellent. But the videographer sat him in front of a blank off-white office wall. Not a limbo background (see "Limbo Down," page 127), which would have been hip, but an ordinary painted wall. The white paint picked up and amplified the white in his hair, and the diffuse shadows on the wall made the video feel impoverished somehow.

Backgrounds add information to all videos, but unfortunately this one communicated "old" and "cheap." Worse, it missed an opportunity to tell me something good about him. Location gives us context. A media consultant could be in front of a wall of video

monitors, in a newsroom, or at a podium with great PowerPoint video running behind him. He could be in front of the Museum of Television and Radio or casually addressing us from his beautiful office or home library.

An interview with anyone against a blank wall is just a waste of an opportunity to communicate something important about your subject. An interview against the *wrong* background is an accidental miscommunication. Think carefully about where you shoot your interview and make sure you like it. You're going to be looking at it for a while.

Webcam Rants

There's nothing more naked than a webcam rant. It's just you and your audience, mano a mano. Because it's just you and the computer, you may forget that you are making a video, but all the rules of video still apply. Even more so, because this time, it's personal.

A few of the key concepts to remember to make your rant more watchable:

You're the star: Treat yourself like one. Think about yourself, or your character, if you're playing one. What should you wear? How do you want to brush your hair? Makeup or not?

> There's nothing more naked than a webcam rant. It's just you and your audience, mano a mano.

Check your lighting too. Bringing in a table lamp makes a big difference. Look at yourself on screen as you light. Avoid sharp shadows and overly harsh light, unless that's a look you're going for. If your light is too harsh, try pointing it at a wall in front of you or off to one side. The light will reflect off it and back on to you, often in a much nicer and softer way.

Get a mic: Your distance from the crappy mic in your computer makes a big difference in sound quality. If you move your head too far, your

voice will change. If there's any room noise, like a computer fan, we'll hear it. If the room echoes, so will you. A plug-in clip-on mic is a must if you're planning a career as a regular vlogger.

Look at the camera, not the screen: If you do, the audience will perceive you looking right at them. Hopefully you've rehearsed enough to do the rant without a script. If you have to have one, move the script window, printed in BIG letters, up to the camera so it looks like you're looking at the camera. And us.

Think of the background as your set: Where you are tells your audience a lot about you. Someone sitting in a cubicle is a very different character than someone whispering in her bathroom. In addition to choosing your location, you can dress it. Is there anything you want to add or take out? Move your computer to find the best background available.

You can edit a webcam rant: And please do. When you're finished shooting, open your movie in a simple editing program. Cut out everything that doesn't work.

You'll find that jump cuts between lines can help punctuate what you're saying. You can move closer to the screen or farther away, or shift left or right, or turn the computer camera to another background between cuts to make things more interesting. Experiment—but absolutely, positively cut out the long pauses, the mispronunciations (unless it's part of your character), and other screwups.

But don't trash them! Keep the screwups in another file—audiences love blooper reels.

Planned Stunts

X

Two angles ensure
better stunt coverage.

The incredible run through the half-pipe, "punking" a friend, the daring motorcycle leap over 43 buses, tripping a dominoes run that took a week to assemble—all these and more are planned stunts.

Whether it's an argument in a reality show or a meticulously planned explosion masterpiece in the movies, stunts are hard to do. By their nature, you aren't sure how well, or even if, they'll work on camera.

As a general rule, the riskier a stunt, the more planning will help you get it right. It's not that tough to run a friend through the half-pipe again, but you may not have the budget to blow up that second BMW, and it's impossible to punk somebody the same way twice.

Here are some ways to turn stunts into great video:

Use more than one camera: Stunts have a way of going wrong. Shooting with more than one camera increases the odds that even when they do, you'll be able to catch the action. If you have two cameras, keep one closer and one farther away, and you'll be able to cut between them.

Camera 1 shoots wide for the big picture.

Camera 2 goes tight for the details.

Make one camera a high-speed camera: There's nothing cooler than a stunt played in slow motion. Slowing down a normally recorded video on the computer looks grainy and blurry. The best way to do slow motion is with a camera that records at high speeds. That's not a typo. Set the camera to record at high speed—a higher frame rate per second than normal. When the video plays back at a slower (and normal) 24 or 30 frames per second, voilà—slow motion. You need a reasonably high-end video camera to do real high-speed video. The 60FPS setting on some cameras gets you partway there. Other cameras can record at an even higher frame rate.

Rehearse what you can rehearse: You may not be able to rehearse the whole stunt, but you can walk through what might happen with stand-ins. Rehearsing your camerapeople increases your chances of success. As an exercise, brainstorm a list of things that can go wrong, then consider how you're going to shoot in each case. Disasters, well filmed, can be every bit as entertaining as successes. Sometimes more so.

Check your lighting: If people move in ways you don't expect, will you still be able to see them, or will they be lost in the shadows? Make sure you're lit.

Shooting a Scripted Video

I f you've gone to all the trouble of writing a script for a video sketch or short film, casting it, finding a location, and putting together a team to help you shoot it, you're ready to try shooting it the way the pros do.

Most of the movies, TV shows, and videos you've seen in your life are shot "single-camera." Even though the finished product appears to cut from one angle to another within a scene, what you're actually seeing is an edited montage of several different takes, shot by the same single camera from a different place each take.

The reason most production is done this way: We don't want to see a camera in the scene. If you had three cameras working at once, they'd have a tough time keeping out of one another's line of sight in a car chase.

Film and TV actors and crews are trained to repeat the same scenes over and over. They keep the scenes technically simi-lar, using the same lighting, props, and movement, but the acting varies, intentionally, from take to take. That gives the director maximum choice when he edits the pieces together later to make a seamless whole.

Shoot your scripts like movies. Start wide.

Repeat the scene closer for more detail.

Then go in tight for more emotion.

Experiment with this technique by shooting your scenes twice, from two different angles, and cutting them together.

Multiple takes give you one last chance to rewrite your script—in the edit room. If your lead actor paused too long before delivering the punch line, you can now shorten the pause by cutting to him sooner. If an actor was great in Take 1 but everyone else was better in Take 4, you can mix the performances together knowing the audience will be none the wiser. You can change how the actors respond to each other and even change the script by cutting lines or moving them around.

Here are the steps to shooting a multi-take, scripted scene:

1. Rehearse the scene with your actors. Look through the camera to find your best camera angles while they run through it. (You can even record the rehearsals, in case they're really good.) Once you've got the scene looking the way you want it:

2. Do your first take with a wide shot that includes most or all of the actors.

3. Next, shoot a "medium" take or two. They should key on one actor at a time—starting with the scene's hero—but they may be framed to include more than one actor.

4. Run the scene a few more times, shooting a close-up of one of the key actors each time. By this point, you and your camera are probably standing in the middle of the acting area. Have the actors you're not shooting keep their movements as close as possible to the rehearsed version of the scene. That way the actor you are shooting will look natural.

Armed with these various takes of your scene, you can now edit it to perfection.

Geek note about exceptions to single-camera shooting: Directors sometimes use more than one camera when actors aren't able to repeat takes, as in reality shows, or scenes with young children and/or animals. Choreography to keep the cameras out of one another's way is carefully blocked out and rehearsed.

Expensive one-shot events also call for multiple cameras. If you're crashing a real train and you have only one to wreck, you'll want multiple cameras running to capture every crunch of metal from every angle. The cameras are carefully hidden behind things or even buried underground so they can't be seen by the other cameras.

Sitcoms and variety shows are often shot multi-camera. Think *Letterman, I Love Lucy,* or *Two and a Half Men.* Those shows keep a sort of "stagey" look by putting all the cameras more or less in the audience. That way they can shoot different angles without looking at each other, and we feel like we're in a theater watching a show.

Sporting events, award shows, and other "live" events where you're screwed if you miss the running play or embarrassing acceptance speech, shoot with four to 26 cameras going at once. They don't worry too much about hiding the cameras, so we're used to seeing them in this kind of show.

The How-To Video

Our house in Los Angeles has a basement—a rarity here. Since we live halfway down a long slope, the basement has a sump pump to take care of water that would like to flow through our basement on the way to the Pacific. It works great—unless you don't look at it for 10 years. Then it develops a thick crust of clay, burns out in the rainy season, and floods the basement.

Once the basement dried out, I needed a new pump. The plumber wanted $600 for the job, but the pump could be purchased locally for $130. What to do? Google. I found a terrific how-to video online and installed the pump myself. The cost was $3.49 for a new length of steel pipe, plus the unrelenting plumber butt-crack jokes from my kids.

Two points to this story: The obvious one is that how-to videos rock. I've upgraded my Mac, replaced light fixtures, and decided not to re-grout my tiles after realizing what a messy pain in the ass it is.

The other point is more problematic for you if you're thinking of doing one: While I'm grateful for the sump pump video, it was poorly shot and I have absolutely no recollection of who did it.

Even if you really *are* doing your "How to Upgrade Your Mac" demo purely to share knowledge with the world, you should at least get the credit for helping.

With that in mind, here's how you can do a great demo *and* help your chances of getting repeat visits and a great reputation:

Explain just one thing: Someone coming to a demo video wants what they want *now*. They don't want to sit through 10 minutes on currying a horse if what they need *now* is a 90-second review on "how to assemble a bridle." If you know a lot and burn to demonstrate it, create a series of short videos instead. You know your videos are focused (and short) enough when you can easily fill this blank with five words or less: "My video is about how to _____."

Consider your voice: Check out the great teaching tone in voice-overs for the Kahn Academy videos (www.kahnacademy.org) that my kids look to for extra help with math. The videos are written with humor and intelligence, and the host is personable, intelligent, and a little funny. The better your figurative (written) and literal (acted) voices are, the more likely people are to remember your video.

Your money shot sums up what the demonstration is about. It's the shot that's so visually compelling you *can't* look away.

Clear steps: We need to see what you're doing. Good lighting and close camera work help. If things move too fast, shooting at high speed (which results in slow motion, you'll recall) is a big plus.

Use graphics to label and number your steps. If your video covers a complex process (like a recipe), consider referring people to your website for downloadable instructions that go with the video.

Cut the clutter: How-to videos take a journey from "not done" to "done." Too much distraction along the way and we nonexpert viewers get

lost. For each fact you're tempted to put in your demo, ask yourself if you can do the task well without it. If you can, cut it.

Find the money shot: If you've ever watched *Deadliest Catch* (the Discovery show about crab fishermen in the northern Pacific) you'll see their money shot over and over: The winch goes on, the cable tightens, and the crane hauls up a huge net on deck, dumping thousands of live crabs. There is something mystical about this shot—the crew lives or dies on its crab harvest, so the number of crabs hitting the deck plays an important role in the story. And the crabs are intensely visual: They're huge. And alive. And orange. We never get tired of watching them.

Does your video have a money shot? Your money shot sums up what the demonstration is about. It's the shot that's so visually compelling you *can't* look away: Where you flip the omelet, open the hood of the car, sledgehammer the wallboard, or drop the turkey into the deep fryer. If you can identify a money shot for your video, produce the heck out of it. Show it from different angles. Add music to it. Shoot it in slow motion. Your video will be more fun—and more memorable.

Nix the jargon: Jargon exists to exclude others. If I'm teaching you how to shoot great video and I deliver a long speech about a "gobo" as if you should already know what one is, you'll feel stupid and confused. Instead of involving you, the video will push you away.

(A *gobo* is a screen that goes in front of a light to create a pattern. If you want your scene to be lit as if sunlight is coming through a window on the set but you don't actually *have* a window, you put a window-shaped gobo in front of the light, and voilà! Don't you feel more included now?)

How to Shoot a Viral Video—Guaranteed!

T wo words: Naked celebrity.

I don't know where you get one, or how you convince them to get naked, but it's the only surefire, guaranteed-to-go viral video out there.

Everything else is a crapshoot.

People who throw around the idea that the solution to your marketing problems is to just "do a viral video" have no idea what they're talking about. A viral video is a "hit"—like a hit song, a hit television show, or a hit movie. If it were easy to do, all songs would sell a million downloads, all movies would break box-office records, and all videos would go viral. But it's not. It takes skill, vision, artistry, marketing savvy, and a huge amount of luck. (Sometimes all you *need* is luck—more on that in a moment.)

It's much easier to create a viral video if you already have a reputation for creating hits and the demonstrated skill to make them and the marketing to support them. Then you're Beyoncé. Or Lady Gaga. Or Will Ferrell. Or, in this example that I cowrote, Microsoft. (Go to www.VideoThatDoesntSuck.com/examples.)

Viral videos often emerge when people accidentally stumble on "lightning in a bottle." For that, you'll need the luck to have captured *Charlie Bit My Finger* (www.VideoThatDoesntSuck.com/examples) and the luck that others find it as funny as you do. Like lightning, you can't make it strike when and where you want it to.

People who throw around the idea that the solution to your marketing problems is to just "do a viral video" have no idea what they're talking about.

Your best bet for creating viral videos is to make as many videos as you can that really excite you, and post them. You'll learn as you go. As you get better, you'll develop a reputation and an audience.

If you're lucky, you'll come up with an idea that's really spectacular, you'll execute it well, and your audience will start sending the link around all by themselves. If you support that video with all the marketing you can, you'll have a shot at going viral.

Promoting Your Product or Services

People don't watch videos to do the creators a favor They watch because they want to. (We talked about the "entertainment transaction" inherent in all video on page 20. If this doesn't sound familiar to you, reread it right now. I'll wait.)

For an obviously commercial video like one promoting your product or service, the audience's trigger fingers will hover even more anxiously over the mouse. They know you're trying to sell them. If you don't *also* entertain the hell out of them, you're history.

Business video is a book topic all by itself. You'll find more business tips at the website www.VideoThatDoesntSuck.com. But here are some big ideas to consider:

Start with the target customer in mind: Brainstorm a description of your customer. Who are they? How old? Where? In what frame of mind? Are they looking for your business already, or will this video be the first they've heard of it?

Evaluate your video ideas by looking at them through your customers' eyes.

If they're actively shopping: What information do they need from you? How can you deliver it clearly, concisely, and in a way

that intrigues them? Break information up over multiple videos, so customers can focus easily on what they need to know. Take a look at Apple.com's product rollout videos—their home page always features something new. When you click inside, you get fast-moving, well-produced videos broken down by topic. You don't have to sit through a long video about the iPod Nano—instead you can see short videos that focus on whatever information about the Nano you're looking for.

If they're not: A great video grabs your attention even when you have no interest in buying the product. Someone sent me a link to Blendtec's "Will It Blend?" videos (www.VideoThatDoesntSuck .com/examples), which have millions of hits each. I don't watch

How can you use video to build your relationship with your customers?

them because I'm endlessly fascinated by blenders. I watch because I'm endlessly fascinated by Blendtec's slo-mo video of blenders pulverizing things they shouldn't, like golf balls, iPads, and bullets. Will these stunts influence my purchase decision next time I buy a blender? I don't know. But I'm certainly aware of the brand now, and I wasn't before.

If you want to intrigue a potential customer into learning more, you'll need a big idea and plenty of entertainment value.

Think customer needs, not yours: For your bakery, your first answer about the customers' needs might be "They need our corn muffins." But that's a product-centered need, not a real audience need. It's also not a very interesting start for a video concept.

But take that first need and keep asking it "Why" and you start to get someplace interesting. Just brainstorming here, but:

Why do they need corn muffins? For energy.

Why do they need energy? Because their lives are busy and tough.

Why are their lives tough? Because they don't have time for love.

We can do this all day, but "corn muffins = love for busy people" strikes me as an interesting start for a video. I can already picture interviews with formerly cranky librarians, politicians, and ax murderers whose lives were changed by corn muffins. Or cute kids who stop fighting on the playground, or football players who quit . . .

Think about how your product improves the lives of your customers.

Think relationship, not sale: Every time Martha Stewart appears on TV she's selling a product. Sometimes it's her next TV show, sometimes it's paint. But people don't tune in because they care deeply about her line of products. They tune in because they can't believe someone would actually dry Thanksgiving's turkey carcass, sprinkle it with powdered sugar, and turn it into a Santa's sleigh centerpiece for Christmas. (Okay, I made that up. But I'd watch if it were real.)

They tune in to be entertained and informed—and as they come to know Martha and what she's about, they may well buy her products.

How can you use video to build your relationship with your customers?

Don't exceed your level of video excellence: A sincere interview with the company founder, well shot and edited, will sell your company better than a lame sketch video.

Consider hiring someone to shoot your business video: As a busy businessperson, you may not have the time or inclination to become a brilliant videographer. But you do know good video when you see it. Consider hiring a pro to do your promotional video. You can reference the advice elsewhere in this book (especially about planning a video that

really communicates in Parts 1 and 2) to help make sure you're getting your money's worth.

You may not have the budget or need for a national-level production company (or you may . . . operators are standing by!), but there are videographers in your town who may be just right for the job. Even cheaper—and sometimes even better—are students in college-level video programs. Be sure to ask for a demo reel before you interview your prospective videographer. If you don't like their work, *run,* don't walk, to the next candidate.

After the Shoot

Videos don't always fall out of the camera ready to watch. On more complex productions, you'll edit, tweak the sound, correct the color, and add graphics or digital effects. This can take as much or more time than shooting did.

Postproduction (or just "post" for short) is the process of transforming your footage from just what the camera captured to finished video.

Editing 101

Cut Like a Knife

Load a recent video into your editing program. Keep a copy so that you're not worried about hurting it.

Play through the video. If you see anything that sucks, cut it. If you're not sure if it sucks, cut it. Be ruthless. Cut at least one scene you hate to cut. (That would be the one you really loved when you shot it, but it just doesn't work on the screen. Kiss it good-bye.)

One thing that keeps people from cutting is worrying about how the scenes fit together. For this exercise, don't. Just cut every single thing—whether it's one frame of video or 10 minutes—that you don't like or doesn't help you tell your story. You'll find that most of your cuts are just fine however they fall. And even if you never fix the ones that are a little off, your video will still be better than it was.

When you're done editing, your video will be more exciting and easier to watch. And if it's not? You probably didn't cut enough.

Editing in its simplest form is this: Take a video you've shot and cut out all the parts you don't like. Just as the video camera, distilled down to its basics, is about "record" and "stop," editing programs are, in the end, about "delete." The odd camera moves, the bad lighting, the time the camera was on and you didn't know it— all gone. Cutting the bad stuff means that all that's left is the good stuff. A video that's nothing but good stuff should be—good!

Editing programs can seem scary. You load footage into the computer, open it up, and suddenly you're on a pretty steep learning curve. Edit bins, project libraries, effects, soundtrack management—all kinds of stuff it turns out you don't really need to know anything about. All computer programs are based on three commands: Cut, Copy, and Paste. For your first editing session, you really only need to know one command: Cut.

Start by cutting the big chunks of stuff that are obviously awful. If it's out of focus, unintelligible, badly composed, lose it. Make

another pass and cut the stuff that's not *awful,* exactly, but just not that exciting. What you have left should be pretty good. If not—keep cutting!

Practice ruthlessly cutting the crap, and little by little you become a great editor. You'll figure out your editing program's features too. As a bonus, learning what really works in an edit makes you a better shooter. You'll instinctively start avoiding shots you know won't cut well later, giving you more time to shoot the good stuff.

POSTPRODUCTION AND THE RULE OF LESS

Once you get your footage into a computer for editing, it's time to start living by the "Rule of Less."

The Rule of Less states (and yes, I did just make it up) that everything in a finished video (a) has to be good and (b) has to have a reason for being there.

The rule applies to the simplest decisions, from which shots to use to what the titles look like. If a shot isn't that great—maybe it's a little dark, or your subject looks too mean, or you can't really see the rabbit you spotted on your hike because you were too far away—cut it.

Good but off-track stuff also has to go. If in the middle of your interview with the company vice president he veered into a juicy anecdote about the company president and a venture capitalist but it has *nothing* to do with your video promoting the new product, cut it.

Anything you're considering adding to the video also has to conform to the rule. The fonts Helvetica, Courier, and their relatives make nice, simple, classic-looking titles. Yes, you can make them bold, shadowed, underlined, and red, and make them fly in spinning, but if the result is not both (a) good and (b) there for a reason, you're (fortunately) prevented from doing so by the Rule of Less.

So, Grasshopper, begin your journey according to the Rule of Less: The less footage you have in the finished piece, the fewer special effects, the simpler the graphics, the better.

Editing 102: Edit Seamlessly

E diting a chronological sequence of recorded events requires no more than cutting the bad stuff. If you leave the video in the order you shot it, it will look fine.

Editing scenes with multiple takes and dialogue is a whole 'nother story.

There are rules of editing, but they change over time—basically whenever a bold editor or director violates them and makes the violation work.

Compare the editing styles of *The Bourne Supremacy* and *It's a Wonderful Life.* Frank Capra, director of *It's a Wonderful Life,* sped through years of a man's life, playing with time and fantasy. Many critics loved it, but many real people (in 1946) got lost in the time shifts. The movie did well, but didn't become the icon it is now until television allowed audiences to see it over and over again and get comfortable with it. Yet it seems perfectly normal to us now—even a little quaint.

The main rule is pretty simple. If you see a "jump" in the cut and it jars you, you did it wrong.

Paul Greengrass, director of the last two *Bourne* films, pushed the limits on editing his action scenes, making them faster and more

TRY THIS

Don't Let Your Seams Show

You'll need a scene of dialogue you've shot from multiple angles. If you don't have one, don't worry: They're easy to shoot. Your scene doesn't have to be long—two people talking about the weather in the living room will be fine. Or have them exchange a few lines from a movie or play.

You'll want your actors to repeat the scene a couple of times from each angle, trying to keep the same action each time. Some things to consider as you're cutting the scene together:

1. Start with a "rough assembly." Just slap the scene together with different angle shots and see how it looks. Once you've got all the lines in place, you can start to make it prettier.

2. If you're cutting between two scenes with the same character, the cut will appear seamless if you change the angle or the size of the character in frame *by a lot*. How much is *a lot*? You'll know it when you see

it. If it's not enough, the picture "jumps," telling you that you can't make the cut work.

3. A character's motion in one cut needs to match in the shot you cut to. If a woman is drinking wine in one shot but has already put the glass down in the next, the audience will perceive either a jump or the passage of time. The easiest way to make them match is to cut just a frame before the action starts and let it begin in the next shot.

4. If you can't make a cut work, try bridging two shots by inserting a shot of another character listening or a tight close-up of something unrelated—a hand, or the family dog (see "Shoot the Details," page 132).

5. Lighting and color have to match well enough between the shots or we'll think it's a mistake. Again, if you see the jump, it isn't right.

Keep working the scene until you like what you see. Don't be afraid to experiment!

visceral than anyone else's. He's a major influence on action-film cutting today, but in Capra's time audiences wouldn't have been able to see fast enough to read the action. In film school even 20 years ago (and 40 years after Jimmy Stewart jumped off that bridge), they would have thrown Paul out. But Greengrass created his own style, and now it's part of our film language.

We're used to "jump cuts" now—those blip edits that cut words or sentences out of a senator's speech on the nightly news—that used to be strictly forbidden. Styles of film color change over time too, from Technicolor's overly bright, theatrical look in the late

Seamless editing: Shot 1, the phone rings.

Cut on action just before he lifts it to his ear.

1930s (see *The Wizard of Oz*) to *Slumdog Millionaire* and *Avatar*'s hyperrealistic look today. All of which is to say that in the long run, there are no rules. You can make up any style of editing you like.

But making a mess on purpose and making it because you don't know better are two different things. Picasso didn't just jump into Cubism—he actually knew how to paint. Your first few edited videos will be enough of a mess anyway, so it's worthwhile learning a simple system of traditional, seamless editing.

"Seamless" editing is an editing style in which the audience is not consciously aware of the cuts. Done right, they won't nudge their husbands and go, "What was that?" The basic rules are pretty simple, and the main rule is even simpler:

If you see a "jump" in the cut and it jars you, you did it wrong. If you become aware of the edit—if the scene doesn't look to you like a piece of continuous action—it's not working.

This kind of editing is sometimes called "match cutting," because your goal is to get the two shots you're cutting together to look like they happened continuously. The action in both shots has to match.

You can learn this only by doing, so dive in!

|||

YOUR GOOD FRIENDS "SAVE AS" AND "UNDO"

Occasionally, I've had an idea for an edit and known with 100 percent certainty that it was perfect. And it turns out that once or twice I was even right. For the rest of the times, there's "undo."

The only way to know if really something is going to work in an edit is to try it. Your video may go from dull to funny with a snip of your edit button, or you may totally screw it up. You won't know until you look. And if you hate it—excellent! That's one less thing to try. Knowing what you hate in an edit can be just as important as knowing what you love.

The "undo" button is there to support you. Never be afraid of trying something. You can always un-try it.

If you're working on something that really matters and you're going to polish it to perfection, get in the habit of "saving as" a retitled version. I use computer software notation. *Matthew's Birthday Version .90* is my rough draft, .91 the next, and so on. Once I have the video assembled the way I like it, the versions go forward as 1.0, 1.1, etc. A HUGE change takes me to 2.0. This notation keeps things in order.

Some home video-editing programs don't do "save as," which makes it much more difficult to compare two or three different cuts of your video. If you're serious about editing, get a program that lets you save multiple versions of the same project.

End with the Beginning in Mind

*T*he Wizard of Oz begins and ends at Dorothy's house in Kansas. *The Godfather* begins and ends in Don Corleone's office. *Avatar* begins and ends with a shot of Jake's eyes opening. Each of these callbacks to the opening action or location makes us, the audience, feel good. Something about these endings just feels *right*. The heroes have returned from their journey to the place where it began, yet changed in some irrevocable way. Dorothy is home. Michael has become his father. Jake has reawakened in a new body with two working legs (and only eight fingers, but that's another story).

Callbacks to the opening action or location makes us, the audience, feel good. Something about these endings just feels *right*.

In narrative storytelling, it's part of the storyteller's contract with the audience that information you introduce at the beginning is important to the story. The beginning is the setup—we listen (or watch) with rapt attention, waiting to learn what the story is. The details mean something: What happens next matters because of what's happened before. A return to the beginning confirms the importance of those details and shines a spotlight on the completion of the hero's journey.

We're also obligated as storytellers not to waste the audience's time with stuff that doesn't matter. If you start your video with a girl breaking up with her boyfriend of five years and then she auditions for the ballet and we never hear so much as a mention of the boyfriend or her relationship again, we feel cheated. Why, we will wonder, did you waste our time telling us about the relationship in the first place? Or if we really liked the boyfriend character, we'll be pissed off that he never returns.

Storius Interruptus can be very painful for a viewer. When you leave them wondering how major chunks of the story turn out, the story doesn't end for your audience. It just . . . hangs there, limply.

TRY THIS

Bookend It

You don't *have* to literally end in the same place as the beginning—but it's a trick that almost always works, and it's worth practioing.

Go through your footage for scenes that help tell the story by bookending it. Ideally, the scenes take place in the same location or look similar in some way—with one key difference that works with your theme.

For example, try opening your wedding video with the bride and groom arriving separately and closing it with the bride and groom driving away together. If you're doing a video about your company's customer service, you might open with a customer placing an order from the comfort of her couch and close the video with her opening the box of merchandise in the same living room. If it's an interview with an environmental scientist, you might open with her talking about her concern for the world that got her into the field and close with her making a hopeful statement for the future.

If that's not working for you, you still have to make sure your ending satisfies the audience based on what you've set up. After you've run through shots of your five-year-old daughter looking at the animals on a trip to the zoo, you can close with her sound asleep in the backseat as the car drives away. You might spend the extra time to shoot the team cheer at the end of the Little League game, or end on a shot of your dad blowing out the candles at his 75th birthday party.

As you go through the video, make sure that you've deleted any threads that don't go anywhere. Don't mention details at the beginning of the video that you aren't interested in pursuing—and be very interested in every detail you do bring up. If you've opened a narrative question that you can't (or don't want to) answer by the end of the video, cut it.

Think of your video opening as your "before" scene.

"After": same place, hero transformed.

A story ending that clearly relates back to its beginning feels more satisfying. The main tale is told. Darth Vader is redeemed by a final act of good and dies. Or the true King of Men takes his Half-elven wife and ascends to the throne. Or Brad Pitt, born very old, descends into infancy and dies.

The world's best filmmakers make sure that the beginning of the film and the end relate to each other. They help the audience see the meaning of what came before. And when they make those connections, the audience will be very satisfied.

Editing gives you a last opportunity to "rewrite" your video in a way that's more satisfying to your audience. Make one pass through your footage looking for loose connections. Most of the time, connecting them makes your video stronger.

STRENGTHENING YOUR STORY

The audience forgets nothing.

When they watch your video, they're focused on the screen, picking up on every nuance of story, every detail. They'll see themes in your work that you may not even know are there. If you also pick up on these details and use them elsewhere in the story, it will be stronger, and the audience will be very happy. Ending at the beginning is one way to do it, but there are others.

The easiest way to strengthen your piece is to go over it as early in the process as possible, ideally at the script or idea stage, and try to build threads that run throughout.

In a stand-up comedy act, a callback brings a joke from early in the routine into a later joke. This works in videos too. In my film *Two Weeks,* a story about a family dealing with death, one helpful friend brings a tuna-noodle casserole for the family that nobody will eat. Later another well-meaning neighbor brings one, forcing the family to lie about how much they love them. At the end of the film, a character opens the refrigerator. It's packed top to bottom with casseroles. This callback completes the casserole story and adds a layer to the texture of the film.

If a callback is a form of recapitulation—coming back to something you introduced earlier in the video—I'm also advocating "pre-capitulation." Take something you've discovered late in the video and introduce a "pre-callback" earlier.

For example, if your character's life is saved at the climax of your video when a cat crossing his path keeps him from stepping in front of an oncoming truck, can you show him setting out milk for the same cat (or sneezing when it rubs against him) at the beginning?

You can look beyond characters as well. If a big scene at the end of your video takes place in the subway, what happens if you set an earlier scene there too? If something bad happens at midnight at the end of the video, can something ominous happen at midnight earlier? Spreading information and themes throughout the piece can make your video tighter and more interesting.

It will also strengthen your story to think about your subplots as needing a beginning, middle, and end, just like the main plot. In an hour-long TV show like *House,* the main plot might be about a blogger dying of some mysterious disease. The main subplot might be House revealing embarrassing secrets about Wilson's past to the entire hospital. A second subplot might be the mystery of why House, a logic nut who believes only in what he can see, is reading a book about sermons. Each plot has a different hero, but each has a clear beginning, a middle, and an end. They all come together to weave the complete, complex, and satisfying story of the show as a whole.

Clarity Is the Prime Directive

The biggest cause of audience tune-out is boredom. The second biggest is confusion (which leads to . . . wait for it: boredom). If people in the audience don't understand what's going on in your video, they're not going to stick around to try to figure it out. Let a commitment to clarity guide all your video decisions.

Clarity requires that we always take care of the audience. We must give them the information they need, in a way that they can understand. It means being obvious, and thinking about our video as the audience will—as virgins, people who don't know anything about the video except what they see on the screen.

If people in the audience don't understand what's going on in the video, they're not going to stick around to try to figure it out.

We need to fill in the blanks, dot the *i*'s and cross the *t*'s for the audience. If we mystify them, we need to do it in a way that lets them know we know what we're doing. And that the mystery will be solved before the video ends.

Consider two approaches to showing a character being sneaky:

In the first, the hero peers around a city street corner. We don't see what he's looking at, but he's looking at it carefully. In the next shot, the character puts on a fake mustache, nose, and glasses and ducks around the corner and into the flow of humanity. In the next, he's hiding behind a potted plant, surreptitiously photographing a woman having lunch with a friend at a restaurant.

These three shots add up to a story.

We don't know what he's doing in the opening shot, but each subsequent shot adds information. By the end we know the hero of this video is spying on a woman. As long as he's deliberately and clearly doing *something,* and we're learning more about it as the video progresses, we're okay with it—even though we may not know why he's doing it (yet). In fact, we want to know why he's spying, which carries our interest into whatever happens next.

Our character is following someone . . .

Now imagine this sequence: In shot (a) the same guy walks down the street with his hands in his pockets, CUT to (b) the guy peers around a corner, CUT to (c) the guy walks down the street again, CUT to (d) the guy argues with his buddies in a bar. Do you understand what the character is doing? Me neither, and I wrote it.

. . . and we want to know why.

Is the Action Clear?

Look at your video in increments. A couple of scenes or so, no more than a minute at a time. For each chunk of video, ask yourself:

- *Do I really understand what's going on right now?*

- *Does this scene or section intrigue me? Does it make me want to see what happens next?*

- *Does this scene follow from the last one? Does it answer some of the questions the previous scene raised?*

- *What questions does this scene ask? Do we get the answer soon?*

In this version, the videomaker may be *thinking* his character is sneaky, but he hasn't *shown* us. We have no clue how these disconnected shots relate to each other. There's no focus. No information has been added. After a few minutes of video like this, we're bored. After a few more minutes, though, we won't care: We'll be watching something else.

As part of your edit, your job is to make sure your ideas get out of your head and into your video. You've got to put yourself in the audience's head and make sure you've connected all the key points. You need to tell your story in a way that they can understand.

Turn Off Your Computer's Transition Effects

There are basically three kinds of video transitions—ways to move from one shot to the next. Each transition has its own meaning, its own look, and its own feel.

A **"cut"**—going from one shot to the next in one frame—can be invisible if it cuts between angles in a scene, or a shock if it takes you from a character's throat being torn out to—GASP!—that same character waking up in bed realizing it was all a dream.

A **"dissolve"**—a slow fade from one scene to the next—usually indicates a passage of time. But a dissolve to a white screen might mean the character just died, and a dissolve to black usually means the end of the movie (although sometimes it means a somber mood shift to another scene).

A **"wipe"** is when a new scene "moves in" from one side of the screen. In the more modern version, passing an object—a wall or a person—transitions us to another scene. Wipes mean the same thing as a cut, but they feel different. It's as if we're being physically moved—from one place and time to another instead of just appearing there.

Wiping the frame: Shot 1 establishes the characters and their first location.

The camera passes something that crosses the entire frame—in this case, a wall.

The wall is our transition point to a new scene—the same characters in a different location and time.

When you open your video editing program, you'll see many more choices than just these three. Like that cool effect where nine little boxes open in a grid in the frame, each containing a view of the next scene. Or a circle that shrinks or grows, revealing the next scene. Or digital trails that sparkle into the next scene, or . . . The list goes on and on. As fast as third-party developers can create dorky video effects, people buy them and load them onto their computers.

Here's the question you need to ask yourself: What do they do on *CSI*? What transitions do you see in a Pixar movie? Or on the news? You'll see mostly cuts, a few wipes, and possibly one or two dissolves. That's it. No sparkly digital trails. No circles.

As you crank out your 30th beautifully edited video, having mastered the basics, you may decide to use one of those digital effects for a laugh. Or you may have experimented just for fun and hit on a unique and amazing transition that mixes a bunch of techniques—maybe even a sparkly video trail. It's possible. But only after you've mastered the basics.

Until you do, the choice is yours. Do you want your video to look like it was made by a pro or a novice?

Transition Your Transitions

Do you have an edited video on which you've used a lot of fancy transitions? Load it into your editing program (the original, editable file, not the finished video output). Don't worry if it's dorky. We're going to fix it. It was in your past, and all is forgiven.

Now, delete all the complicated editing-software wipes and digital transitions.

Got any dissolves? You probably won't need those, either. Hollywood directors once used them to indicate the passage of time. But audiences have become so sophisticated in their understanding of video language over the last 30 years that now we don't: We just cut from one location to another, and everyone gets it. Dissolves almost always look old-fashioned. Turn them off too.

Wipes, used very, very sparingly, can look okay. I think I use one or two a year. If you've used even one in this video, turn it off.

Hmmmm. No wipes, no dissolves, no effects? Where does that leave us? Ah, yes. Cuts. Your video should now be composed entirely of cuts.

Go through the video and tighten the edits so they're nice and crisp. Better the shots be too short than too long.

Now—how does it look? I'm guessing cleaner and more professional. Simpler and more elegant. But it's your video—you be the judge.

Next video, even if you really like all the effects, start with a simple all-cuts version first. Your edit will go faster, and odds are you'll find when you're done that you don't need all that stuff you used to put on top.

When in Doubt, Cut It Out

I shot a medical Web series for which we developed a team called "The Health Squad." The squad included two doctors and a nurse who did surprise home makeovers to help people with whatever health issue they had—in this case, type 2 diabetes.

The series was shot reality-style. Based on the patient's history, we outlined a list of makeover tasks the squad would perform. We had a shooting plan, but since this was reality, we were planning to let things unroll pretty much as they actually *did* happen.

After half a day going through my shot list and getting great footage, it came up in an on-camera conversation that the patient hadn't tested her blood sugar in two years—a potentially fatal mistake if you have diabetes. Naturally, we made her stop on the spot and test it—also on camera. It was too high, which was great for video. It also gave our team a chance to do some real good and seriously intervene in her life.

A couple of weeks later, the video was edited and *waaaay* too long. Each of my three planned 90-second segments ran over three minutes. The problem was, it all looked pretty good. Pretty good but not great.

That's when we got serious about cutting. We went through each piece, shot by shot, and trimmed whatever wasn't *great*. Which saved all of 20 seconds. Now it was time to get *really* serious. It's amazing how long three and a half minutes is when you're doing a 90-second piece.

To finally make the piece work, we had to hack out whole storylines. The part where the doctors make the patient a diabetes-friendly meal? Gone. The exercise bike? Trashed. That extra joke the nurse told while they cleaned out the cabinets? History. Hours of shooting went right into the computer dumpster.

When we finally got the video down under two minutes, a funny thing happened. It started to come alive. Everything made more sense. There were no distractions. All the action was clear. Getting there was painful, but the result was great.

The difference between a great video and one that sucks often comes down to how much you're willing to get rid of. There was nothing wrong with the "doctors make dinner" storyline, it just wasn't important to the "patient tests her blood sugar" storyline. It pulled focus away from the more important story, weakening it.

GOOD VIDEO GETS BETTER WITH TIME; BAD VIDEO GETS WORSE

God has a special hell for filmmakers who settle for something they don't really like. It's called "seeing your work over and over."

Great video gets better the more you see it; bad video gets worse. A little problem you gloss over hopefully the first time you watch will start to nag like a splinter in your finger, hurting more and more each time you see it.

Save yourself the trouble. When something you're watching starts to catch your attention every time you hit "play," figure out why. If you hate something more every time you see it, you're probably right. As soon as you realize you've made a bad choice, fix it or cut it. Else madness this way lies.

On the other hand, if you like it more and more every time you see it, rejoice! You may be on to something great!

It's easy to throw out the bad stuff. The hard part is throwing away the good stuff. This is why you'll hear the expression "Kill your children" applied to video editing. Even though you conceived of it, even though you birthed it, if it isn't helping the final piece, you need to cut it.

The "have to's" are your enemy here I have to include this . . . "Because it was so hard to shoot." "So [insert name here] won't be mad" or "Because it's my favorite shot." Even when there is no "have to," cutting a shot you love feels like you're firing someone (and sometimes you are—I cut a whole character out of *Two Weeks* after we shot it).

You really have to man up to get from mediocre to good. That's where the hoary film maxim "When in doubt, cut it out" comes in. If you can get over this hump, goodness awaits on the other side. Even if you only *suspect* a shot isn't helping you, lose it. Recognize that "Not sure if it's bad" = "Pretty sure it's not good but resisting."

Bite the bullet. Cut it.

Time limits make you a better editor. If you can't decide whether or not to drop a shot, knowing you'll save six much-needed seconds helps you make the tough call.

It's easy to stay disciplined on projects with an established drop-dead length. If you're doing a commercial, it can't be any longer or shorter than 30 seconds. If you're doing a network hour, you get 44 minutes of program. Period. Movie trailers are 2:30.

On the Web, time is more flexible. You'll have to set your own limits.

Cut to Time

For your next project, pick a time that seems on the short side of reasonable. Force yourself to edit down to that length and not a second more.

If you're making something that you want to look or feel like one of the aforementioned time-locked forms, lock yourself to its time restrictions. Don't do a demo commercial that's 2 minutes long—do one that's 30 seconds, otherwise it won't feel like a commercial to people watching.

Get in Late, Get Out Early

You'll never see this restaurant scene in a movie:

Man (to waiter): Check please! (To the woman opposite) Great seeing you!

Woman: Yes, it was fun. I can't believe it's been a year since we had lunch. You will say hi to Debbie for me.

Man: I thought you hated Debbie.

Woman: And you hate Roger.

Man: Just jealous, I guess.

Woman: Really?

They look into each other's eyes. The check arrives.

Man: I've got this.

Woman: Thanks! I'll get the next one.

The man looks at the check.

Man: How much is 15 percent of $35?

Woman: Hang on. (She thinks, counts on her fingers) $5.25.

> To keep your scenes short, start them as late as you can—just when the meat of the scene starts.

Man: Thanks.

He puts his credit card on the table, and they wait.

The woman pulls out her iPhone and checks the screen. The man looks around for the waiter, who finally returns with the check. The man pays.

CUT to the next scene.

This is not a long scene. It might play for 45 seconds in a movie. But you'll never see it in a movie because it's at least twice as long, hence 30 times as boring, as it needs to be. When the character on-screen pulls out her iPhone, we'll want to as well.

Now suppose we re-edit the scene, starting as late as we can without missing any key information, and getting out the second everything interesting that's going to happen has:

CUT to a man and a woman finishing lunch.

Woman: I can't believe it's been a year since we had lunch. You will say hi to Debbie for me.

Man: I thought you hated Debbie.

Woman: And you hate Roger.

Man: Just jealous, I guess.

Woman: Really?

They look into each other's eyes. A long beat . . .

Man (to waiter): Check please!

CUT to the next scene.

TRY THIS

Bare Essence

Open a recent video in your editing program.

Pick a scene (or even a long shot) you like and find its real starting point by trimming the opening line or action and see what happens.

If cutting some of the opening works, keep trimming. Start later with every cut. Play the scene after every change.

At some point, cutting more will feel wrong. If the scene no longer makes sense, undo one cut. Take a look at what you have left. Does it still tell the story the way you'd like? You can always add things back a line at a time. Keep working the scene until you find that special point where you have just enough of the opening and no more.

Now do the same at the end by cutting out of the scene early. Cut farther and farther back, one action or line at a time, until it suddenly feels too early, then go back a cut. How does that change the way your scene feels?

If you cut something and don't miss it, don't worry about it—it shouldn't have been there in the first place.

This version of the scene runs 15 seconds, and instead of being bored out of our minds with the trivia of restaurant dining, we see only the relationship between the characters. And we're intrigued. We want to know what happens next.

Short scenes keep a story moving. Movie and television scenes rarely last much longer than a minute.

To keep your scenes short, start them as late as you can—just when the meat of the scene starts. Cut everything that comes before it. Do you really need to see your kid lacing up his cleats? Or can your first shot be him charging down the soccer field?

On your way out of scenes, look for that moment when you've gotten all the new information you're going to get—then get out. When your daughter takes a bow at peak of the applause after the play and smiles right at you, the video can end. You don't need to hold on until the lights come up.

CUT "TRAVEL TIME" IN ALL ITS FORMS

When we want to get a movie character from her office to her living room, we don't show her putting on her coat, riding the elevator, walking to her car, starting it, driving out of the parking lot, and then making every turn to get home. It's boring.

Instead, in Scene One she's crying at her desk downtown and then we CUT to an apartment living room as she carries a box of Kleenex to the couch and turns on the TV to a sappy romantic comedy. The audience never asks "How did she get there?" We understand a cut to a different location as a transition of time and space.

Keep your videos short by cutting metaphorical "travel time" in all its forms. The next time you shoot a birthday party, don't cover every second of your daughter eating cake in real time.

Shot 1: Someone puts chocolate cake down on the highchair tray in front of your clean baby, who looks at it with interest. CUT.

Shot 2: Your daughter, now covered in chocolate, stuffs more frosting in her mouth. Just as cute, much less boring.

The next time you wonder "How do I get from here to there?" remind yourself that you probably don't have to. Just cut, and the audience's brains will do all the work for you.

Shot 1: Baby meets cake.

Shot 2: A mess. Our brains will interpolate what went on in between.

Great Effects Make Your Video Pop

In J. J. Abrams' recent *Star Trek* reboot, Kirk and Spock run across the interior of the giant Romulan ship blasting everything that moves. The music swells as they run inside a smaller ship, one they're trying to steal, trading witty banter as they go. Finally, Spock starts the spaceship, and with an enormous roar of the engines, takes off. Victory.

How much of the sound in that sequence was there when the picture was shot? Almost none of it. The music, the gunshots, the footsteps, the heavy breathing, the ship's door opening, and at least some of the dialogue were added later, in the editing room.

If there's one lesson Hollywood learned early, it's that a gunshot isn't shocking without the BANG.

A typical feature film spends weeks having sound effects added and audio being mixed. Because if there's one lesson Hollywood learned early, it's that a gunshot isn't shocking without the BANG.

We're so used to hyped-up sound effects in video, you're probably not aware of them. If you really punch a guy, the sound lives in the neighborhood of a nearly inaudible *thud* (try punching your thigh if you don't believe me—and if nobody's looking). Maybe a small *crack* if you break something. In movies, a punch sounds like a bone-jarring *thud-crunch* with a surround-sound *ungh!* courtesy

of a sound effects technician whapping a watermelon with a bat and the actor rerecording his reaction later.

If you're editing on the computer, it's easy to add sound effects to heighten the impact of almost anything. You can buy sound effects libraries on CD or on the Web, or you can record your own.

The effects may seem a little strange at first. Volume level makes a big difference; too loud an effect will seem very unnatural. Play around until the effect sounds like it belongs. When you've done it right, your effects will seem so natural you'll forget you added them.

TRY THIS

Listen Up!

As you edit (and certainly once you're done), go through your video with your ears. Anything you see happening that doesn't make a sound is an opportunity. Start with the big-impact items and work your way down to the smaller ones. Car doors should slam, but you probably don't need to bother with rustling clothes.

Add Music

The right music brings video to life. It gives you a rhythm to edit to, emotions to play off, and a lift when you need it. As you play with music in your edit, you'll find that the right music makes your video shine and the wrong music will kill it.

Some directors know the music they want to use when they see the script. Some writers know it when they write. For everyone else, the process of finding the right music is some combination of instinct and trial and error.

The only sure way to know if music will work for your video is to try it. Don't be shy about dropping music on top of your video. If it isn't better with the music (and you'll know), try something else. Some scenes shouldn't have music. You'll know it when you have one, since *nothing* will work right.

While your instinct will be to find music that sells the emotion of the moment—a sad song for a sad scene—sometimes you'll find what you need by playing opposites. Find a song that plays against the intent of your scene and use that. Happy music for a sad

While your instinct will be to find music that sells the emotion of the moment—a sad song for a sad scene—sometimes you'll find what you need by playing opposites.

Score It

Take a video you completed without any music. It doesn't matter if you've edited it or not, but if not, load it into your editing program now.

Pick three cuts of music—one that seems to go with the mood of the video, one that is completely opposite, and one that doesn't seem to relate to the video's mood at all. They could be songs, they could be classical or jazz instrumentals, or cuts from movie soundtracks. They could even be something you've composed.

One at a time, drop them into your video. As a general rule, if the music doesn't make it better, you should dump it. Do any of your selections improve the video? If not, do you now have any clues on what would?

scene, depressing music for that moment of victory. See what it does to your edit.

More often than you'd think, your opposite song choice actually works. And if nothing else, this exercise shows you the possible range of your musical choices.

It always surprises me which music or piece of score makes a scene really sing. I once scored a piece with torch songs from the 1940s, a jazzy sound I was sure would work—until it didn't. The score my composer wrote—which was simpler, with just guitar and piano—really brought the scenes alive.

Easy on the Graphics

O ne of the questions you should be asking yourself often in edit is "What do I need this for?" If the answer is "I don't, really," you cut it. That goes triple . . . or perhaps quadruple for graphics.

Here is where they can be useful:

Title of the video: *Matthew's 15th Birthday, October 24, 2011* is a great use of graphics. The title can be white type on a simple black card that's up for three seconds before the video starts, or it can appear briefly over the opening scene.

Identifiers: Graphics also work well to identify people or to set time and place: *Steve Stockman, Noted Author* or *Los Angeles, 2076*.

Entertainment: Think pop-up video information, thought bubbles, stunning designs, short slug-lines that are truly dramatic or insanely funny.

Credits: Everyone likes to see their name on screen at the end if they helped.

> Graphics have many uses in video, but conveying a lot of factual information isn't one of them.

Note that "conveying a lot of factual information" isn't on this list. This is video, not PowerPoint. Video doesn't do facts well

(neither does PowerPoint, but that's another book). Your audience expects a short film that entertains them, not a lecture.

When should you pretty much *never* use graphics?

To convey information you don't need: I did testimonial commercials for a client who decided at the last minute we should identify each of the people interviewed with a title giving their first name and the town they were from. When I asked why, the client suggested that it would help "localize" the commercial and make the people seem more "real." When I pointed out that we shot the commercial in Seattle and telling a national audience that that's where all the people were from was unlikely to add to their experience, the idea went away. This spared me having to ask what knowing that their names were "Sue" and "Rich" was going to do to help sell the product.

> **Everything in video needs a reason to be there, and graphics are no exception.**

Everything in video needs a reason to be there, and graphics are no exception.

To convey facts and figures you think you need but don't: Video is notoriously poor at communicating lists of objective information (see "Should It Be a Video?" page 28). The audience will take in only one or two facts that are an integral part of your story. The rest goes in one eye and out the other.

If you're going to break into your video for a graph or chart, it had better be good. Like any other component of your video, your graphic needs a clear hero and a beginning, middle, and end. It needs a single clear point. And it had better entertain.

Funny is always good. See Morgan Spurlock's documentary *Super Size Me* (2004) for graphics used well and sparingly. In one animation, Spurlock used Monopoly-like fat cats pulling cash out

of their pockets to dramatize just how much more money fast-food companies spent to advertise than growers of fresh fruits and vegetables. He gives us numbers. I don't remember them—but I get and remember the main idea of the graphic.

Other graphics in the film convey clear, focused, and bold points: the island of Manhattan covered in McDonald's flash cards showing health problems caused by obesity, cutouts of stick-thin models over an interview with an overweight girl, and a cartoon showing how unnatural McNuggets are. Each told a memorable, entertaining story—a must if you're doing more than putting up a short title.

TRY THIS

Follow the Rule of Less

Keep graphics simple and elegant. Keep typefaces simple and easy to read. Keep them black (or white over a very dark background). Keep them small. Keep them from doing stupid tricks. And keep them *only* if they help you tell the story.

If you are using type:

Should you TYPE IN ALL CAPS?

Should you flash words ON and OFF and ON and OFF and ON and OFF?

Should you use SHADOWS and OUTLINE FONTS?

Should words SPIN and TWIST across the screen?

You've read more than 200 pages so far. What do you think the answer is?

If you want your graphics to look even better, take a look at the work of some great graphic designers for inspiration. A trip through your recent browser history should reveal some nice-looking sites. I love to look at Apple.com, but there are plenty of other places to go for inspiration. Find a website that's clean, easy to use, and easy on the eye, and see what it's doing.

Titles on screen should last just a beat longer than you need to read them out loud. You can present them alone over black, bring them in over a single shot, or let them hang over a couple of shots, depending on how much time you need to read them. One way will feel better than the other, but you won't know which until you try.

The Cake-Frosting Principle

You've done a series of interviews with your family for an upcoming wedding video. You're having trouble cutting the interviews down—people were talking really slowly, your questions weren't always great, and the good comments you were hoping for are few and far between. When you try cutting out words and long pauses, things just look jumpy and jumbled. The wedding is in two days.

It's time for an exception to the rule.

Chefs know that if a cake gets damaged, the quickest way to fix it is to bury the damage in delicious frosting.

I know I've regaled you with the horrors of bad effects. Your desktop video program undoubtedly has many buttons on it that do many strange things, from star-shaped wipes to sepia-with-dust for that oh-so-precious "old film" look.

I've repeatedly pointed out that you don't want to do any of this. Simple and elegant should be your mantra.

But—

Every once in a while you'll look at what you're editing and realize that there's no way those two shots will ever fit together the way you want them to. That your cut just blows, but you need it,

somehow, to work. That's when it's time to think like a baker.

Chefs know that if a cake turns out oddly shaped or gets damaged coming out of the pan, the quickest way to fix it is to bury the damage in delicious frosting. Once it's on the plate, nobody can see the flaws.

Think of those normally-to-be-avoided editing effects as frosting for your damaged cake. Maybe a flash frame, digital zoom, color shift, or an effect will help you hide the problem.

Instead of giving up on your wedding video, slap an up-tempo rap song into the soundtrack and cut the hell out of it. Edit flash frames (frames of white or blown-out video) where the cut points are so that instead of trying to hide them, you're emphasizing them. Turn your slow-moving edit into a hip-hop video. It just may work.

Playing with your editing program can save your cut. Remember that nobody knows what the video was *supposed* to look like except you.

GIVE THEM A WAY TO RESPOND

If your video is intended to sell, educate, or motivate, give people a way to respond.

If you're selling, invite them to your website to buy. If you're doing a charity video to raise money, put it on a page with a "donate" button. Building community? Invite comments and get people to join in.

Look for opportunities to give people an action to take. Your Web address at the end of the video should be a no-brainer. Some newer Web apps allow you to add clickable links to the video. Others, like YouTube, let you put contact info and "action steps" in the description box.

Be specific—very specific—about one simple action step you want the audience to take. People are busy. If you leave them wondering what to do, they're never going to do it. "Go to this URL to donate." "Click here to sign our petition."

The more information you can directly attach to the content of your video, the better. If the video is linked or embedded on someone else's site, note that your accompanying information may not come with it.

Wrapping It Up

One of the hardest parts of any video project is knowing when it's done. You may ask yourself:

How do I know it works? How can I improve it? How do I know when it's good enough?

Here are some clues.

When to Show Your Work

I f your video shows in the woods and nobody is there to view it, has it made a sound? We may paint or write poetry for ourselves, but video is a performance art. It needs an audience.

With any art produced for an audience, the artist (that's you!) walks a tightrope of conflicting goals. You have to entertain in order to communicate, but if you fail to communicate, there was no point in merely entertaining. Take a step off the line to one side, and you've pandered to the audience and lost your vision. Step off the other side, and you may have created something that is so audience-unfriendly that they'll run away as fast as they can.

To make a great video, you need to hit both goals, creating something that's truly yours *and* holds an audience.

With any art produced for an audience, the artist (that's you!) walks a tightrope of conflicting goals.

The way to achieve this balance is to make what you want—and then check in with the audience when it's "done" to see if your point is getting through. Movies and commercials test-screen for audiences all the time. Often they'll ask the audience to "rate" the project, but that's mostly a device to make the client or studio happy. What's important to the filmmaker are the comments: What didn't the audience understand? What did they get "wrong"?

What do they wish had happened instead?

You can do the same thing by showing your work to a select group of friends and asking them the same questions.

The time to show it is when you've looked at your video, perhaps for the 400th time, and realized that there's nothing you can do to make it better. The edits look fine, it's technically solid, you're happy with the way it plays. You've run out of ideas on how to improve it.

If you show it earlier, while you're still wondering how to end it or if the product shots work or if the villain is villainy enough, you'll find yourself arguing with viewers about what you should do next— their ideas versus yours. You'll be talking in future tense, inviting the audience to become little directors and derailing your own ideas.

If you wait until your version is finished, your choice becomes very concrete: Do I change what I have or not?

Whom to Show Your Work

There are two kinds of people you can show your work to, and they correspond directly to two kinds of human relationships.

The first kind I call the "if/then relationship": You hook up with someone you're attracted to, and as you spend time together, you realize that they would be much happier with you if you would change. *If* you had different friends or didn't stay out so late or home so much. Maybe, just maybe, if you dressed differently, didn't laugh so loudly at parties—*then* you would be perfect.

The second kind is the "as-is relationship." The person you hook up with accepts you basically for who you are. It isn't that you couldn't improve, but their interest in your improving serves only to support *your* interest in your improving. If you think you're fat, they'll support you getting more exercise. If you have a big presentation at work and you're nervous, they'll help you pick out your clothes. If you don't want help, they'll make you breakfast.

The "as-is" relationship is primarily about helping you grow to be the best version of yourself you can be. In an "if/then" relationship, the other person wishes fundamentally for you to become someone else.

Video viewers fall into the same two categories. "If/then" viewers look at your comedy-sketch video and don't get the humor. They'll tell you it would be a lot funnier if the rabbi were a quarterback and it took place in a locker room instead of a bar. And if you maybe changed the punch line to be something about bikinis instead of ducks. "If/then" viewers would love your video—if only it were actually some other video.

Viewers who understand what you're doing and accept it give you a very different critique. They'll get the joke and think it's funny, but ask why it takes so long for the duck to respond to the bartender. They'll let you know that they think the sound of the bar blender competes with the punch line a bit too much, and ask if you have a shot of the rabbi and the duck walking into the bar

"If/then" viewers would love your video—if only it were actually some other video.

together to help set the scene. "As/is" viewers help you find problems and help you solve them. They help you make your video the best version of itself it can be.

Just as finding that one special person to spend a lifetime with can take a while, you have to kiss a lot of "if/then" frogs to meet an "as-is" prince. Over the years, I've collected about 10 people who give me incredibly helpful feedback on scripts. They're not my 10 closest friends or relatives—my brother isn't a great reader for me, but his wife is—it's just been trial and error over time. I've collected them based strictly on whether or not they get what I'm doing, enjoy giving me feedback, and give me feedback that helps me grow.

Your best critics may know nothing about making videos: They may just know what they like and have some natural critical ability—that is, they can explain what they feel and a little bit about why. I've met studio executives who can't do it to save their lives, and car salespeople who can. Since everyone watches video, you

may be surprised at who gives you a thoughtful viewing and exciting suggestions.

When you give someone your video to look at, consider how you feel about their feedback. If you walk away inspired and full of new ideas, you've found an "as-is" critic. Once you've found one, treat them well. They're rare! Be sure to let them know how much you appreciate their feedback. You'll want them to enjoy it and do it again.

If, however, the feedback you get makes you feel like a loser and doubt the whole project, you've found an "if/then" critic. They may be good friends, or even married to you, but you should never show them your work in progress again.

How to Take Feedback

Feedback is best used to discover two things: trends and great ideas. Everything else is a waste of time. Especially if, in our eagerness to have attention paid to our work, we end up heeding bad advice.

A trend is when you hear the same comment a lot. If multiple people have problems around the same general area of your video, pay attention—it's likely to be a real issue. You have to listen carefully, because different people may sense the same thing but talk about it differently: "I didn't get the joke she told him in the subway" versus "I thought the subway scene ran long" versus "I didn't like that girl in the subway." The comments aren't all exactly the same, but these people are not directors and they're not responsible for your video. You are. Not taking another careful look at the subway scene would be a real mistake.

When you hear something troubling from three or four trusted viewers, pay attention.

A trend is *not* one loud or charismatic viewer beating you over the head with their opinion. Remember, as the critic makes you doubt your thinking, that their one opinion is no more valuable than yours. It's less important, in fact, because it's your video!

What you can get from a single person is an idea. "Hey, what if you . . ." from a relative stranger has improved my work many times. You'll hear a lot of them—the trick is how to deal with what you get. Start by writing them all down. Resist the temptation to respond to the idea-giver with anything more than "That's interesting! Thanks!" You don't need to agree to do it in their presence. You're looking for ideas, not negotiating their screen credit.

Later, review your list. If an idea sparks something in you, consider it. Otherwise it's just another idea on another brainstormed list. You're the filmmaker. Ideas for ways to improve your video are only brilliant if *you* think they're brilliant.

When you hear something troubling from three or four trusted viewers, pay attention. Something is happening between your intent and the audience's response that needs to be fixed.

Anything that isn't a trend is just an idea. If you love it, use it. If you don't, don't.

MANAGING EXPECTATIONS

Let's face it, you have very different expectations of quality when you click on the video your daughter made for her ninth-grade Italian class than you do walking into an IMAX 3-D theater.

Your daughter's movie was done by amateurs. It's five minutes long, shot on her iPod Nano. It's in Italian, so you don't expect to understand it. If it isn't awful, you're pleased. One or two cute moments (and a "B" grade or better), and you're very happy.

But suppose you asked a friend to accompany you to a 3-D movie theater, paid for your ticket ($3 extra for the geeky glasses!), and bought popcorn at seven bucks a tub. The lights go down, the film starts—and it's your daughter's Italian class video. Not as pleased now, are you?

The movie is identical in both cases. Only your expectations have changed, demonstrating that managing expectations is a huge factor in creating a successful video experience. It pays to think about what your audience expects from you, play to those expectations, and exceed them when you deliver.

Two cases in point: Jim Cameron and 20th Century Fox spent a mint to raise expectations through the roof on *Avatar*—and delivered handily. Exceeding huge expectations = huge reward. But if the film had sucked, the audience would have been furious, and the film would have tanked faster than it would have without the hype.

In contrast, Zappos shoes developed its corporate identity in part by lowering expectations. Its Web videos were done by regular employees, and they looked it. When they made you smile, you were thrilled, because you'd invested nothing, expected nothing, and gotten a dose of entertainment in return. Low expectations exceeded = huge financial win for Zappos when it sold the company to Amazon.com.

You set expectations based on what your video promises—both by its content and how you sell (or explain) the video to others. A three-minute epic you shoot with professional actors in a castle in Britain creates higher expectations from frame one than a high school girl sitting in front of her webcam talking about makeup. "Pro" videos set higher expectations than amateur. Longer videos need to be better to justify their length.

Hype raises expectations—unless it's hype about how cheap the movie was to make, which lowers them. (See many successful indie films, but most recently *Paranormal Activity.* Allegedly made for $7,000, it grossed $100 million.) A clever title for your YouTube video might attract viewers, but if they show up for *Hot Beach Wardrobe Malfunction* and get a sales pitch for a Styrofoam cooler, they won't be pleased.

Consistently excellent work is the best way to exceed audience expectations. Do that. But you should always be aware of your other imperative: Hype only to a level you can deliver. Manage expectations so you don't disappoint.

Video Is Never Finished. It's Just Taken Away

You can edit, massage, and polish your video forever—but fortunately, there are deadlines. If you have a work deadline, an event your video needs to be ready for, or a client expecting delivery, you're in luck. Your deadline has been imposed. You can work up until the very last minute—but then the video has to ship.

It can be harder when there is no deadline. You may cling to your project, forever editing to improve it. Sometimes this is a manifestation of fear: the fear of letting other people see it and judge.

If you want to get better at shooting video, you have to let go. Experience is the best teacher, and experience rearranging the deck chairs on the *Titanic* (or luxury chairs on a patio overlooking the Pacific) is very limited experience indeed.

Time is your most precious resource. Don't waste it by staying too long on one video when you could be learning from your next one.

But Is It Art?

These are the secrets to getting good at video: Commit to your own point of view. Work at the top of your intelligence. Practice.

When you're making a video, you get to decide what goes into it. You not only *get to* make these decisions, you *have to*, because every moment you shoot, you're deciding. Do I press start now? Do I point here or here? Is it right or wrong to zoom in on the guy in the pink shirt? Who knows. You're shooting it, you're looking at it. If you like it, do it. The risk—and the reward—is all yours.

Trust yourself. You are sufficient to the task of making great video. You have what it takes. You know what's good and bad. You're stepping up to make the project, and you're showing it to people. And ultimately, your commitment to your way of looking at the world is enough. With practice, you'll get better and better at sharing your video with the world.

> **Trust yourself. You are sufficient to the task of making great video. You have what it takes.**

And if you do all that? You're making art.

Let's leave aside the pomposity of declaring oneself an artist and cut right to the philosophical chase. First, you'll have to buy my definition:

Art is finding your own truth and sharing it with others. Or as I prefer to say it: Art is the act of ripping out your guts and putting them on the table for everyone to look at.

To be an artist, you have to be willing to say, "This is my work." "This is my truth." "This is my best effort." You assert your video truth by making choices that you stand behind in order to create it. Like how to shoot it, how to edit it, and whether to hit "upload."

And it's a scary thing to do because we first have to admit to ourselves that we have a truth. That we believe that our opinions are worth something and worth sharing. Overcoming the fear—that's art. Whether you're a writer with the balls to generate a novel and believe that people should read it, a painter committing her work to canvas and acrylic, or a director making a film, if you've ripped your truth out of your guts and put it on display, it's art.

Art is uniquely selfless and selfish. Selfless because it's an act of sharing that allows others to see their own experience and truths in light of yours. Selfish because it's saying, in no uncertain terms, "I've got something worth saying and I'm going to say it." You're asserting *your* truths, the choices *you've* made. When you choose a shot, it's *your* shot.

You may not be doing "art" if you randomly shoot video on and off through Benjamin's bar mitzvah. But if you scout the synagogue ahead of time, make a shot list, think about what the real story is, you're putting yourself into the work and exposing it to the world, just like any other artist.

One Last Word

The advice contained in this book is mine. There's no Official Board of Video Advice that can tell you whether or not it's on target. That's up to you.

At some point, you're going to disagree with me. Ideally, the disagreement will come after you've tried the advice. Then if you hate it—congratulations!

Anytime you move from not thinking much about your video to thinking about it enough to disagree is progress.

If you read, think, try things, then make your own choices, we both win.

Do-It-Yourself Great Video Grad School

Sure, you can apply and pay to go to a fancy film graduate school. But for those of us too busy, too old, too young, too unmotivated, or too mortgaged, it's pretty easy to get a great self-directed film and video education.

Let's start with a plug: There's a lot of great stuff at this book's website, www.VideoThatDoesntSuck.com. You'll find video versions of some of the lessons in this book, examples of technique, new things I've written since the book was finished, great videos, and more. On my blog I answer reader questions, and I'll even critique *your* video.

There are a *lot* of great videos on the Web—more and more every day. You can see my current favorites (and the classics that are still up) at www.VideoThatDoesntSuck.com.

But you should also start renting and downloading great movies. The movies are where film (and video) language was invented. Most of what you understand about

how video works comes from movies—or someone else's riff on an idea that was born in a movie.

Do-It-Yourself Great Video Grad School: The Syllabus

For a good education, you want to go to the best out there—and these movies are by the best directors, writers, and actors that ever lived.

Below is my personal list of some of the best films ever made—all well known and easy to find. All of them played an important role in the continuous development of cinema and video. After you watch one, follow up by reading the film's entry on Wikipedia.org for great behind-the-scenes information. If you really love the film (and you have it on DVD or Blu-ray), check out the commentary track too.

If you're one of those people who hates black-and-white movies, get over it. Not one of these films is a slow, arty snoozefest. Even

the silent ones. Some do move a little slower than, say, *Transformers,* but this is school, after all.

I've put these in chronological order by date of release, but you can jump in anywhere.

Sherlock Jr. (1924) You've seen these elaborate special effects comedy bits in other movies. Buster Keaton did them first.

The Gold Rush (1925) Everyone's *heard* of Charlie Chaplin. If you've never seen him in action, watch this movie.

Frankenstein (1931) The origin of horror movie conventions still copied today, plus a classic monster.

Horse Feathers (1932) The Marx Brothers kicked ass then, and they still do. Anarchy on film.

A Night at the Opera (1935) The Marx Brothers' other truly great film, though *Duck Soup* is right up there.

Modern Times (1936) Chaplin's last silent. Why did he do it even after sound came out? You'll see.

Swing Time (1936) Fred Astaire and Ginger Rogers defined elegance and dance during the Great Depression. They had moves *Dancing with the Stars* wishes it had.

The Wizard of Oz (1939) If you were born before 1970, you probably have this movie memorized. If you don't, see it (again) now. Way ahead of its time when shot, it still looks modern today due to great effects, songs, performances, and structure.

His Girl Friday (1940) Howard Hawks directs Cary Grant and Rosalind Russell in a fast-talking farce.

Citizen Kane (1941) Nonlinear structure and many camera tricks were done here first.

The Lady Eve (1941) Preston Sturges wrote and directed a near-perfect screwball comedy.

Sullivan's Travels (1941) Sturges again, this time taking on pretentious directors.

Casablanca (1942) Humphrey Bogart's iconic role. Brilliant story structure.

Yankee Doodle Dandy (1942) A fast-moving, catchy musical that time travels you back to America's 20th-century war efforts.

Double Indemnity (1944) This nasty detective thriller from Billy Wilder practically invented film noir. Directors *still* steal from it.

It's a Wonderful Life (1946) You've seen it on TV, but be sure to see it without commercials. It's a lot darker than you think.

Notorious (1946) Alfred Hitchcock spy thriller. Romantic, great-looking, and Ingrid Bergman.

Adam's Rib (1949) The signature comedy featuring Katharine Hepburn and Spencer Tracy.

Sunset Boulevard (1950) Billy Wilder again, in a film narrated by a corpse. You know a lot of the lines even if you've never seen the movie.

Singin' in the Rain (1952) Gene Kelly, Donald O'Connor, Debbie Reynolds. One of the two best live-action musicals ever made, and a blast because it's about the movies.

The Ten Commandments (1956) Cecil B. DeMille was the James Cameron of his day. This was his most ambitious film.

Vertigo (1958) For my money, Hitchcock's best movie.

North by Northwest (1959) For my money, Hitchock's most fun movie.

Some Like It Hot (1959) Another Billy Wilder film. See it for the comedy and for Marilyn Monroe.

Psycho (1960) For my money, Hitchcock's scariest movie.

West Side Story (1961) A great example of how to borrow a story and turn it into something completely different. Based on Shakespeare's *Romeo and Juliet*.

Lawrence of Arabia (1962) When you look up "epic" in the dictionary, it has a still from this movie. Watch it in HD on a big screen. And remember—they didn't *have* digital back then. All those people are real.

The Man Who Shot Liberty Valance (1962) A movie about the power of story, and who the real heroes are. Plus John Wayne and Jimmy Stewart.

Mary Poppins (1964) My other vote for the two best live-action musicals ever made.

The Graduate (1967) Watch this to see where director Mike Nichols put the camera— it's someplace you don't expect, in every single shot.

Butch Cassidy and the Sundance Kid (1969) The writing, from William Goldman, is the real star. But when you're watching, you'll love Paul Newman and Robert Redford.

The Last Picture Show (1971) Why would Peter Bogdanovich make a black-and-white movie in the 1970s? It's a memory piece.

The Godfather (1972) If you can't tell from the rest of this book, it's hands down my favorite movie of all time. This is confident, authoritative filmmaking. A *perfect* film.

Paper Moon (1973) Another great black-and-white memory piece from Peter Bogdanovich.

The Conversation (1974) A cerebral film from the director of *The Godfather*. Gene Hackman is great in the lead.

The Godfather Part II (1974) I like this one almost as much as the original. Sprawling, tragic. Notice Part III is not on this list.

Young Frankenstein (1974) Mel Brooks at the top of his game. A near-perfect example of *parody*.

Jaws (1975) Steven Spielberg's box-office-busting early feature. The birth of the blockbuster.

Nashville (1975) The Altmaniest Robert Altman movie. No structure; interlocking stories.

Taxi Driver (1976) Martin Scorsese directs Robert De Niro and a young Jodie Foster in a harrowing story of violent redemption. Scorsese virtually invented the much-copied steam-vent-wet-streets look of New York.

Annie Hall (1977) Woody Allen's career best.

Star Wars (1977) This film created a universe. Which is very, very hard to do.

Animal House (1978) The father of raunchy R-rated pics like *The Hangover*.

The Deer Hunter (1978) An early, big part for Meryl Streep, and an allegory of unparalleled power.

Apocalypse Now (1979) Epic. Sweaty. Outrageous still.

Manhattan (1979) Woody Allen's second greatest film and best-looking by far, with astounding cinematography by Gordon Willis, who also shot (wait for it) both *Godfather I* and *II*.

Airplane! (1980) Still-classic shotgun parody is the father of a long line of much lesser product.

The Empire Strikes Back (1980) The best, by far, of the six Star Wars movies. Gordon Willis didn't shoot this.

Raging Bull (1980) Scorsese/De Niro again. The most unlikeable hero in movies.

The Stuntman (1980) This movie sets out to trick you over and over and over again. And it does. And you'll like it.

An American Werewolf in London (1981) Humor, horror, and gore *can* mix.

Body Heat (1981) A trickier, even darker updating of *Double Indemnity*. Great performances. Kathleen Turner's performance may be the hottest ever caught on film.

Raiders of the Lost Ark (1981) You know this one, right?

Blade Runner (1982) Detective film of the future. This film has influenced the look of every science fiction movie since.

E.T.: The Extra-Terrestrial (1982) If a puppet can make you cry, the writing and directing must be really good.

Once Upon a Time in America (1984) Sergio Leone was known for his Westerns (*Once Upon a Time in the West; The Good, the Bad, and the Ugly*) and should be. But this nearly out-Godfathers *The Godfather*. Epic. Make sure you get the longer uncut version.

Stop Making Sense (1984) The best concert movie ever shot captures the alt-rockers Talking Heads at the peak of their power. Count how many times director Jonathan Demme cut to shots of the audience (hint: none).

This Is Spinal Tap (1984) The father of all mockumentaries, and still as funny as it was then.

The Fly (1986) A gross, scary-funny-tragic story of a man's descent into flyhood. Don't plan on eating right after.

The Hidden (1987) This cult sci-fi horror film has more energy in its opening scene than most movies have in 90 minutes.

The Princess Bride (1987) Must-see family film that adults will like every bit as much. Great action, great characters, great comedy.

Die Hard (1988) The first hyper-realistic action feature. The crashes are crashier, the violence is violenter than any film before it.

sex, lies, and videotape (1989) An intelligent, low-budget indie film that set the bar for all that followed.

When Harry Met Sally . . . (1989) *Perfect* genre romantic comedy.

Edward Scissorhands (1990) This is the Tim Burtoniest of all his movies. A young Johnny Depp stars in this portrait of the artist as a young freak.

Beauty and the Beast (1991) The best cartoon movie musical ever made.

The Silence of the Lambs (1991) Watch this movie for director Jonathan Demme's camera work. He turned extreme close-ups into an art form. Scary as hell, too.

The Player (1992) I love the whole thing, but you *must* watch the opening shot. It's 10 minutes long.

Unforgiven (1992) A great modern Western from director/star Clint Eastwood.

Pulp Fiction (1994) Quentin Tarantino's second film plays with actor icons and story structure. And it's a blast.

Toy Story (1995) Cartoon emotion at its best from Pixar.

The Truman Show (1998) Peter Weir directs Jim Carrey in a film about life as seen by the media.

The Matrix (1999) It's rare that a film really bends your brain. This one does. Skip the sequels.

The Sixth Sense (1999) An intelligent horror movie that will scare the hell out of you *and* make you cry? Yep. A must-see even if you know the surprise ending already.

Crouching Tiger, Hidden Dragon (2000) If you haven't seen a real Hong Kong kung fu movie, start here. Then check out Jackie Chan in *The Legend of Drunken Master* (1994).

Gosford Park (2001) Kinda sorta a mystery, kinda sorta a British-class drama.

Spirited Away (2001) A bizarre, Japanese animé *Wizard of Oz*-like film from Hayao Miyazaki. Like nothing you've ever seen before. You must, *must* see one Miyazaki movie (there are lots of great ones), so start here.

The Lord of the Rings trilogy (2001–2003) Epic. Masterful. Stunning.

Kill Bill: Vol. 1 (2003) and *Kill Bill: Vol. 2* (2004) Tarantino again. Why aren't there more female action heroes? This should be a trend.

The Triplets of Belleville (2003) I love movies and videos that make me see through someone else's eyes. This French animated piece is as odd as the oddest Japanese anime, but totally different. Don't worry about translation—only two words are spoken in the entire film.

The Bourne Supremacy (2004) The second and best of the Bourne movies. Watch it for the gut-wrenching action scenes courtesy of director Paul Greengrass's much-copied hyper-hyper-edit techniques.

The Incredibles (2004) What is a hero? A great script with great characters that just happen to be animated.

Spider-Man 2 (2004) A near-perfect superhero movie. A great reworking of the ideas in an earlier generation's near-perfect superhero movie, *Superman II* (1980).

Pan's Labyrinth (2006) A director with an eye like no other. You know you're in Guillermo del Toro's world from frame 1.

Two Weeks (2007) I won't pretend this one's in the same league as these other masterworks, but it made the list because it had a big influence on *my* film education. Great performance from two-time Academy Award–winner Sally Field, if I do say so.

Ratatouille (2007) Portrait of the cartoon rat as artist. Subtle, beautiful, and great characters.

Slumdog Millionaire (2008) Watch the use of color, and how it pulls you into a world Westerners have never seen before.

Avatar (2009) A lesson in managing expectations: The men expect action and 3-D. The women know it's a love story. They're both right (as they were with Cameron's earlier *Titanic*).

District 9 (2009) Bleak, modern sci-fi. Gritty interaction between animated characters and real-life.

Inglourious Basterds (2009) The power of cinema, violence, and wishful thinking.

The Informant! (2009) An unreliable and unlikeable hero still manages to carry the movie.

Do-It-Yourself Great Video Grad School: Extra Credit Film and Video Reading List

Most of these books can be picked up and read a bit at a time. Put them by the bedside or in the bathroom and read when you can. There will not be a quiz.

On Story

Story, by Robert McKee

Secrets of Film Writing, by Tom Lazarus

Three Uses of the Knife, by David Mamet

Characters and Viewpoint, by Orson Scott Card

Also, read any screenplay you can get your hands on: The more you read actual, produced screenplays, the more you'll understand how film and video stories are told well. There are many downloadable online (see www.VideoThatDoesntSuck.com/downloadablescripts) and you can purchase them in bookstores everywhere.

On Film- and Video-Making

The Annotated Godfather, by Jenny M. Jones (includes the complete screenplay by Francis Ford Coppola and Mario Puzo)

On Directing Film, by David Mamet

Producing Great Sound for Film and Video, by Jay Rose. My friend Jay wrote *the* book on the subject, now in its third edition.

The Conversations: Walter Murch and the Art of Editing Film, by Michael Ondaatje

On Life in Hollywood

Adventures in the Screen Trade, by William Goldman

Conversations with the Great Moviemakers of Hollywood's Golden Age, by George Stevens Jr.

Great Reading on Creativity

The Creative Habit, by Twyla Tharp

The War of Art, by Steven Pressfield

The Art of Possibility, by Rosamund Stone Zander and Benjamin Zander

Links

Links to some great videos and more can be found at www.VideoThatDoesntSuck.com.

Acknowledgments

Somehow I thought writing a book would be a more solo endeavor than, say, shooting a movie. As it often turns out, I was completely wrong. Books, too, take a village.

So thank you—to my family, Debbie, Sarah, and Matthew, for putting up with me and letting me use you as examples.

Thanks to all of my students over the last 11 years at Summer Stars Camp for the Performing Arts for helping me develop what turned out to be a video curriculum, and to camp director Donna Milani Luther who encouraged me to teach the course in the first place. Summer Stars is a nonprofit camp that helps economically disadvantaged kids succeed through the performing arts—donate now at www.summerstars.org.

Thanks to Bob Rivers for starting the conversation that lead directly to this project; to Steve Goldstein who, when I called him to say I had this great idea for a book called "How to Shoot Like a Hollywood Director" said of his radio station staff, "That's great and all, but I just wish they could shoot video that doesn't suck!" I'm also grateful to Jenny Swift, for always being a great first reader, and to Jay Rose, Steve Marx, John Marias, Andy Goodman, Terry McNally, and Steve Bornstein for thoughtful advice and support all the way through.

Thanks to my agent, Lisa DiMona, who helped me find a home at Workman, and my editor, Margot Herrera, who furnished the home with warm rugs and an ottoman (and is probably dying to edit that tortured metaphor, but if you're reading this, didn't). Plus, Walter Weintz, Jessica Weiner, and Yin Wong at Workman whose support was like homemade cookies from new neighbors. (Okay, a metaphorical step too far, perhaps. I'll stop now.)

Finally, to all of the great teachers at whose feet I've been lucky enough to sit—I hope I was able to pass along a little bit of what you taught.

About the Author

STEVE STOCKMAN is the founder of Custom Productions, Inc., in Los Angeles. He is a producer, writer, and director of hundreds of commercials and a slew of short films, Web series, music videos, and TV shows. He wrote, produced, and directed the award-winning 2007 MGM feature film *Two Weeks*.

For more on video and all Steve's bloggy thoughts, visit stevestockman.com. For information on Steve's keynotes and video workshops for your organization, see the website or email info@stevestockman.com.

How to Shoot Video that Doesn't Suck is his first book, and he hopes it will impress his kids.

Made in the USA
Monee, IL
01 February 2022